WILDLIFE
SKETCHING
PEN, PENCIL, CRAYON AND CHARCOAL

WILDLIFE
SKETCHING
PEN, PENCIL, CRAYON AND CHARCOAL

FRANK LOHAN

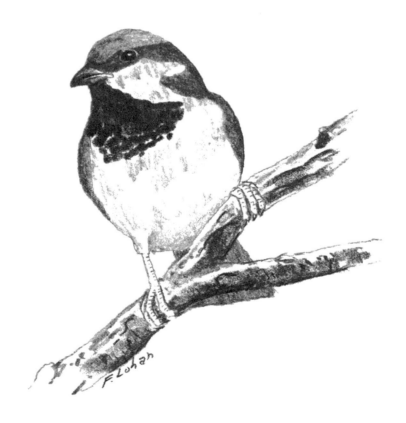

DOVER PUBLICATIONS, INC.
MINEOLA, NEW YORK

Bibliographical Note

This Dover edition, first published in 2009, is an unabridged republication of
the work originally published by Contemporary Books, Inc., Chicago, in 1986.

Library of Congress Cataloging-in-Publication Data

Lohan, Frank.
 Wildlife sketching : pen, pencil, crayon, and charcoal / Frank Lohan. —
Dover ed.
 p. cm.
 Originally published: Chicago : Contemporary Books, 1986.
 Includes bibliographical references and index.
 ISBN-13: 978-0-486-47457-1
 ISBN-10: 0-486-47457-7
 1. Wildlife art. 2. Plants in art. 3. Drawing—Technique. I. Title.

NC780.L64 2009
743.6—dc22

 2009010685

Manufactured in the United States by RR Donnelley
47457703 2015
www.doverpublications.com

Dedication
To Jack and to others who have risen
above the conventions and
restrictions of our world, yet wisely
have not lost sight of them.

Contents

WILDLIFE
SKETCHING
PEN, PENCIL, CRAYON AND CHARCOAL

Introduction

Baseball legend Yogi Berra reputedly said, "You can see a lot just by looking." There is a subtle wisdom in this remark, and it bears on our ability to *perceive*—a deeper and more knowledgeable action than simply seeing.

Perception is absolutely vital to the artist. One way to develop it is to analyze what you don't like in your drawings, which helps you recognize what you failed to perceive about your subject as you drew it. But this process can be slow and might discourage you from continuing to pursue this very gratifying pastime.

I believe that perception can be *learned*—at least a method can be learned that makes perceptive study and analysis of any subject simpler, thereby more quickly bridging that first obstacle to realistic nature drawing: getting a reasonably realistic composition sketch.

In this book I show you how to look for—to deliberately perceive—the underlying geometric shapes of natural things. Once you can do this, and then spend a few seconds making a structure sketch, your task of getting a reasonably realistic composition drawing of your subject is more than half done.

The simple approaches I outline in the book are probably not totally adequate for technical illustration—but then this is not a book on technical illustration. It is a book for those of you who start with no knowledge of the anatomy of animals or plants, but would like to learn how to draw them. It is meant to show you how to use reference illustrations of your subject to draw poses or actions different from the references, and do it in a reasonably realistic manner. It is not designed to show you exactly how to produce given results. Rather,

it is meant to teach you, through numerous examples, how to recognize the basic structural elements of *any* subject: the framework on which to base your drawing.

I hope the book helps you to quickly reach that exhilarating moment when you suddenly see how "easy" it is to produce a beautiful result—the "Look what I did!" point in your creative learning process, the early-on success that whets your enthusiasm and keeps you drawing.

How to Use This Book

For best results, first read chapters 1, 2, and 3—*Tools and Materials, Drawing Techniques*, and *Perspective Drawing*. These sections introduce terms and procedures that are constantly referred to in the later sections. Then go through Chapter 4, *Songbirds*, fairly thoroughly, since the basics of creating and using structure sketches with different media (pen, pencil, lithographic crayon, charcoal pencil) are treated more fully there than in the later sections. Once you've gone through these basics, you can skip around the book to any subjects that interest you.

1
Tools and Materials

Pencil Drawing
Pen Drawing
Paper

Pencil Drawing

The tools needed for pencil drawing are inexpensive and readily available in any art supply store. Pencils, two kinds of erasers, an erasing shield, paper towel, and fixative to eliminate smudging are all you need for many hours of drawing.

Pencils

There are dozens of kinds of pencils available for sketching. The pencil illustrations in this book were done using only graphite pencils in hardness grades 2H, HB, 3B, and 6B (fig. 1-1). The *H* series is *hard*, while the *B* series is *soft*. The larger the *H* number, the harder the lead is. The larger the *B* number, the softer the lead is. Using a 6H pencil can be like drawing with a nail—it makes a light line and usually leaves an indentation in the paper.

I do not recommend the common No. 2 writing pencil as there is no telling just how hard or soft any brand might be. It is best to buy four drawing pencils, all from the same brand, in the 2H, HB, 3B, and 6B grades. This will give you a completely adequate tonal range for the subjects treated in this book.

Sharpen your pencils with a pen knife or single-edge razor blade or a utility knife. Leave about one-quarter inch of lead beyond the wood (fig.1-3). Then, using a small piece of sandpaper (fig. 1-2), put a slanted, flat surface on the lead. This gives you a broad, flat surface so that you can cover larger areas with a uniform tone, and also gives you a very sharp edge at the tip for putting details in place. I glue a small piece of sandpaper in the cover of a small box, and also glue a piece of paper towel there. This keeps the graphite dust in the box and off my drawing, and gives me a towel to wipe the lead on each time I sharpen it.

Erasers

I recommend two different erasers: one is a soft, pink or white pencil eraser (fig. 1-4), and the other is a kneaded eraser (fig. 1-5). The eraser on the back of a common writing pencil is much too abrasive for use in sketching; it destroys the paper surface.

I'm sure you are familiar with the pink or white pencil eraser, but you may not have seen a kneaded eraser before. It comes in a small rectangular package. Tear about one third of the eraser off—it is like dry chewing gum and tears easily. You can squeeze it together with your fingers, twist it, fold it; press it together again and it becomes one piece. You can pinch it to a sharp edge and press that edge on a dark area of your sketch, or press a larger part of it on your drawing. You will get results like those illustrated in figure 1-6. It is great for slightly lightening a dark area. As you use it, keep kneading the dirty part inside and it will last a surprisingly long time.

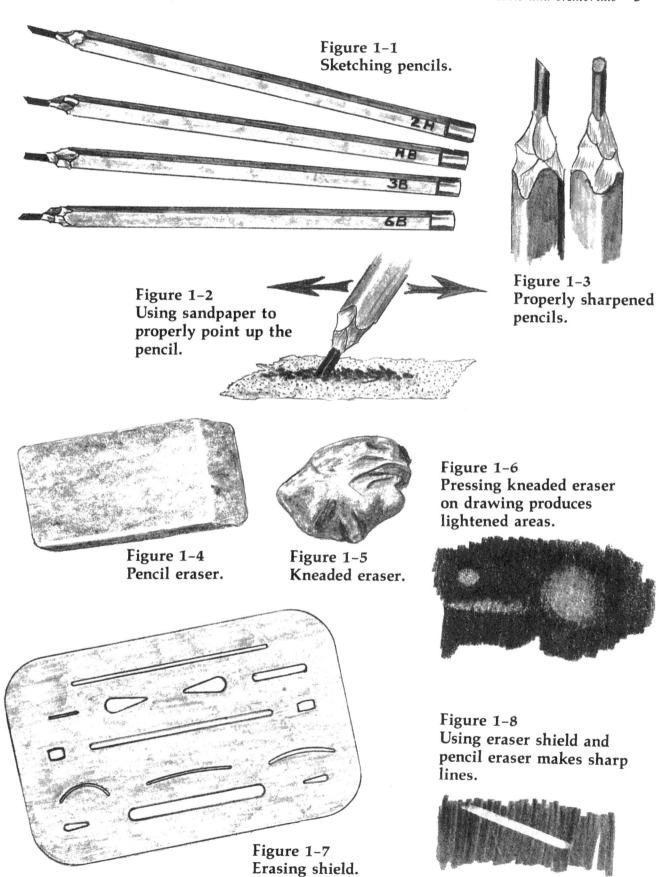

Figure 1-1
Sketching pencils.

Figure 1-3
Properly sharpened
pencils.

Figure 1-2
Using sandpaper to
properly point up the
pencil.

Figure 1-6
Pressing kneaded eraser
on drawing produces
lightened areas.

Figure 1-4
Pencil eraser.

Figure 1-5
Kneaded eraser.

Figure 1-8
Using eraser shield and
pencil eraser makes sharp
lines.

Figure 1-7
Erasing shield.

Erasing Shield

An erasing shield is a very handy drafting tool (fig. 1-7). It is a thin piece of stainless steel with variously shaped cutouts. You lay it on your drawing to protect areas you do not want to touch, and to expose what you want to erase. You then use the pencil eraser to trim an edge or to erase in the middle of a toned area, as illustrated in figure 1-8.

Paper Towel

I use a folded paper towel like a paint brush to dust the eraser residue from my drawing.

Fixative

I use clear spray enamel to fix or protect my finished drawings after I have cleaned up any smudges. Three or four light coats leaves an invisible, clean surface that greatly reduces smudging from handling or storage.

Two other pencil-like tools illustrated later are the *lithographic crayon* and the *charcoal pencil*. Both of these produce intense darks. The lithographic crayon leaves a waxy black residue that smears rather easily but works well with pen and ink. It is usually used on a highly textured paper such as coquille paper to produce a dotted gray background or shading tone very quickly. I use four or five layers of clear spray enamel over the drawings made with lithographic crayon. The use of this crayon with pen and ink is demonstrated in the section on sketching songbirds.

The charcoal pencil in the 4B or 6B grade also produces an intense black quickly. The dust residue may be blown off the drawing and details put in with pen. Charcoal pencil is suitable only on a coarser, toothy paper with grain enough to "hold" the charcoal. It, too, requires three or four coats of the fixative to keep it from rubbing off or smudging other areas.

Pen Drawing

The tools required for drawing with pen are widely available and vary in cost. What you spend depends entirely on your personal preferences. I use all three pens described below in my classes. Each type of pen is made by several different companies, and can be found in any art store.

Technical Pen

The technical pen (fig. 1-9) is widely used for engineering drawing and is becoming more and more popular for art work. Basically the point is a very tiny tube with a fine wire inside the tube. This wire is attached to a weight inside the pen that moves the wire inside the tube when the pen is gently shaken. This movement of the wire is what keeps ink flowing through the extremely small hole in the tube.

The technical pen must be used in a position almost upright to the paper to get the ink to flow out the end and onto the paper. This is different enough from the normal writing position that many people find it a little awkward at first. With a little patience and practice, however, you

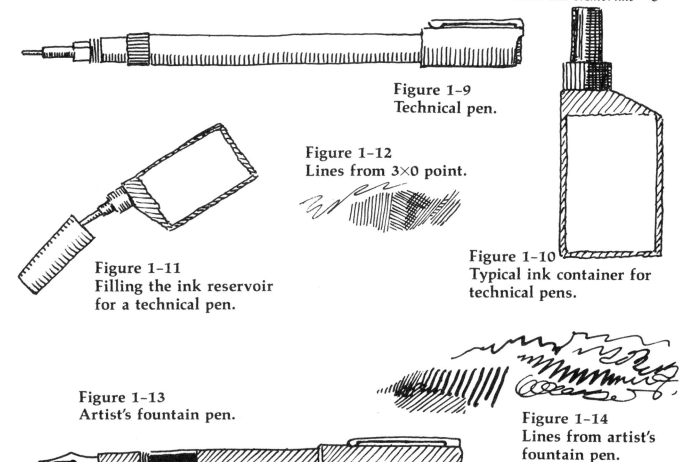

Figure 1-9
Technical pen.

Figure 1-12
Lines from 3×0 point.

Figure 1-11
Filling the ink reservoir
for a technical pen.

Figure 1-10
Typical ink container for
technical pens.

Figure 1-13
Artist's fountain pen.

Figure 1-14
Lines from artist's
fountain pen.

will develop a feel for it and will achieve considerable dexterity.

There is no flexibility to the technical pen. The line width produced is fixed by the size of the point—that is, by the size of the hole in the tube. To obtain a different size line you change points.

The benefits of using such an implement include portability and convenience—it eliminates constantly dipping the point into ink, which is characteristic of the replaceable nib crowquill-type pen.

It is important with technical pens that you use the ink specifically produced for them to minimize the possibility of clogging the point. Such ink usually comes in a plastic container similar to the one illustrated (fig. 1-10). The ink reservoir for these

pens usually is a little hollow plastic piece that slips over the back of the point assembly. To fill the reservoir, remove it from the point assembly, then put the spout of the bottle into the plastic piece and squeeze the bottle until the reservoir is almost full (fig. 1-11). Then twist the full reservoir onto the rear of the point assembly, and screw the hole into the tube that acts as the holder.

Although there usually is a moisture retainer in the cap of these pens, I have learned from experience to clean all the ink out of the point whenever I am finished sketching for the day. The hole in the tube that forms the point is very fine and once ink dries in it, it can take hours of soaking, shaking, and washing to get it clean. Once I clean the point, I

reassemble the pen and store it upright in a glass with the point at the top. If I do not expect to use the pen for several days I also clean out the ink reservoir with soap and water and a Q-tip, as little flakes of dried ink can also make the ink flow erratic.

Point sizes range from the smallest, 6×0 (six zero), on up to 3, 2, and 1. I find a 3×0 (three zero) most suitable for all the work I do; the finer points (4×0, 5×0, 6×0) tend to clog more easily. The line produced by the 3×0 point is illustrated in figure 1–12.

Artist's Fountain Pen

The artist's fountain pen (fig. 1–13) is perhaps the most widely used implement for pen and ink sketching. It has the advantage of portability, just as the technical pen does, without the need to carry ink. In addition, the point is flexible, which allows for varying, or modulating, the line width simply by varying the pressure on the point as you draw. This lends a free look to your work, especially to looser sketches. Typical lines from an artist's fountain pen are shown in figure 1–14. Points can be interchanged on these pens, although I just keep one marked *fine* in my pen all the time. You cannot achieve as thin a line with the fountain pen, however, as you can with the technical pen.

Depending on the make, fill an artist's fountain pen either as described above for the technical pen, or by submersing the point in the ink bottle and operating the fill mechanism. I use a nonwaterproof ink in my fountain pen and do not worry

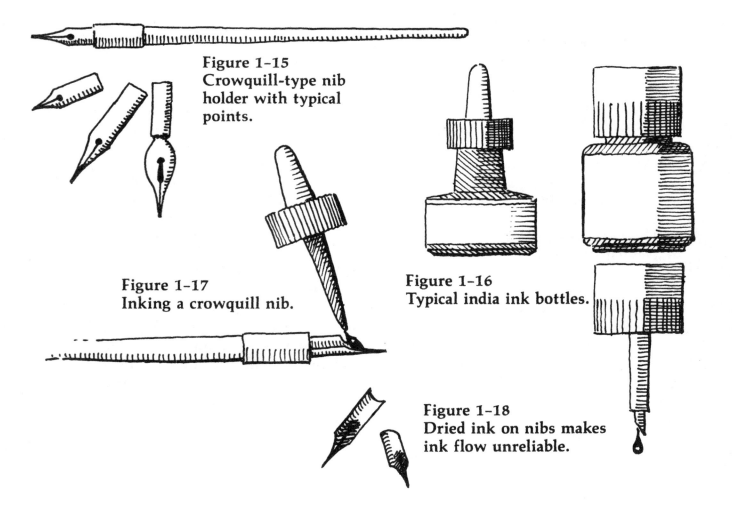

Figure 1–15
Crowquill-type nib holder with typical points.

Figure 1–17
Inking a crowquill nib.

Figure 1–16
Typical india ink bottles.

Figure 1–18
Dried ink on nibs makes ink flow unreliable.

much about how long I let the pen sit between uses. Very heavily pigmented waterproof ink can ruin an artist's fountain pen if it dries out inside the pen and on the point. If I use such ink I clean my pen completely at the end of the day. The ink I use most often states "for fountain pens" on the container.

Crowquill Pen

This replaceable nib pen is the old standby sketching pen. It is the least expensive and utilizes any ink, even the most heavily pigmented ones and the ones that achieve their waterproof characteristics from the use of shellac. A crowquill-type nib holder with point inserted is shown in figure 1–15 along with some typical points. A wide variety of points with different degrees of flexibility are available at several for a dollar in any art supply store. Crowquill points produce line work similar to that of the artist's fountain pen.

India ink is a popular choice for crowquill pens. This ink usually comes in one-ounce glass bottles with eyedropper-type fillers (fig. 1–16). You can ink the point using the dropper (fig. 1–17) or by pouring some ink into a shot glass and dipping the pen into it. (Dipping into the ink bottle itself is very messy.) Both the front and back of the point must be wet with ink. Be sure to keep points clean and shiny by frequently dipping them in a small glass of water and wiping them with a paper towel as you work. This keeps the ink flowing reliably.

If ink dries on your crowquill points so that they look like figure 1–18, they are too dirty to work reliably. Soak them overnight in ammonia, soap, and water; then clean them.

Paper

There are many different kinds of paper available that are suitable for drawing. Try a variety of them to see what unique effects they may produce for you. In general, however, if you are just starting out, the first four papers listed below will work quite well until you are ready to experiment with other papers.

Bond Copier Paper or Tablet Drawing Paper

This is good for pencil composition drawings, which inevitably require erasing to get things right. Make all composition drawings in pencil, whether you plan to do the final drawing in pencil or in pen. Only when the composition is satisfactory should you then transfer it to your final working paper (as described later).

Quadrille Paper

This lightweight bond paper has light blue squares all over it. I use this for all my pencil compositions—the blue lines keep my verticals vertical and my horizontals horizontal. On unlined papers my verticals always tend to become slanted, with the tops drifting to the right. Quadrille paper is available in pads at art or drafting supply stores.

Tracing Vellum

This semitransparent paper generally is available in pads. It is usually 100 percent rag content, which makes it as permanent as the

best watercolor paper. For this reason vellum is often used in drafting rooms for permanent engineering drawings. If you use vellum for your final drawing, you can lay a piece of it directly over your pencil composition and go to work with pencil or pen without having to transfer your composition.

A vellum sketch mounted with a piece of white paper behind it seems to glow—the light goes through the vellum and reflects back from the white underlayer. Vellum is available in art supply or drafting supply stores in pads.

Bristol Board

This is the standard paper for pen and ink sketching. It comes in several thicknesses and in several finishes, from smooth to quite toothy. The smooth paper is better for ink, and the toothy paper better for pencil and for lithographic crayon or charcoal pencil with ink. I like the two-ply (100-pound) kid, or regular finish bristol board, for both pen and pencil drawing.

Watercolor Paper

A 140-pound medium finish watercolor paper is actually kind of rough. I like it for pen sketching, as the rough finish gives a sort of broken line that can be quite expressive in rustic sketches. The smooth watercolor papers (hot-pressed) are great for detailed pen work.

Coquille Paper

This pebbly surfaced paper works well with lithographic crayon and ink. Using the crayon lightly produces a uniform gray tone, since it only sticks to the tops of all the little bumps on the paper. This paper is often used for

drawing editorial cartoons and can be useful for technical illustrations, as it makes shading, using a lithographic crayon, very quick and easy. The drawings of the flint and the crab are good examples of this technique (fig. 1–19).

Mylar or Acetate

These materials come both clear and frosted. The frosted kinds are frequently used for engineering drawings. The inks that are made for these papers say "for film" on the box, and will not creep or ball up on mylar or acetate surfaces. I only use such inks with my crowquill pens—never with my technical or fountain pens, because of the possibility of clogging them.

Like vellum, mylar and acetate can also be used directly over your pencil composition, since they are either transparent or semitransparent. The rough frosted material will take pencil and ink, but the smooth material only takes ink that is made for film. The clear films may also be placed over a photograph for drawing directly in ink with no intermediate composition drawing.

Textured Papers

Textured papers such as linen paper or watercolor paper offer interesting results with pencil because of the unique texture of the papers. The linen pattern of the paper shows through the first sketch of a cedar waxwing (fig. 1–20). Observe the difference when the same bird is done in pencil on thin rice paper that was placed on top of coarsely textured watercolor paper (fig. 1–21).

The more texture there is to the paper, the less pencil detail you will be able to achieve. When trying for more scientific accuracy, use a

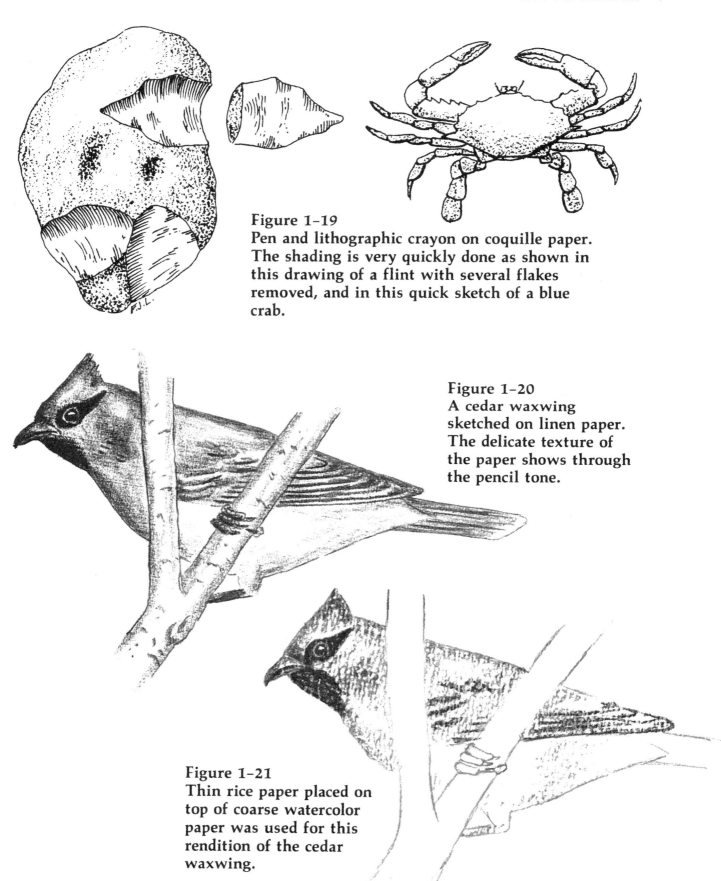

Figure 1-19
Pen and lithographic crayon on coquille paper.
The shading is very quickly done as shown in
this drawing of a flint with several flakes
removed, and in this quick sketch of a blue
crab.

Figure 1-20
A cedar waxwing
sketched on linen paper.
The delicate texture of
the paper shows through
the pencil tone.

Figure 1-21
Thin rice paper placed on
top of coarse watercolor
paper was used for this
rendition of the cedar
waxwing.

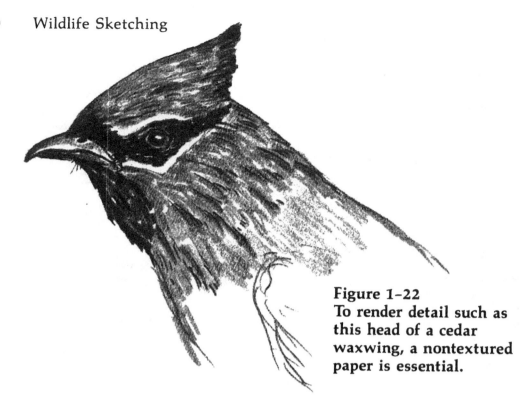

**Figure 1-22
To render detail such as
this head of a cedar
waxwing, a nontextured
paper is essential.**

smoother, hard-surfaced paper like two-ply bristol board. Such detail is shown in the sketch of the head of the cedar waxwing (fig. 1-22), which was done in pencil on hard-surfaced, smoother paper; and in the drawing of the three hawks (fig. 1-23), which was rendered in ink on a smooth-surfaced paper. The smooth surface is necessary for careful detail work either with pencil or with ink.

A list of basic tools and materials recommended for sketching follows for your shopping convenience:

Pencil Drawing
- Pencils: grades 2H, HB, 3B, 6B
- Erasers: pink or white pencil eraser; kneaded eraser
- Erasing shield
- Fixative: clear spray enamel
- Lithographic crayon
- Charcoal pencil
- Paper towels

Pen Drawing
- Technical pen; points for various widths
- Ink for technical pen
- Artist's fountain pen; nonwaterproof ink
- Crowquill pen; variety of points
- India ink for crowquill pen
- Paper towels

Paper
- Bond copier paper or tablet drawing paper
- Quadrille paper
- Tracing vellum
- Bristol board, such as 2-ply (100-lb.) kid
- Watercolor paper: 140-lb., medium finish; hot-pressed smooth
- Coquille paper
- Mylar and/or acetate papers: clear and frosted
- Textured papers, such as linen or rice

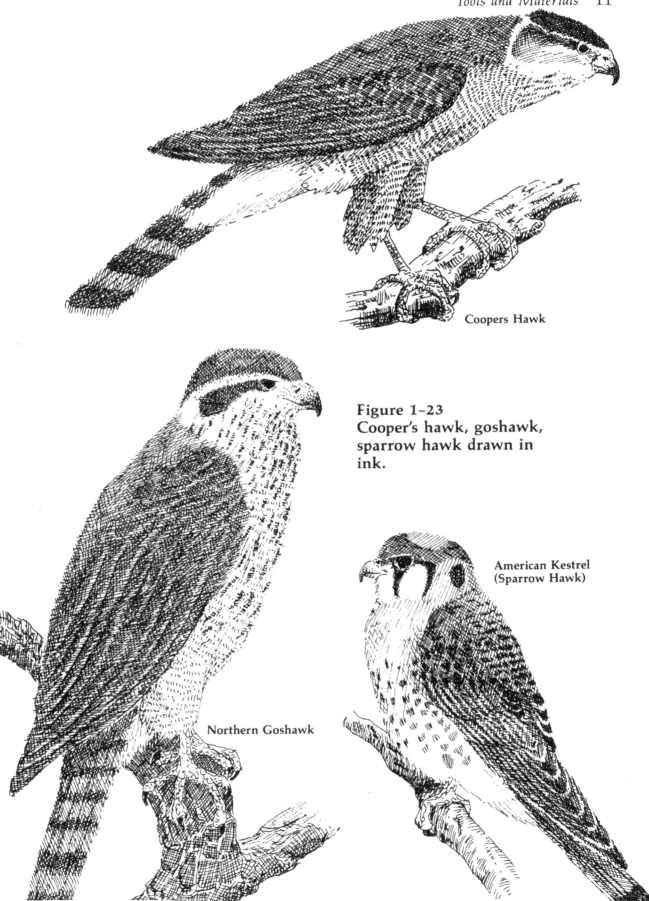

Coopers Hawk

Figure 1–23
Cooper's hawk, goshawk,
sparrow hawk drawn in
ink.

American Kestrel
(Sparrow Hawk)

Northern Goshawk

Technique—1: the manner in which technical details are treated . . . *also*: ability to treat such details . . . 2: a body of technical methods . . . 3: a method of accomplishing a desired aim
—*Webster's Ninth New Collegiate Dictionary* (1984)

2
Drawing Techniques

Basic Guidelines
Pencil Techniques
Pen Techniques
Loose Drawings Versus Tight
Using a Grid to Enlarge, Reduce, or Copy
Transferring a Composition Drawing

Basic Guidelines

There are some close similarities and some very significant differences among the techniques used when drawing with pencil, pen, or pen in combination with lithographic crayon or charcoal pencil. The similarities are primarily in composition and tonal planning. All three methods simply use black on white to produce their effect. Regardless of how the black is achieved, one principle of technique applies; that is, only by the alternation of tone can you bring about a distinction between elements of your sketch. The application of this principle can be seen in all three sketches of the group of pine trees in an open field on a sunny day (fig. 2-1, 2-2, and 2-3). The trunks of the four trees on the left all cross the dark band of background trees and background foliage. Where they do, they are rendered in a very light tone. This tends to bring them forward. If they were too dark, too near in tone to that of the background trees, the spatial separation—the visual sense of depth—would be reduced and possibly lost altogether. A tonal difference is necessary to obtain visual separation.

The differences among the techniques used in these three black and white sketches primarily concern detail and tonal range and the ease with which these are rendered.

A pencil sketch is the quickest of the three methods to execute. This is because it often contains less line detail than the pen rendering and because, with the broad point, a relatively large area can be covered with one stroke. However, there is nothing haphazard in skilled sketching with the pencil. Each of the relatively few strokes must serve a definite purpose. With masters such as Ted Kautzky, author of *Pencil Broadsides*, the simplicity and beauty of pencil drawing take on new meaning.

The pen permits the most detailed rendering of the three, although pencil can be a close second when handled skillfully. When drawing with a pen, a rather small amount of ink is placed on the paper with each ink line drawn. It requires many such lines to create a dark area with a pen. Since each line takes time to draw, it follows that the pen is the slowest of the three media—especially when there are large dark areas in a composition.

Drawing with a lithographic crayon or charcoal pencil to cover the dark areas rapidly, with ink lines added to define detail, falls between the two other methods of drawing in terms of time required. Actually, in the illustrations shown here, the pen-only sketch required over one hour to accomplish; the pencil version required about twenty-five minutes; and the combination pen/lithographic crayon about forty minutes.

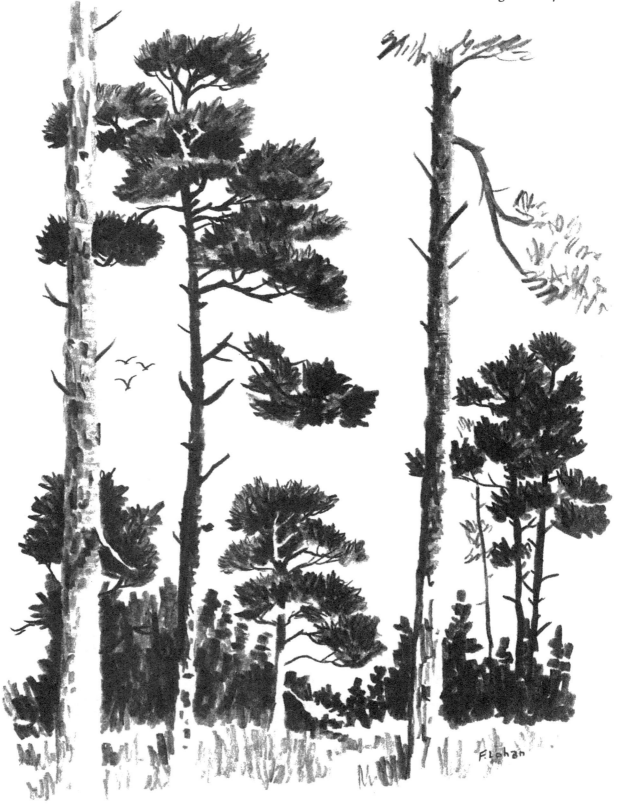

Figure 2–1
Pencil technique. Dark tones are achieved by a few strokes of a broad
point. Details are done with a sharper point over the darks.

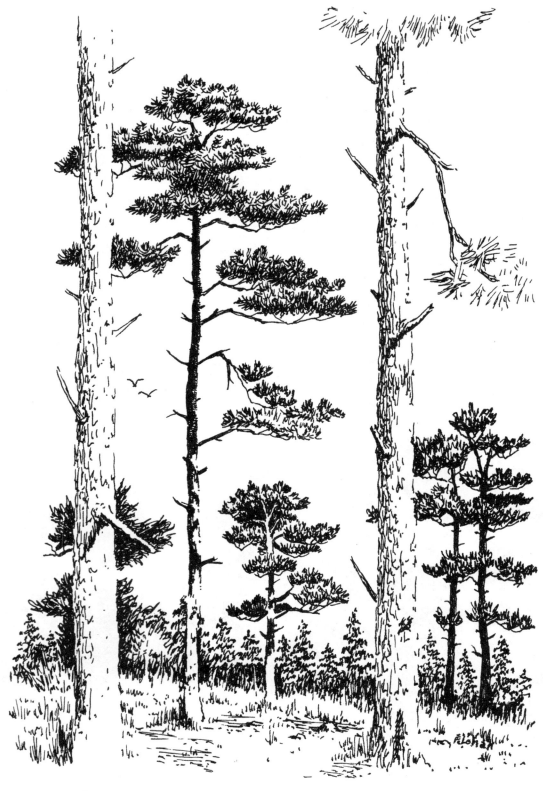

Figure 2-2
Pen technique. Many pen strokes are required to
achieve the dark tones.

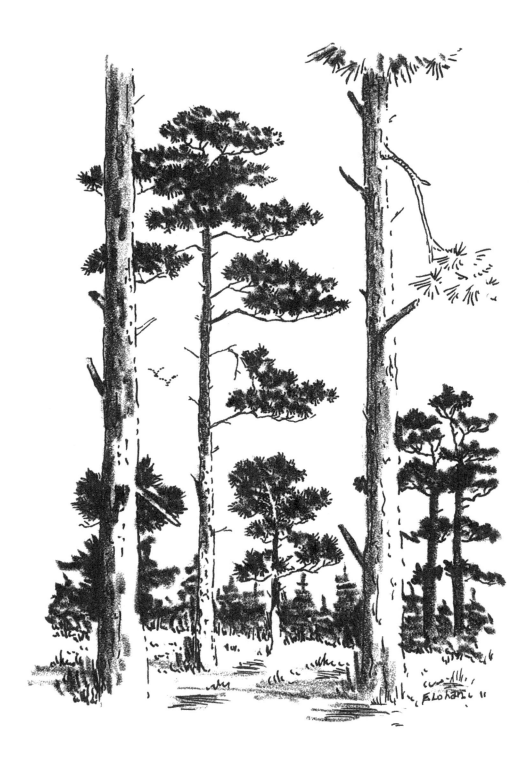

Figure 2–3
**Lithographic crayon technique. Darks are achieved
with very few broad strokes of the crayon.**

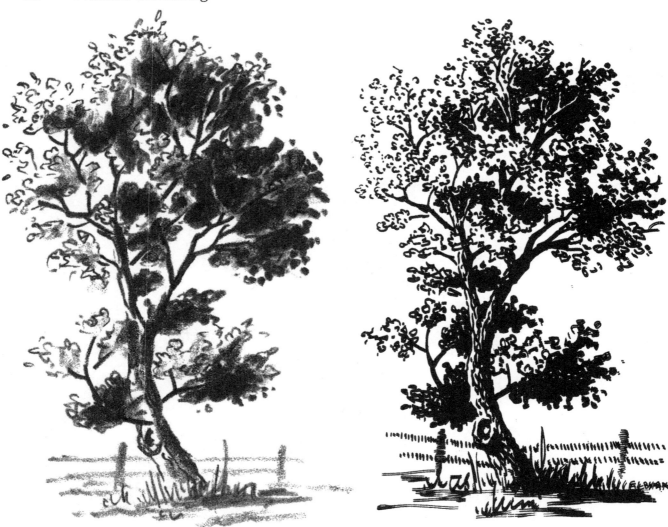

Figure 2-4
Pencil sketch in twelve
minutes.

Figure 2-5
Ink sketch in twenty
minutes.

Pencil Techniques

Pencil drawing requires a great deal of simplification, and uses suggestion to create the illusions necessary for a good finished drawing. Pencil strokes are broader than those made with the pen when defining masses. In drawing a tree, for instance, a few minutes of pencil work can be equivalent to many minutes of pen work. Compare figures 2-4 and 2-5, which illustrate two small studies of a tree. The pencil drawing was done on vellum placed directly over a compositional drawing and required twelve minutes to complete. The pen drawing of the same tree required twenty minutes. Pencil allows rapid tonal treatment of masses; a few broad strokes define the mass, with a sharp line or two to suggest the edge of the form. Light areas are often simply left untouched by the pencil.

Figure 2–6
6B pencil on coarse paper.

Figure 2–7
3B pencil on coarse paper.

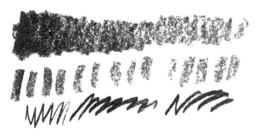

Figure 2–8
HB pencil on coarse paper.

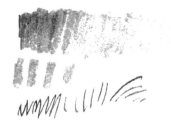

Figure 2–9
2H pencil on coarse paper.

Figure 2–10
6H pencil on coarse paper.

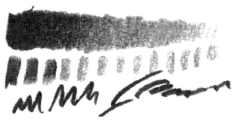

Figure 2–11
6B pencil on smooth paper.

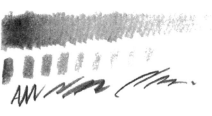

Figure 2–12
HB pencil on smooth paper.

Figure 2–13
2H pencil on smooth paper.

Tone and tonal variation are vital in any black and white medium. The four pencils suggested in Chapter 1 (6B, 3B, HB, 2H), when used on coarse paper, produce the range of tones shown in figures 2–6 through 2–9. Results from the 6H pencil (fig. 2–10) are shown only for comparison. Remember, however, that the results depend greatly on the surface texture of the paper. The next three examples (fig. 2–11, 2–12, 2–13) show how much lighter a tone the pencils produce on smoother bond paper. The lack of a "tooth" to the paper is evident by comparing figure 2–11 with figure 2–6. Figure 2–11 does not show any of the graininess that the rougher paper of figure 2–6 does. For full tonal possibilities use a coarser paper with graphite pencil and charcoal pencil.

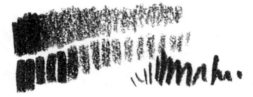

Figure 2-14
4B charcoal pencil on
coarse paper.

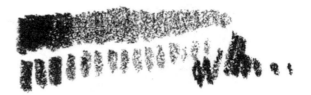

Figure 2-15
Lithographic crayon on
coarse paper.

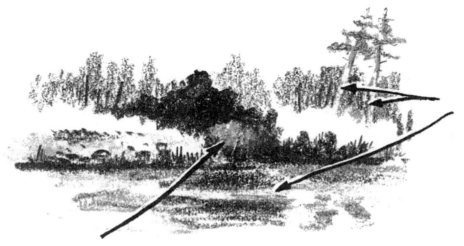

Figure 2-16
Use of kneaded eraser to
lighten dark tones.

Charcoal pencils and lithographic crayons can also be used to produce really dark darks quickly, since they cover so much area in a few strokes (fig. 2-14, 2-15, and 2-3). Neither charcoal pencil nor lithographic crayon is really capable of very sharp detail, so they are usually used along with pen and ink, with the pen providing all the necessary detail. Some of the demonstrations later in the book will show you how to use both of these with pen and ink.

The eraser is an important tool in pencil drawing. It not only removes unwanted lines and corrects mistakes, it can also deliberately alter dark tones for specific effects. The kneaded eraser, described in Chapter 1, is most useful in this regard. When pressed into a dark area, or pressed to an edge between the fingers and drawn across any pencil-toned area, the effect is subtle since it does not leave sharp edges.

The landscape sketch (fig. 2-16) illustrates the use of the kneaded eraser. The eraser was used to create a lighter highlight in the dark mass of foliage in the center; and when pressed to an edge between my fingers, was used to create the two lighter narrow tree trunks at the right and a narrow highlight in the water (see arrows).

The kneaded eraser works well with pencil and charcoal, but is useless with lithographic crayon. Once on paper, that waxy medium is there to stay.

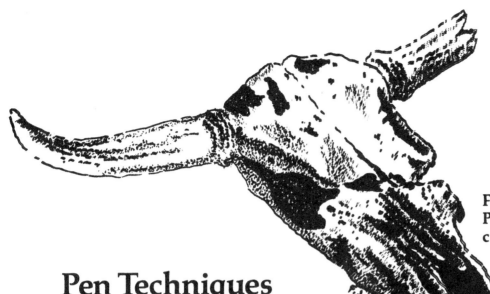

Figure 2–17
Pen and lithographic
crayon on coquille paper.

Pen Techniques

The pen is capable of producing a wide range of tonal values as well as sharp, distinct lines. For this reason it is often used for technical and biological illustration, often in conjunction with other media such as ink wash, watercolor, acrylic paints, lithographic crayon, or charcoal pencil. Pen with lithographic crayon on coquille paper is shown in the quick rendering of an old cow skull (fig. 2–17). The lithographic crayon quickly produced the shading, while the pen provided detail. The convenience and portability of a pen also help to make it a favorite for on-the-spot nature sketching and note-taking for later drawing work in the studio.

The whole idea of black and white drawing is to produce controlled tone somewhere between solid black and pure white. The pencil creates tone by covering an area with fairly wide strokes. The pen creates the same tone in an area by filling it with lines or dots. Figure 2–18 illustrates *hatching*, pen lines used to create several different tones from dark to medium. Figure 2–19 illustrates *cross-hatching*, which simply lays one set of

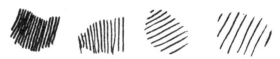

Figure 2–18
Hatching with pen to produce tones.

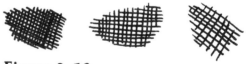

Figure 2–19
Cross-hatching with pen to produce tones.

Figure 2–20
Dotting or stippling with pen
to produce tones.

hatch lines on top of another, in a different direction, to achieve a darker dark. The most gradual tonal scale you can produce with the pen is by the use of stippling, as shown in figure 2–20. You can achieve almost photographic results with this technique, although it is slow going.

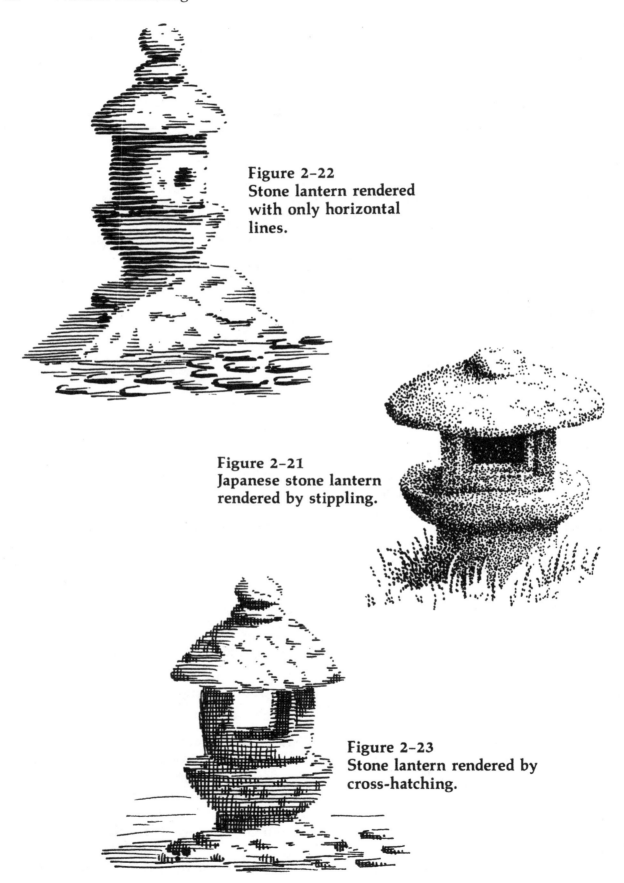

Figure 2-22
Stone lantern rendered
with only horizontal
lines.

Figure 2-21
Japanese stone lantern
rendered by stippling.

Figure 2-23
Stone lantern rendered by
cross-hatching.

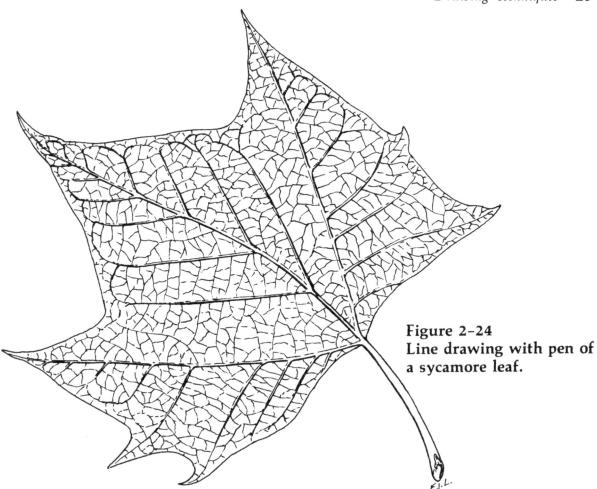

Figure 2-24
Line drawing with pen of a sycamore leaf.

Figure 2-21 shows a Japanese stone lantern rendered by stippling. Figures 2-22 and 2-23 show other such lanterns rendered by line techniques. No one technique is "right" or even preferable. It is simply a matter of what appeals to you for the particular sketch you are working on. For sketching birds, animals, trees, and other things from nature, all these techniques are useful individually and sometimes in combination.

Erasers are virtually useless for ink drawing. Only on the best of the heavy bristol boards or good heavy watercolor paper can you hope to remove an ink line or an accidental drop or splatter. If such an accident happens in a busy area of your drawing, you can sometimes get away with pasting a piece of white self-stick label over it, then recreating the line work. Heavy line work can hide the edges of the label. If the accident happens in a relatively clean area, however, there is little you can do that will not show in the final drawing except to somehow work it into your composition.

However, if your work is for reproduction, you can paste and paint out to your heart's content—such corrections will not show in the reproduction.

A simple pen line can often be very useful for showing structure with no attempt to add roundness by shading. Figure 2-24, an accurate drawing of the veining in a sycamore leaf, is an example of pure line work using the pen.

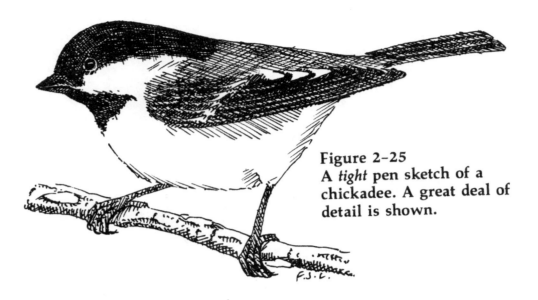

Figure 2-25
A *tight* pen sketch of a chickadee. A great deal of detail is shown.

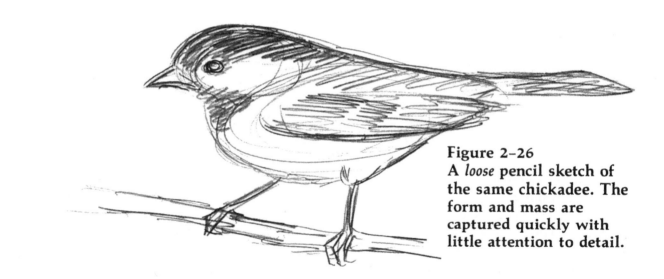

Figure 2-26
A *loose* pencil sketch of the same chickadee. The form and mass are captured quickly with little attention to detail.

Loose Drawings Versus Tight

Whatever your medium, you can draw your subject in the exacting manner characteristic of scientific drawings, or you can rapidly put down lines to define the overall shape and mass with little or no attempt at detail. The first is a *tight* drawing, and the second a *loose* one. Compare the two drawings of a chickadee: it is sketched tightly with a pen in figure 2-25, and loosely with a pencil in figure 2-26. Loose sketches are usually done quickly to try different compositions, to quickly capture a pose or action from life, or to make color and shading notes for later use. A loose technique is also quite attractive for impressionistic sketches, so don't relegate it solely to preliminary work. You'll find you'll really be pleased with many of your loose sketches.

Figure 2-27
**Composition drawing with transparent
grid of squares placed on top.**

Using a Grid to Enlarge, Reduce, or Copy

Sometimes your composition is just the right size for your working drawing. Mine frequently are, since I measure out my final size on the quadrille paper before I start my composition. Sometimes, however, you may want to enlarge or reduce a drawing or photograph. I have designed a tool to make this quick and easy.

On an 8½" by 11" piece of clear acetate, ink-rule a grid of horizontal and vertical lines every one-half inch. Place this grid over whatever you want to enlarge or reduce, and on composition paper draw a second grid of squares so that you have, at the size you want your final sketch, the same number of vertical and horizontal lines that cover your

Figure 2-28
Composition size is reduced by using smaller squares to copy the outline.

Figure 2-29
Composition size is enlarged by using larger squares to copy the outline.

subject. Make sure you have *squares*—if one of the sets of lines is compressed, your result will be too short and fat or too tall and thin. This grid arrangement provides a system of squares over your subject and a corresponding system of squares on your composition paper—copying is very easy using the squares as guides.

Figures 2-27, 2-28, and 2-29 show the principles involved in enlarging and reducing by this method. Figure 2-27 illustrates the original composition with the transparent grid placed over it. Figure 2-28 shows the grid system being used to *reduce* the sketch, with the squares drawn smaller than those placed over the composition. Figure 2-29 shows the grid system being used to *enlarge* the

figure, with the squares drawn larger than those on the composition. To copy, just note where the composition drawing lines cross the vertical and horizontal lines on the acetate grid, make corresponding marks on your composition paper grid, then connect the marks, noting how the line is supposed to flow through each particular square.

If the paper on which you draw your squares is your final drawing paper, draw the squares very lightly so they will erase easily later. However, if you make your reduction or enlargement on an intermediate piece of paper, you can easily transfer it to your final paper, using the method that follows.

Figure 2-30
Blacken the back of your composition with a pencil in preparation to transfering it.

Transferring a Composition Drawing

Once you have a composition that satisfies you—with all proportions and perspectives correct and all details in proper relationship to one another—you are ready to transfer it to your final drawing paper. The following process holds whether you do your final sketch in pencil, pen, or any other medium.

Turn your composition drawing over on a clean piece of paper, drawing side down. Take a soft pencil (such as HB) that is sharpened in a conventional pencil sharpener, not with a knife. Using the side of the lead, blacken the back of your composition behind your drawing (fig. 2-30). This, in essence, turns the back of your composition into carbon paper. Then turn your composition back to drawing side up and lay it on top of your final paper.

Now simply trace over your composition; you will place a light but distinct copy of it on your working paper. The lines on your final paper are easily erasable, yet they are distinct enough to guide you through the final drawing. Do *not* use carbon paper! The carbon impression is greasy, smears all over the paper, and is almost impossible to erase.

Foreshorten—1: to shorten by proportionately contracting in the direction of depth so that an illusion of projection or extension in space is obtained
—Webster's Ninth New Collegiate Dictionary (1984)

3
Perspective Drawing

One-Point Perspective
Foreshortening
Two-Point Perspective

One-Point Perspective

You have probably seen illustrations of one-point perspective many times. The classical one is the view of straight railroad tracks on level land where the tracks converge to one point on the horizon. If there are telephone poles paralleling the tracks, these also converge to the same single point, as would building tops that paralleled the tracks.

As simple as it is, the principle of one-point perspective can be very handy for determining the size of objects in the middle ground or background of your sketches.

There are two things to remember:

- The horizon is at eye level
- The vanishing point lies on the horizon

Whether you are in an airplane at thirty thousand feet or lying on your stomach on the ground, if you are looking straight ahead you will see the horizon at your eye level. The illusion of a high point of view or a low point of view comes only from observing where things lie in relation to the horizon. If you are up *high*, things tend to be lower in relation to the horizon; if you are down *low*, things will appear high relative to the horizon. This is demonstrated by the stick-figure artist in figures 3-1 through 3-6. In figure 3-1, the artist is standing on level ground holding a frame up while he looks down a straight road toward the horizon. He notices that the horizon seems to cut the telephone poles in half and the poles seem to get shorter as they get farther away (fig. 3-2). Figure 3-1 clarifies why the poles seem to get shorter with distance—it is because the angle to the artist's eye is smaller if they are farther away. If his frame contained a piece of glass and he had a grease pencil to draw just what he saw, it would look something like figure 3-2.

If the artist then lay on his stomach in the middle of the road and held his frame up, the horizon would be at eye level again—a little lower than it was before, but still well within the frame (fig. 3-3). The big difference this time is that the horizon would cross the telephone poles near the bottoms. The artist's sketch on the glass in his picture frame would resemble figure 3-4. Notice how almost everything is *above* the horizon line.

Now, if the artist wanted to check out a high point of view, he could get a ladder and again view the same scene from the top of the ladder (fig. 3-5). In this illustration the tops of the telephone poles are at his eye level, and since the horizon is also at his eye level, the tops of the poles appear to touch the horizon (fig. 3-6). In this case everything is below the horizon and the horizon itself is moved upward in the frame.

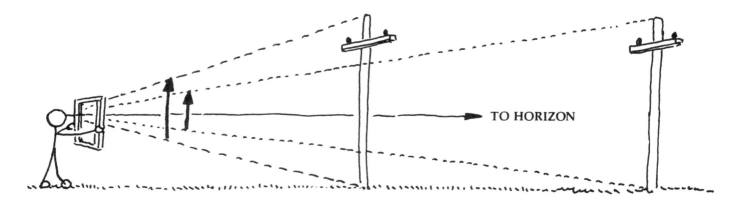

TO HORIZON

Figure 3–1
One-point perspective.
The horizon is at eye level.

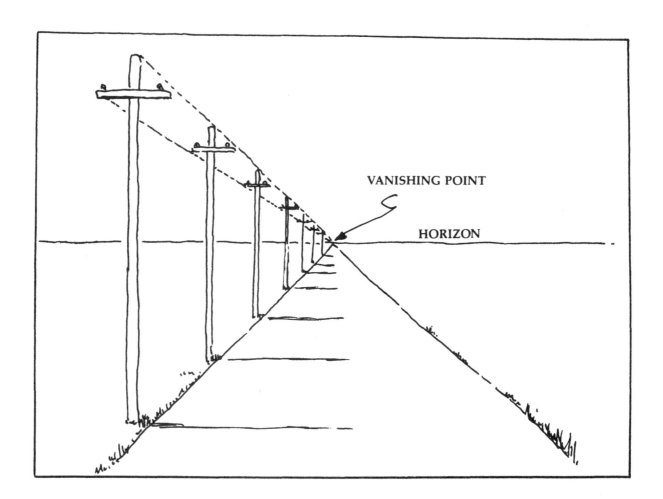

VANISHING POINT

HORIZON

Figure 3–2
One-point perspective.
Everything recedes to the
vanishing point on the horizon.

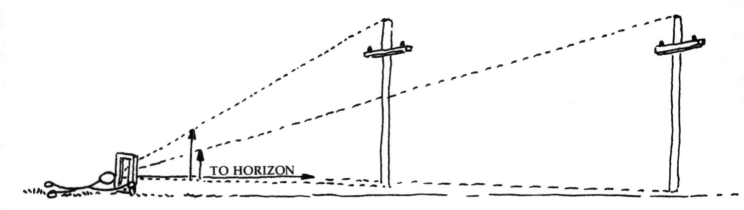

TO HORIZON

Figure 3-3
One-point perspective. A low point
of view. Horizon is at eye level.

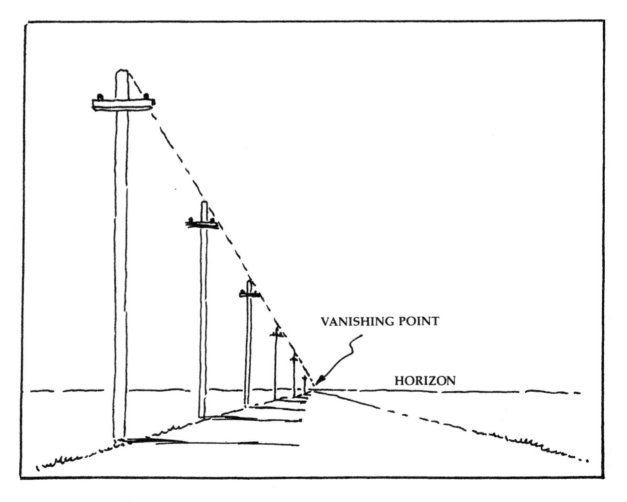

VANISHING POINT

HORIZON

Figure 3-4
One-point perspective. A low point of view.
Everything recedes to the vanishing point on the
horizon and most of the scene is above the horizon.

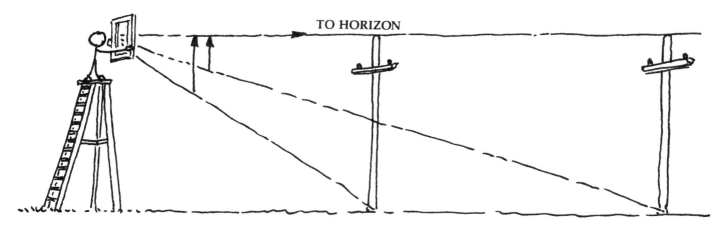

TO HORIZON

Figure 3-5
One-point perspective. A high point
of view. Horizon is at eye level.

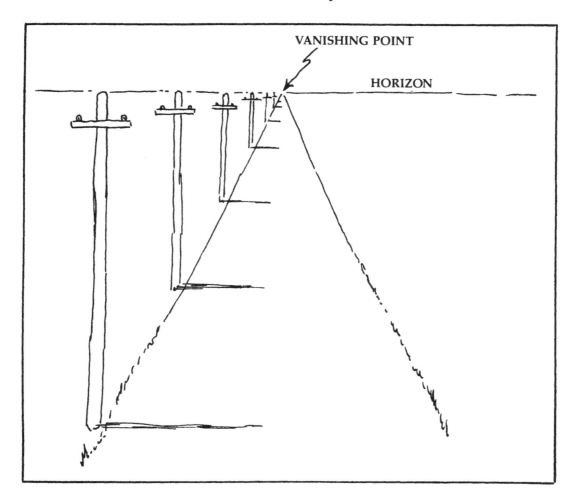

VANISHING POINT

HORIZON

Figure 3-6
One-point perspective. A high point of view.
Everything recedes to the vanishing point on the
horizon. Most of the scene is below the horizon.

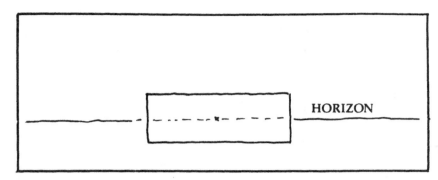

Figure 3-7
A box held up at eye level intersects the horizon and presents only one surface to view.

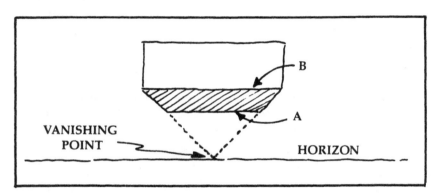

Figure 3-8
A box held above eye level presents two surfaces to view and illustrates *foreshortening*. Lines A and B are actually the same length on the box but the farther edge appears shorter to the eye.

Foreshortening

If the artist holds a box out in front of him- or herself, the one-point perspective principle of everything receding to the vanishing point on the horizon still holds. If the middle of the box is at eye level it appears that the horizon intersects the box at midpoint (fig. 3-7). Only the nearest side of the box is visible.

If the artist lifts the box *above* eye level, the bottom of the box then becomes visible also. It would appear as in figure 3-8 with the bottom edges of the box receding to the vanishing point on the horizon. The front edge of the box (A)—the part

away from the artist's eye—appears shorter than the back edge (B). This is because A is farther from the artist's eye than B.

Drawing edge A shorter than edge B is called *foreshortening*. It is what helps create the illusion of depth, or thickness, in drawings and paintings. Foreshortening is important not only in landscapes with distant backgrounds, but also in much more limited sketches of tree branches or animals (figs. 3-9 and 3-10).

Drawing animals is often easier if a framework of boxes is used to rough in the parts of the animal. If you first

Figure 3-9
The illusion of *close* and *far* is enhanced by drawing the closer things larger, such as the pine needles on the branch at left that comes straight at the viewer. This is an example of *foreshortening*.

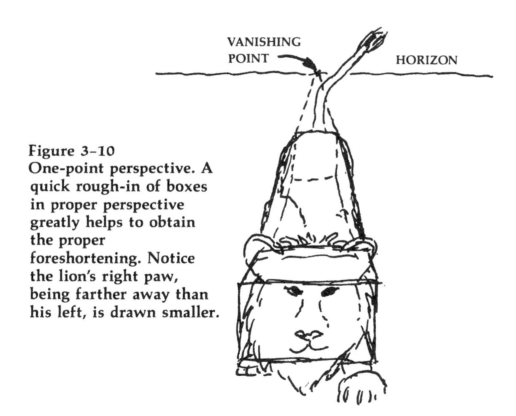

VANISHING POINT HORIZON

Figure 3-10
One-point perspective. A quick rough-in of boxes in proper perspective greatly helps to obtain the proper foreshortening. Notice the lion's right paw, being farther away than his left, is drawn smaller.

quickly sketch boxes in the correct perspective, then draw the animal in the boxes, you will get satisfactory results more quickly than by drawing the animal by eye only, without the reference framework the boxes provide. Experienced artists can see the foreshortening in a subject by observing how sketch elements relate to one another, and therefore usually skip the box framework step. In essence, they do that automatically because of all the drawing practice they have had. Without having a lot of experience behind you, however, you will find it a great timesaver to use the box approach.

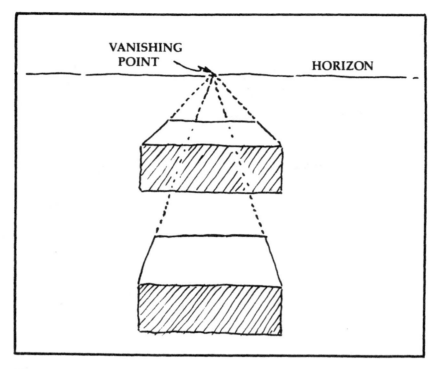

Figure 3–11
Boxes below eye level show two surfaces to the eye.
More of the top surface shows as the box becomes lower.

Figure 3–11 shows boxes held below eye level. The lower the box (or the higher the eye level) the more of the top surface of the box becomes visible. This is, of course, just the reverse of holding the box above eye level. In that case it is the bottom surface that becomes more and more visible as the box is raised higher and higher.

Foreshortening is also illustrated in figure 3–12, sketches of a bird viewed from three different angles: from just above and almost in front of the bird (12A), from the side (12B), and from the rear (12C). In sketches 12A and 12C, the width of the box used to block in the head is shown as H and the width across the back of the tail is shown as T. In the original sketches, the head width measurement (H) was the same in both sketches 12A and

12C—six millimeters. However, the tail measurement (T) was eight millimeters in sketch 12A and ten millimeters in sketch 12C. The tail measures one-fourth larger in view 12C because it is closer to the eye. This difference in size (foreshortening) provides the illusion of depth in the sketch.

Figure 3–12 also illustrates the system of boxes that I used to construct a similar-looking bird in three different poses. In sketch 12B I actually put in the horizon and the vanishing point to get the three boxes and the tail about right in terms of perspective. Then I drew balls in each box, and around them sketched the outline of the bird. (This use of balls is described more fully in Chapter 4.) In sketches 12A and 12C I did not

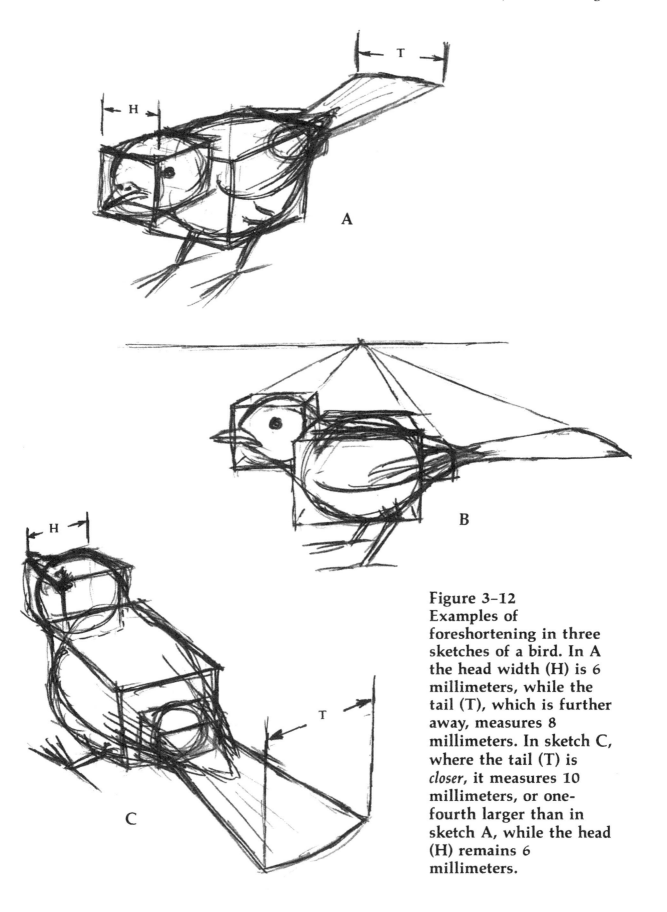

Figure 3–12
Examples of foreshortening in three sketches of a bird. In A the head width (H) is 6 millimeters, while the tail (T), which is further away, measures 8 millimeters. In sketch C, where the tail (T) is *closer*, it measures 10 millimeters, or one-fourth larger than in sketch A, while the head (H) remains 6 millimeters.

construct vanishing points, but, knowing I wanted the boxes below eye level, simply sketched the boxes so they looked right, then drew balls inside them and completed the outline around the balls.

When I use this method of construction, I blacken the back of the composition sketch and transfer only the lines I need to my final paper (see Chapter 2). Figure 3–13 shows the results of this transfer process, using sketches 12A and 12C from Figure 3–12. With these clean outlines, I am ready to complete the sketches with pen or pencil.

In cases like this, where you can't get the real bird to pose for you, you have to invent the poses you need. Sketching boxes and balls only takes a few seconds and allows you to determine proper proportions and angles quickly and to achieve realism easily.

**Figure 3–13
Sketch A was transferred from figure 3–12A and sketch B from figure 3–12C.**

Two-Point Perspective

One-point perspective does not always suit the angle of the subject matter in a sketch. It is appropriate only for head-on views, such as the lion in figure 3–10. Things are most often seen in three-quarter views. Figure 3–14 shows a box at eye level that is turned to show not one, but two, surfaces to the eye. Now each of these surfaces recedes to a different vanishing point on the horizon.

If this box is lowered so that all of it is below the horizon, it will look like figure 3–15. The foreshortening principles still apply here: though lines may be of the same actual

length, the lines that are farther away appear shorter. The two-point perspective rules simply show you how to get the volume and the shape of the box to "look right."

There are several ways to construct geometric diagrams to get the two-point perspective exactly right. Architectural and engineering drafting students learn these constructions in their drawing and drafting classes. However, for most of the drawing situations you will encounter, it is seldom necessary to go through such time-consuming constructions. You can estimate the

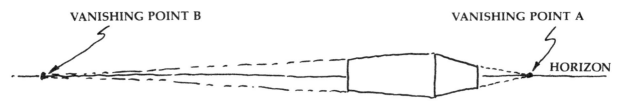

Figure 3–14
Two-point perspective. Box at eye level and two
vanishing points, each on the horizon.

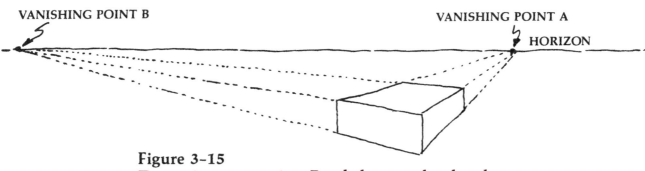

Figure 3–15
Two-point perspective. Box below eye level and
same two vanishing points as in figure 3–14.

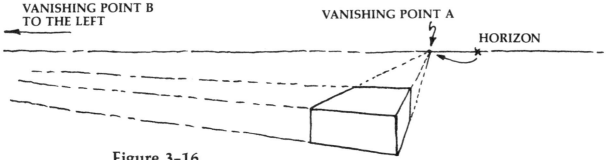

Figure 3–16
Two-point perspective. As the subject rotates, the
vanishing points both move; in this illustration they
moved to the left, but they remain on the horizon.

proper relationships and be suprisingly accurate. The two-point-perspective vanishing points fall on the horizon, just as the one-point-perspective vanishing point does. However, as the angle of the subject changes—that is, as you view more or less of one side—the vanishing points slide along the horizon. In figure 3–16 the box is viewed more from the front

than in figure 3–15, so the vanishing points move to the left. You can see that, as the box rotates toward a straight-on view of the front, vanishing point A approaches that of the single-point perspective in figure 3–11. In this case, vanishing point B is assumed to be at an infinite distance to the left.

To estimate two-point perspective,

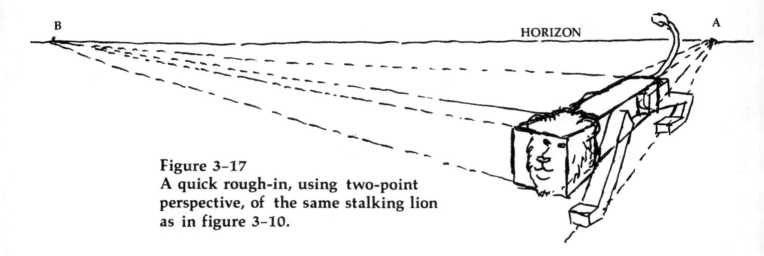

Figure 3-17
A quick rough-in, using two-point
perspective, of the same stalking lion
as in figure 3-10.

all you have to remember is that one of the vanishing points is close to the subject and the other is farther away on the other side. You can tell from a couple of seconds of sketching whether your box appears distorted or about right. If it looks distorted, move one of the vanishing points and try sketching the box again.

The lion shown in figure 3-17 is sketched in a box arrangement based on these two-point perspective suggestions. It takes just seconds to lightly sketch in the boxes and run the lines out to the vanishing points with a ruler.

For an excellent visual explanation of *all* perspective drawing principles, see Ernest Norling's book, *Perspective Drawing*. It is number 29 in the famous Walter Foster art books series. Any art supply store that carries Walter Foster books can get it for you.

4
Songbirds

Basic Structure

If you understand the structure of your subject, you won't have any trouble making your composition suit your artistic ideas. You can change the angle, pose, or point of view of your subject, and still retain realism. But you can't draw what you can't see and don't know. If you just guess—without having good prior knowledge or ready reference material—you can make bad structural mistakes. Figures 4-1 and 4-2 show one very common mistake made in sketching birds.

It is always best to sketch from the real thing. However, trees, plants, and rocks are about the only things in nature that will hold a pose while you get form, mass, and correct relationships down on paper. If you intend to develop your bird sketching abilities beyond casual diversion, you should eventually do a little research on the skeleton and major muscles of birds, how their feathers lie, and how their wings work.

For now, you'll find it fun and instructive to make quick action sketches of birds at your feeder or birdbath—not with an eye to detail, but just to get bird shapes and action quickly roughed out for later development into full drawings. The basic pose will then be your own creation, but—for realism—the details should be based on reference material such as a photograph or bird identification guide.

To make quick action sketches from life (without first taking a bird anatomy course), reduce the bird to an outline fitted around three balls—a small, a medium, and a large one (fig.

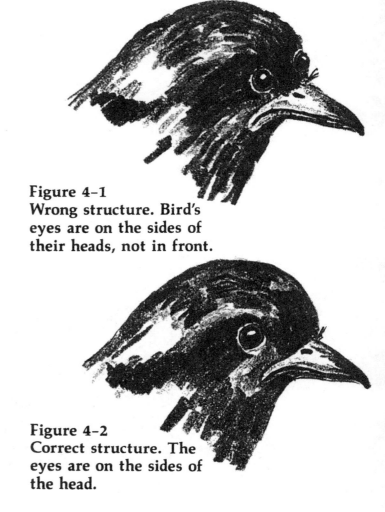

**Figure 4-1
Wrong structure. Bird's eyes are on the sides of their heads, not in front.**

**Figure 4-2
Correct structure. The eyes are on the sides of the head.**

4-3). The large ball represents the bird's body, the small one the rump, and the intermediate size the bird's head. The first step is to arrange the three balls in the pose you want to sketch (fig. 4-4). The balls are shaded in figures 4-3 and 4-4 to remind you that you are dealing with *volume*. This will become more significant shortly when you deal with viewpoints other than the straight side view shown here.

Using the balls (circles) as guides, draw the shape of the bird around

Figure 4-3
Three balls, sketched about in the proportions shown here, are all that you need to quickly establish a reasonably accurate bird form.

Figure 4-4
The large ball represents the body, the medium one the head, and the small one the rump.

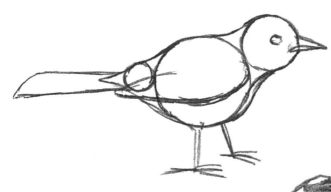

Figure 4-6
A crude bird sketch (no particular bird) developed from the arrangement of balls in figure 4-4.

them (fig. 4-5). It is important to remember that the circles are simply guides to allow you to quickly sketch a proper form. They are generalized and not rigidly accurate in all cases. For instance, a chickadee's head is much larger in proportion to its body than is the head of a mourning dove.

When you sketch those birds, you must draw your circles accordingly. In figures 4-5 and 4-6 the bird needed more breast than the outline of the body circle allowed, so I simply drew outside the large circle in the breast area. You can see both lines in figure 4-5.

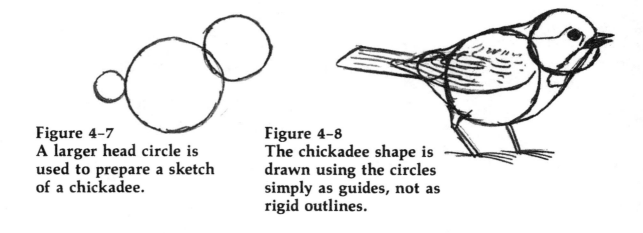

Figure 4-7
A larger head circle is used to prepare a sketch of a chickadee.

Figure 4-8
The chickadee shape is drawn using the circles simply as guides, not as rigid outlines.

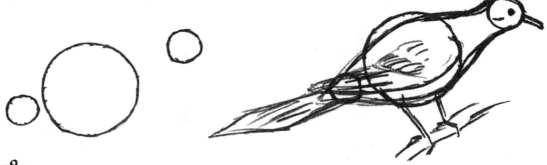

Figure 4-9
The arrangement of circles used to prepare a sketch of a mourning dove. The circle for the head is smaller and spaced away from the body.

Figure 4-10
The outline of a mourning dove superimposed on the circles of the previous figure.

A chickadee's head appears large in proportion to its body, and it almost never shows much neck. In figure 4-7 I used a head circle larger than that in figure 4-4 to get the chickadee sketch started. Note that to minimize the neck, I slightly overlapped the head and body circles.

You can see the deviations I made from the exact circles in figure 4-8. In order to make this bird look like a chickadee, I gave it more breast and I ignored the portion of the circle below the beak, bringing the bird's throat inward. It would have appeared too full if I had closely followed the

circle—just as it appears too full in figure 4-6. In figure 4-9 the three circles are arranged in the proportions of a mourning dove. Photographs and illustrations in bird books show that the mourning dove has a small head in proportion to its body. It also has a pronounced neck. To allow for these characteristics, I used a much smaller circle for the head and spaced it about one head's diameter away from the body circle. Figure 4-10 shows my rough sketch of the dove's shape using the circles as guides. Again I deviated where necessary so that my sketch would look more realistic. This

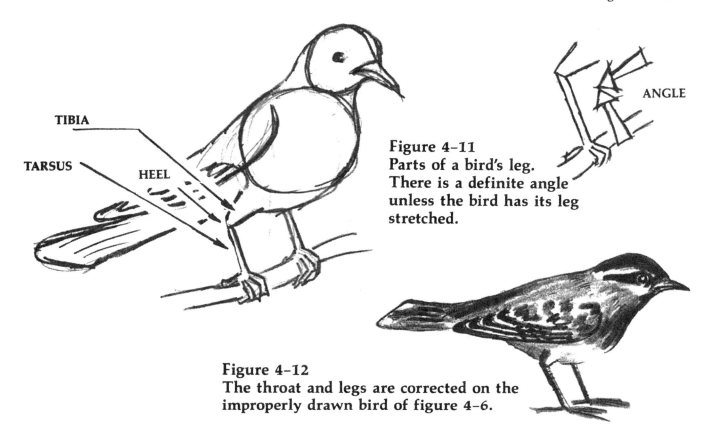

TIBIA

TARSUS

HEEL

ANGLE

Figure 4–11
Parts of a bird's leg.
There is a definite angle
unless the bird has its leg
stretched.

Figure 4–12
The throat and legs are corrected on the
improperly drawn bird of figure 4–6.

time I ignored part of the circle that represents the bird's back.

One other structural feature must be mentioned: the legs and feet. An otherwise very well executed sketch can be ruined if the legs and feet of your bird are not very near to correct. To get them correct you have to know a little about physics and the force of gravity.

Birds have only two feet; hence balance is more important to them than it is for animals with four feet. (This is a simplification, but it is necessary to make the point.) To prevent it from toppling over, a bird's feet must always be under its center of gravity when it is standing or perching. The same holds for two-legged you and me. Now, the bird's leg, that part that usually shows outside the body feathers, is composed of two primary parts—the *tibia* and

the *tarsus*. They connect to the body on one end and the foot on the other (fig. 4–11). The bird's *heel* is at the backward bend, just as ours is, but is high up near the body; the bird walks on its toes. The bend between the tibia and the tarsus is almost always visible when a bird is perching or standing. To make your bird natural looking, the foot must not only be under the bird's center of gravity, but the bend in the leg must show, also. This bend *does not* show in figure 4–6— the legs are stuck on like toothpicks, and the sketch looks unnatural because of it. Figure 4–12 shows a more lifelike positioning of the legs for the same pose. The improperly drawn chin and throat are also corected in figure 4–12. Compare figures 4–6 and 4–12 to see the difference in realism that these two structural changes make.

Composition Drawings

At this point I want to say a little about composition drawings. I want almost everything I draw to look reasonably accurate. Whatever the subject—house, boat, landscape, animal, or bird—I want an artistically pleasing drawing first; but I also want a reasonable degree of faithfulness to the geometry of the subject. To achieve this I do a lot of structure sketching (such as using the three circles for the birds) and a lot of quick trial and error sketching over the structure until it looks about right. By the time it looks right I will have done quite a bit of erasing and there will be extra lines on the paper from my trial and error sketching.

I never do all this work on the paper that will hold my final sketch. If I am going to do an ink sketch, erasing can roughen the fibers of the paper and make some of the ink lines feathery looking. Pencil sketches also suffer—roughened paper from heavy erasing can lead to a blotchy appearance in the final pencil drawing.

I always make my compositional drawing on a preliminary piece of paper. When the "comp" is looking right I blacken the back of it with a soft pencil and transfer only those lines I need to my working paper. (This is explained in Chapter 2.) This transfer process leaves an easily erased, but quite visible, pencil outline for completing the drawing and does not disturb the surface finish of the paper.

Drawing Different Poses

When you sketch the three balls to establish a pose, the small one representing the rump will sometimes be partially hidden (fig. 4–13A) or sometimes fully hidden (figs. 4–13B and 13C). Sketch it anyway because it shows you how to bring the tail feathers off the body. Just remember that the rump is *behind* the body, not in front of it, in poses such as this.

In figure 4–14 I have sketched twelve different song birds using different arrangements of the three balls in each case depending on the pose and particular bird I had in mind. Body shapes of birds vary, often related to the season or what the

**Figure 4–13
Arranging the three balls to get different poses.**

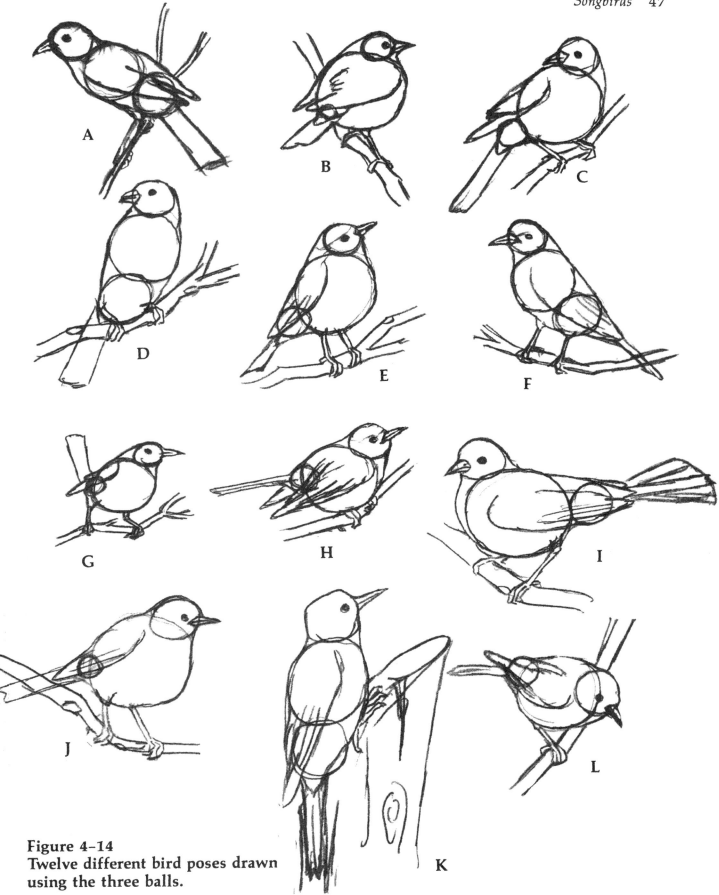

Figure 4–14
Twelve different bird poses drawn using the three balls.

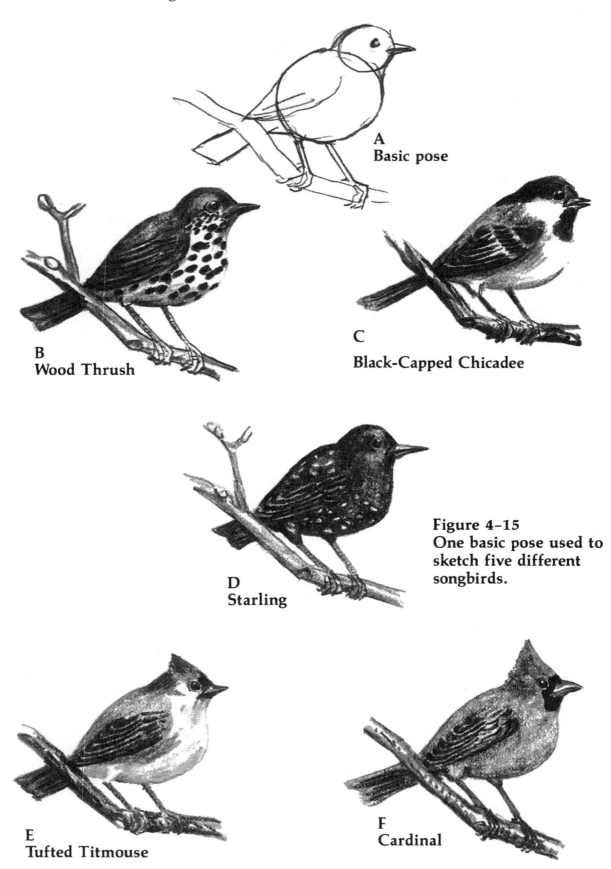

A
Basic pose

B
Wood Thrush

C
Black-Capped Chicadee

D
Starling

Figure 4–15
One basic pose used to
sketch five different
songbirds.

E
Tufted Titmouse

F
Cardinal

birds are doing. The birds in sketches 14A, 14D, 14F, and 14K are more sleek than they are plump. In these sketches the rump circle is made the same size or larger than the head circle to provide a more elongated body.

In winter, birds often fluff up their feathers and pull their necks in to conserve body heat. Sketch 14B shows such a pose. To achieve this, the rump circle is made small and the head circle is made to overlap the body circle a little bit.

Wrens typically exhibit nervous behavior, flitting around with their tails pointing upward. This pose is shown in sketch 14G.

A typical pigeon posture is illustrated in sketch 14I. Here the head is brought back and upward and the tail is made broad and fanlike.

Sketch 14K shows a typical woodpecker pose, with the bird in an upright position. In this case the bird's feet are not under the center of gravity because the woodpecker clings to the side of the wood and props himself with his tail held tightly against the tree.

You should always know a little bit about the bird you want to sketch, either from firsthand observations or from reference material. Does it have a slim or a plump body? Is the head extra small as with the mourning dove or is it extra large as with the chickadee? Is the beak tiny, thin, thick, heavy, long, short, curved? Are the feet of normal proportions or are they large? Is the tail short, medium, or long? Is it wide, narrow, rounded, pointed, forked? Does the bird have a crest? These are some of the things you need to know simply to get the shape correct, before you even think about patterns and colors.

Here is a good exercise for you to try: take one of the poses in figure 4-14 and use it to sketch different birds that all have generally the same shape. Make adjustments to the beak shape and tail size, add crests, and change whatever else is necessary to capture the character of your different subjects. Then finish them off by indicating the coloration and pattern peculiar to the birds you have selected.

Figure 4-15 shows one shape (sketch J of figure 4-14) used to draw five different birds. In each sketch I adjusted the beak and tail as appropriate for that specific bird. Sketch 15A shows the basic circle pattern I used for each of the birds. Sketch 15B shows a wood thrush—a reddish brown bird with a white breast covered with large dark spots. The wood thrush has a moderate length tail and a beak similar to that of a robin, to which it is related.

Sketch 15C, a black-capped chickadee, required that I bring the top of the head back a little to give the bird a more hunched shape. I made the beak tiny and the tail narrow. Then I put in the color patterns—dark cap and bib, grayish back, and dark wings with some white showing.

The starling in sketch 15D is dark all over with sparkling light spots all over the breast, stomach, and upper back. The tail is stubby and broad, while the beak is long and straight.

Crests help to identify the birds shown in sketches 15E and 15F. Sketch 15E shows a tufted titmouse with a small crest, while 15F indicates the large crest, massive beak, and black facial coloring of the cardinal.

In each of these sketches my reference material—bird identification

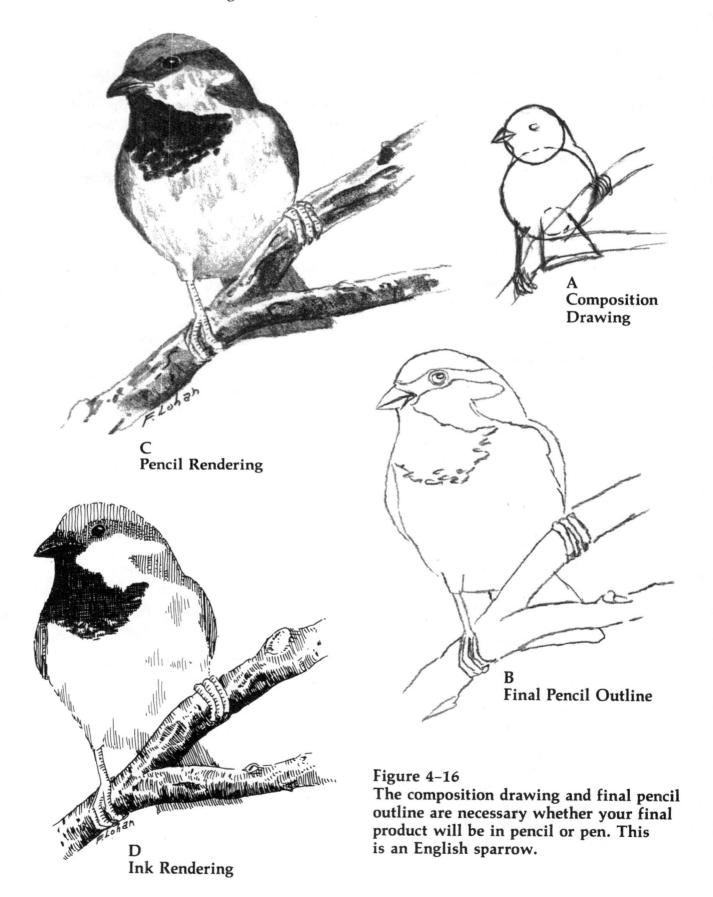

A
Composition
Drawing

C
Pencil Rendering

B
Final Pencil Outline

D
Ink Rendering

Figure 4-16
The composition drawing and final pencil
outline are necessary whether your final
product will be in pencil or pen. This
is an English sparrow.

books—gave me the information I needed to supplement my personal observations. I was able to create reasonable representations of these familiar birds. Do the same: make your quick action sketches from direct observation. Then go to detailed reference works to see just what outline features you need to emphasize (tail, crest, beak). Finally, tone your sketch to indicate the lights and darks, and add the dark patterns where they belong.

The two initial steps—making the composition drawing, and transferring the final pencil outline to your working paper—are necessary whether you are going to make the final sketch with pencil or with pen. This is illustrated in figure 4-16, where both pencil and pen sketches of an English sparrow are produced from the same composition sketch. When you use ink, wait until it is quite dry, then lightly erase over the entire sketch to remove any pencil lines. (Obviously, you don't do this with pencil drawings.)

Drawing Specific Birds

In figure 4-15 I showed you how to take one basic bird pose and turn it into different species. Having done this, you can then have the fun of choosing one species and drawing it in many different poses. Base them on your quick action sketches, and capture the bird in different characteristic postures. You need to make structural composition drawings even if you use photographs instead of action sketches you made yourself.

Figure 4-17 shows a blue jay in five different poses. These poses are taken from figure 4-14. Sketches A, B, and E of figure 4-17 are each reasonable postures for a blue jay. Sketch 17C, however, is more usually characteristic of a wren, although it does not look unnatural for a blue jay. The revised version of sketch 15C, sketch 15F, is more typical of a jay, with the mouth open as if the jay were screaming at a marauding cat or a raccoon.

Sketch 15D shows the jay in a typical woodpecker pose. A blue jay does not look quite natural in this posture, since the jay is seldom if ever seen clinging to the side of a tree or stump. When doing your bird sketches, you won't really put the birds in positions that are unnatural if you base them on your observations or on photographs.

By using photographs as a reference you can observe bird actions that would be virtually impossible to perceive in life. Birds, especially songbirds, are seldom at rest. Figure 4-18 is a sketch of a baby gray warbler waiting to be fed by its mother. This was taken from a photograph showing the mother with three young birds on a branch. The mother bird was feeding one of the others while this bird voiced its objections.

Careful analysis of photographs is a good way to learn about bird structure, as this sketch of the baby

Figure A
Based on figure 4–14A.

Figure B
Based on figure 4–14C.

Figure C
Based on figure 4–14G.

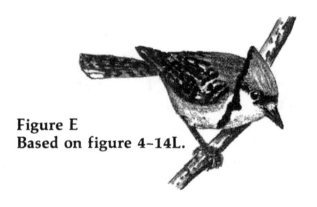

Figure E
Based on figure 4–14L.

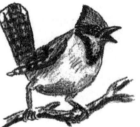

Figure F
Sketch C with mouth
opened to show more
action.

Figure 4–17
A blue jay sketched in different
poses based on figure 4–14, sketches
A, C, G, K, and L.

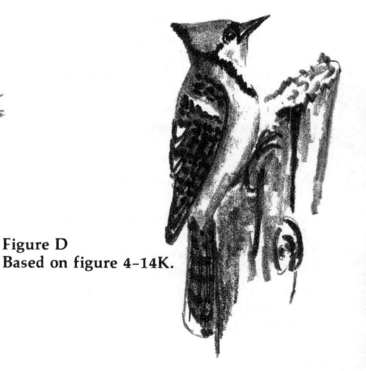

Figure D
Based on figure 4–14K.

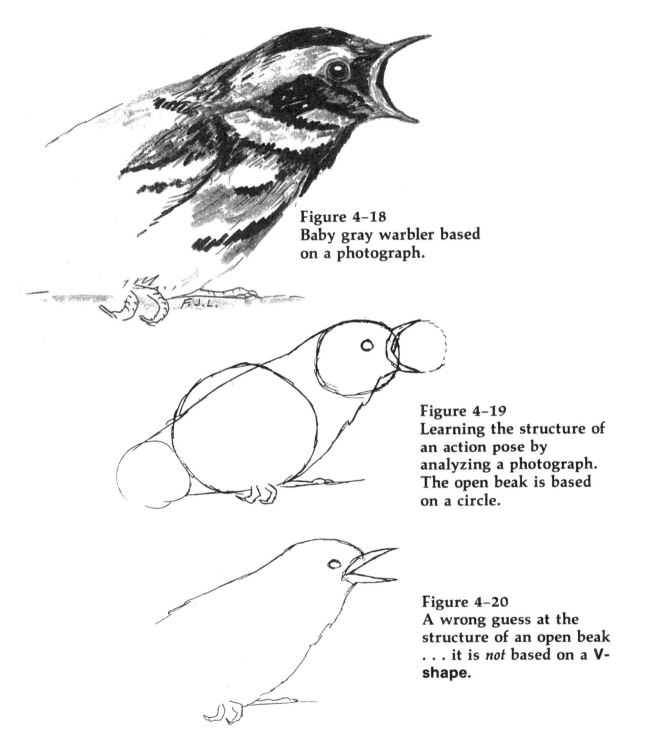

Figure 4–18
Baby gray warbler based on a photograph.

Figure 4–19
Learning the structure of an action pose by analyzing a photograph. The open beak is based on a circle.

Figure 4–20
A wrong guess at the structure of an open beak . . . it is *not* based on a V-shape.

gray warbler in figure 4–19 illustrates. First, the bird is stretching its head forward toward the mother; therefore, the head circle is moved a little way from the body circle. Second, the open beak is actually formed by a circle, not by a "V," which might seem proper if you didn't have a photograph to study. Figure 4–20 shows how wrong the use of a V-shape would look. This is what can happen when you try to draw something you don't know much about and can't see.

A Wood Thrush Drawn Three Ways

This demonstration will cover the steps in drawing the same pose of a wood thrush in lithographic crayon and ink, in pencil, and in ink alone. In each case I used the same composition drawing and transferred it to my working paper. The pose is a reversed image of figure 4-14J.

Lithographic Crayon and Ink Sketch

Lithographic crayon is infrequently used alone, except on highly textured coquille paper where a light touch provides quick shading by coating the tops of all the bumps. This use was shown in Chapter 1 (figures 1-19A and 1-19B). In this demonstration, however, litho crayon is used with ink on ordinary paper.

I cannot stress too much how easily little crumbs of lithographic crayon get around and how quickly they can make a mess. If you see a little crumb on your drawing, blow it off—do not brush it off. Use a separate piece of paper to lay over your drawing for your hand to rest on. Do not slide this paper around but, rather, lift it to move it. Constantly check the back of this paper for any pickup of litho crayon pieces; if you see any, change the paper.

The lithographic crayon looks like figure 4-21. The range of tones it produces is also shown in this figure. When the point wears down or breaks off, pull the little string about one-quarter inch and peel off another piece of the paper wrapping. To get finer lines, rub the litho crayon on a piece of scrap paper and shape it as shown in Chapter 1 (figure 1-3). Then use the sharp edge.

The outline drawing I began with is shown in figure 4-22. This was transferred from my composition drawing by blackening the back of that drawing with an HB pencil, laying it on my final paper, and drawing over the lines I wanted to use.

First, I used the lithographic crayon on the transferred drawing to put big black spots on the underparts, draw the facial markings, tone the beak, add the black eye (being careful to leave a little white highlight), tone the back lightly, and add some tone to the branch. The results are shown in figure 4-23.

Next I added some initial ink work, as illustrated in figure 4-24. This was primarily a broken outline, some indications of the wing feather structure, and leg details. I left about an inch of the breast outline uninked, and when the ink was *good and dry* I carefully erased the pencil outline from this area. Too much outline resembles a child's coloring book.

The final steps involved ink and sharp litho crayon work on the wing feather detail and some careful shading behind the head to help create an impression of roundness. The wing details were sharpened up with the pen. The branch was completed with the litho crayon, with careful attention given to preserving the white highlights. The completed drawing is shown in figure 4-25.

When it was complete, I sprayed the sketch three times with clear spray enamel (available from any hardware store), letting it dry a few minutes between sprayings.

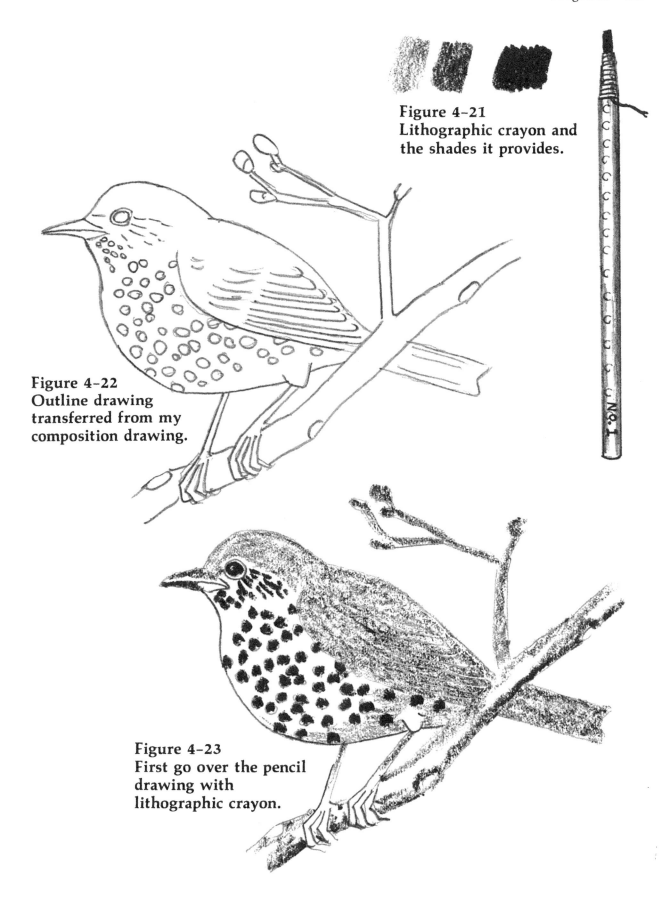

Figure 4–21
Lithographic crayon and
the shades it provides.

Figure 4–22
Outline drawing
transferred from my
composition drawing.

Figure 4–23
First go over the pencil
drawing with
lithographic crayon.

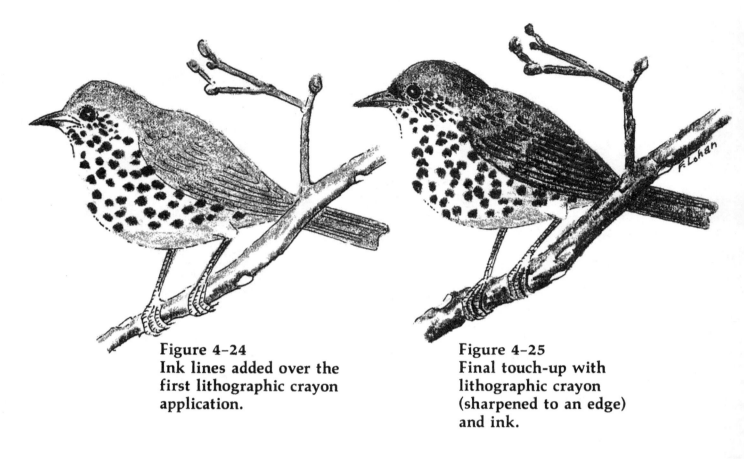

Figure 4-24
Ink lines added over the
first lithographic crayon
application.

Figure 4-25
Final touch-up with
lithographic crayon
(sharpened to an edge)
and ink.

Pencil Sketch

Pencil drawings are developed by working from light tones to dark. The wood thrush drawing demonstrated here started with the transferred pencil outline shown in figure 4-26. Three pencils were used for the final drawing—the HB, 3B, and 6B. These provided tones as shown in figure 4-27. The paper, 70-pound drawing paper, was not particularly rough, but did provide some tooth—it was not as smooth as bond copier paper.

I first put a uniform light tone over the beak, head, back, and tail with the HB pencil. Then I completed the detail around the eye and beak with the 6B pencil. This is shown in figure 4-28.

The wing feathers were made prominent with the 6B pencil as shown in figure 4-29. When doing this I kept the lines sharp so that lighter areas were left to define the feathers.

The last steps are shown in figure 4-30. I used the 6B pencil to put spots on the breast and face area, and to complete texturing of the branch. I was careful to leave some highlights on the branch. A little shading on the forehead, behind the head, and along the back line helped to give the form roundness. One coat of the spray enamel protected the drawing from smudging.

Note in figure 4-30 that I erased all of the pencil transfer line from the throat and along the breast to the tail. Careful shading with the HB pencil defined the outline of this part of the wood thrush.

Figure 4–26
Outline drawing
transferred from my
composition drawing.

Figure 4–28
Developing the head and
beak.

HB 3B 6B

Figure 4–27
The three pencils used to
complete this drawing.

Figure 4–29
Developing the back and
wing details.

F.Lohan

Figure 4–30
Completed pencil drawing
of a wood thrush.

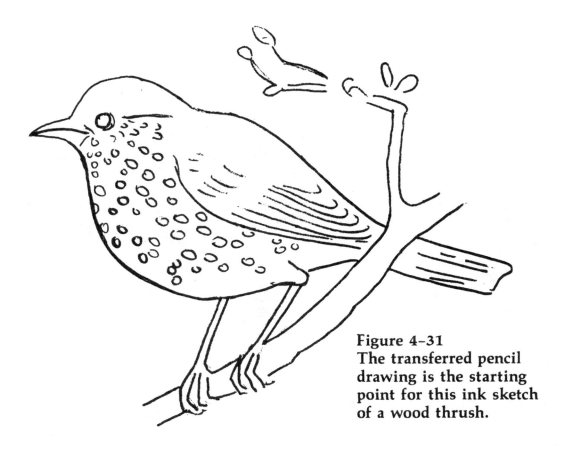

**Figure 4–31
The transferred pencil
drawing is the starting
point for this ink sketch
of a wood thrush.**

Pen Sketches

Next I developed the same subject—
the side view of a wood thrush—in
pen and ink. The starting point was
the transferred pencil outline (figure
4–31). Actually, transferred outlines
are much lighter than you see printed
in this book. They are shown darker
here only for clarity in printing.

Artist's Fountain Pen

Figure 4–32 shows my first ink
work over the transferred pencil
drawing, using my artist's fountain
pen. This pen creates a medium
weight line. My initial shading was
done with just horizontal hatching
(closely spaced lines) on the bird, and
lines that modeled the curvature of
the branch. With this first layer of
shading I was after a middle tone for
the brown parts of the wood thrush's
head, back, wings, and tail. To get

this, I put my hatching lines
moderately close together.

In figure 4–32 you can see how I
used the transferred pencil lines on
the wings to carefully leave white
areas between pen marks to define
the edges of the feathers. Also note
that I did not completely outline the
wood thrush's breast with ink. You
seldom need a 100 percent outline. It
looks much better if, here and there,
you let the viewer's imagination
supply part of the drawing—especially
in this case, where the pattern of
spots on the bird's breast indicates the
shape of the missing outline.

When I finished inking the outline
and horizontal shading work I
carefully erased all traces of pencil
lines.

I have repeatedly advocated the use
of reference material when you do not

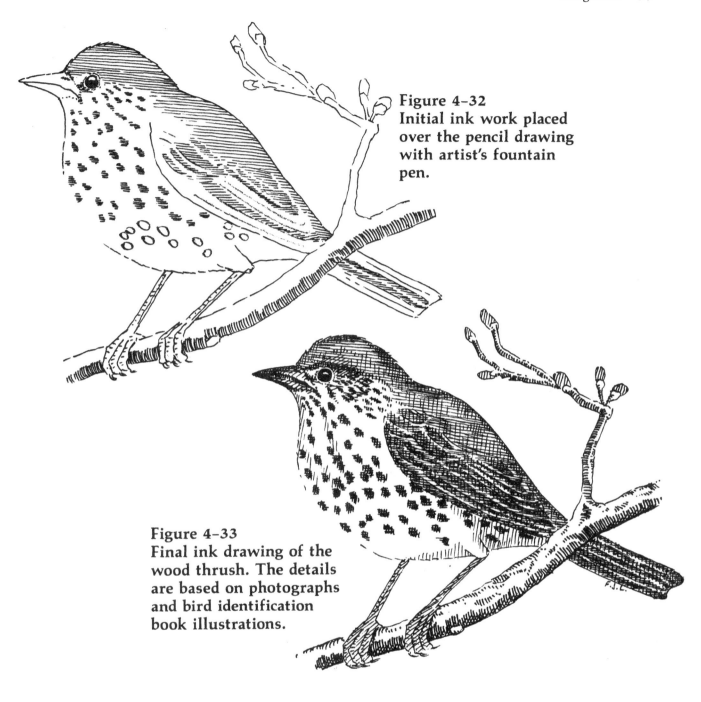

Figure 4–32
Initial ink work placed
over the pencil drawing
with artist's fountain
pen.

Figure 4–33
Final ink drawing of the
wood thrush. The details
are based on photographs
and bird identification
book illustrations.

have the real bird in front of you. In this case my reference photographs and paintings of wood thrushes showed a little patch of white between the bird's eye and its beak. I had to be sure to provide for this white area, as well as the white highlight on the eye, right from the start in this step. Figure 4–33 is the finished sketch.

To create the darker tones I used vertical ink lines to produce cross-hatching over the horizontal ink lines. When trying to show shade in a white area, such as under the rump of the wood thrush, you have to be careful not to make it too dark. Show *slight* shading on white material; even in shade, white remains very light.

Technical Pen

Figure 4-34 shows the same sketch, but done using a technical pen with a 3×0 point. This produces a slightly finer line than the artist's fountain pen. In this figure I used vertical lines for the first layer of ink rather than horizontal lines as in figure 4-32. Also, I did not use any outlines on the bird's body or on the branch—I let the tone lines create the edges. Eliminate outlines whenever possible. See how much softer figure 4-34 looks than figure 4-33.

The exact stroke used does not really matter—your goal is to create a tone with the ink. Besides hatching, tone can also be created by stippling (dots) as shown in figure 4-35 or by very casual, loose, scribbly pen lines as in figure 4-36. Prop the book up in a chair and look at figures 4-33, 4-34, and 4-36 from about eight or ten feet away. At that distance you cannot distinguish the line work—just the

tones. You can see the similarity of results. In each case you use the contrast between the white paper and the dark ink to create the tonal differences and give a presence to details such as the wing feathers. The style you use depends solely on what appeals to you, and what end result you have in mind.

Figure 4-37 shows a very small sketch of a wood thrush. It measured less than two inches from the top of its head to the bottom of its tail in my original drawing. Such a scale requires extreme simplification; there is almost no possibility of developing much detail. Prominent features such as the dark breast spots must carry the wood thrush's identification, just as the crest, dark wing, and tail bars had to carry the idea of "blue jay" in the equally small sketches in figure 4-17.

There is no "right" way to approach a pen and ink sketch. Anything goes

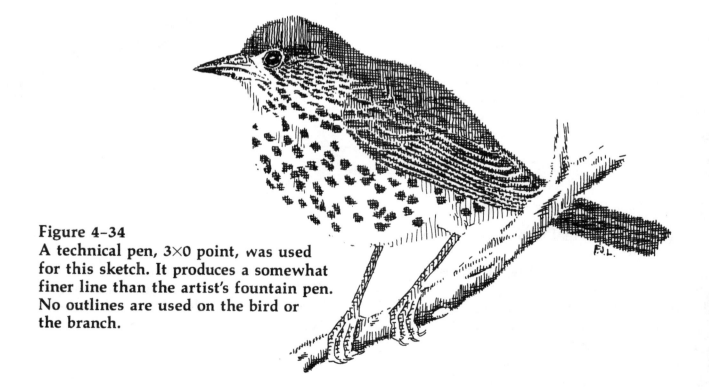

Figure 4-34
A technical pen, 3×0 point, was used for this sketch. It produces a somewhat finer line than the artist's fountain pen. No outlines are used on the bird or the branch.

Figure 4–35
Stippling (dots) used on
the same subject.

Figure 4–36
A very loose, quick
sketch of the same
subject.

Figure 4–37
Very small sketches
require that every line
and dot serve a distinct
purpose. Great
simplification is also
required.

Figure 4–38
A stylized approach
achieved by outlining
every tonal feature, then
toning with hatch marks
in just one direction.

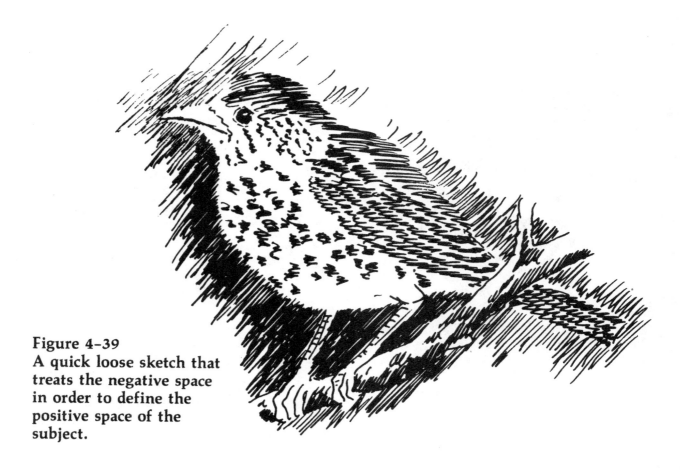

Figure 4-39
A quick loose sketch that
treats the negative space
in order to define the
positive space of the
subject.

as long as it produces the effect you have in mind. You can produce more stylistic results, for instance, by outlining everything, then adding tonal values with lines in just one direction. This tends to emphasize the design of the tonal pattern. This approach to sketching the wood thrush is shown in figure 4-38.

I suggest that you do a sketch of the wood thrush following the steps given for figures 4-31, 4-32, and 4-33. Then, when your sketch is dry, lay a piece of tracing vellum over it and try several different rendering techniques on the vellum. You will not have to trace or redraw your pencil sketch because you can see right through the vellum to the drawing beneath and use it as your

guide. Try the loose technique of figure 4-36, the stipple technique of figure 4-35, and the stylized approach of figure 4-38. Use your imagination to see how many different ways you can render the same subject. For instance, use tone in the negative space (the area outside your subject). Figure 4-39 shows how toning the negative space defines the positive space—in this case, the light breast area. View this figure from about eight or ten feet away to appreciate the dimension and depth that the dark negative area adds to the sketch. When you use this approach you have to be sure your subject does not blend in with the negative space. Notice that I left the beak and legs light so this would not happen in figure 4-39.

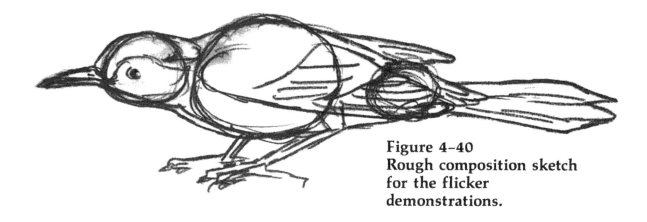

Figure 4–40
Rough composition sketch for the flicker demonstrations.

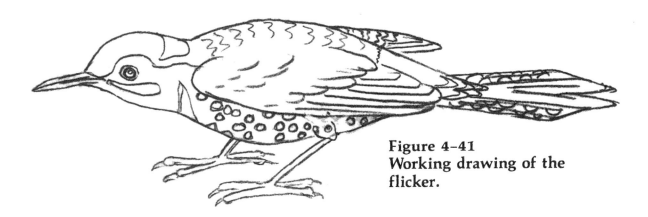

Figure 4–41
Working drawing of the flicker.

Drawing Flickers

Pencil Sketch

The flicker is about the size of a blue jay. It is an ant-eating woodpecker, and is seen on the ground in search of ants just as often as it is seen in a tree hammering away woodpecker fashion. It has black spots on its undersides and black bars on its wings, tail, and back. These prominent markings make it a good subject for black and white sketching.

I wanted to show the flicker in a "displaying" pose so that the white rump, so prominent when the bird is flying, would show. When the male flicker is displaying for the benefit of a female, it crouches with its head low

and flutters its wings a little way from its body.

My composition drawing to establish this pose is shown in figure 4–40. From it, I transferred the lines I wanted and added details to obtain the working drawing (fig. 4–41). Remember, my actual working drawings are much fainter than they appear printed in this book. Yours should be also.

In figure 4–42 I started the pencil toning. The first thing I did was use a 2H pencil to put in the light grays and browns of the bird's head, back, wings, and tail. Then, with a 4B

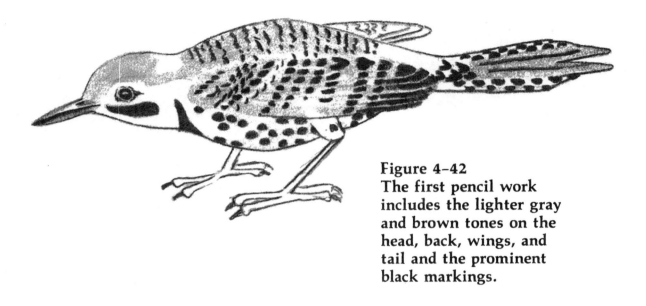

Figure 4-42
The first pencil work
includes the lighter gray
and brown tones on the
head, back, wings, and
tail and the prominent
black markings.

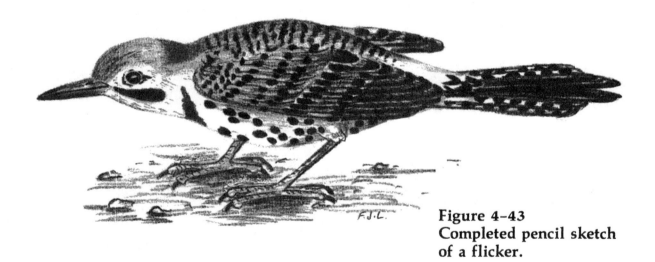

Figure 4-43
Completed pencil sketch
of a flicker.

pencil, I put the prominent black spots on the breast and the bars on the wings, back, and tail.

The completed drawing is shown in figure 4-43. I used a sharp HB lead on the wings to draw the lines showing the feathers and to slightly darken the light undertone. At this stage, care is necessary to prevent losing the fine light lines separating the darker wing feathers. This tonal difference is required to show the structure of the feathers. In these exercises you are not attempting to make illustrations for a scientific journal; you just want to suggest to the viewer how the feathers overlap one another. For scientific accuracy you would count and draw the exact number of primaries and secondaries on the wing. However, since the work in this

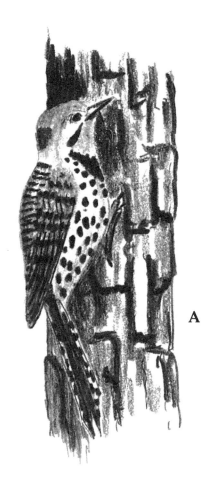

A

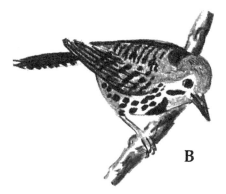

B

**Figure 4–44
Two small pencil studies
of the flicker.**

book is intended for decorative rather than scientific use, I will show you how to suggest such details.

There is a red patch on the back of the flicker's head. You can see in figure 4–41 where I made provision for it. In figure 4–42 I left it white for the moment, and in figure 4–43 I darkened it, making it a little darker than the surrounding gray. When working with black and white you must sometimes create tonal distinctions to have certain adjacent features show up. In this case, the gray surrounding the red was rather light, and if I had indicated the red area with an even lighter tone it would have appeared too light. If the red had been surrounded with a very dark tone, I would have used a darker

tone to show it than I did in figure 4–43 because it still would show up.

Tiny studies in pencil are quickly completed and can be quite instructive by forcing you to observe just the most prominent features of your subject. I suggest that you do several studies based on the flicker. You will be dissatisfied with some of them, but you will learn something from each one. Figure 4–44 shows two such studies of the flicker. I transferred bird shapes K and L from figure 4–14 to a clean sheet of paper, sharpened up my 4B and HB pencils, and completed the two views. In the vertical composition the bird is about three and a half inches tall, and in the other a little over two inches from beak to tail.

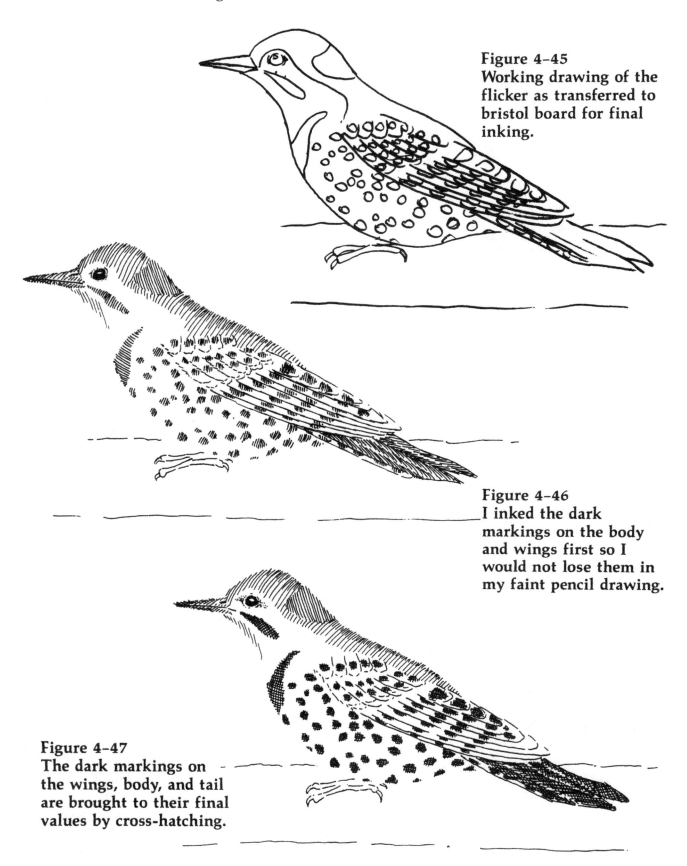

Figure 4-45
Working drawing of the flicker as transferred to bristol board for final inking.

Figure 4-46
I inked the dark markings on the body and wings first so I would not lose them in my faint pencil drawing.

Figure 4-47
The dark markings on the wings, body, and tail are brought to their final values by cross-hatching.

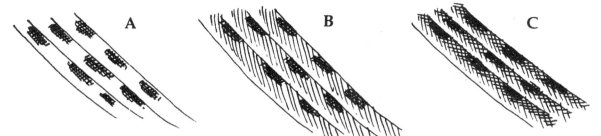

Figure 4-48
The three steps (shown enlarged) in completing the wing feathers.

Pen and Ink Sketch

For this pen and ink drawing of a flicker I used a technical pen with a 3×0 point and bristol board for the paper. Any fine-point pen will do, as will any hard, smooth-surfaced paper, preferably at least 70-pound (thicker than ordinary smooth copier paper). The hard, smooth surface is necessary to take advantage of the fine line the 3×0 point produces. On coarser papers the line can broaden and offer no advantage over using an ordinary artist's fountain pen. For this sketch of the flicker I wanted to use the fine point to help bring out the wing details.

The starting point is shown in figure 4-45, the working drawing that I transferred to the bristol board for the final inking. On the working drawing I indicated where every black bar on the flicker's wing would be, since they had to be evenly spaced to establish the feather definition I wanted in this drawing. My research also showed that this woodpecker has two toes pointing forward and two backward, so I had to be sure to include that.

The first ink work I did is shown in figure 4-46. I wanted to be sure the little black markings on the wings were just where I wanted them before

they became lost in any background ink toning. In the previous example using pencil, I put the background tone in first, then I put the black markings on top of that. In this sketch, doing it that way would have obscured the very faint pencil transfer lines on my working drawing. When I completed the ink work you see in figure 4-46 I lightly erased all the pencil marks.

Figure 4-47 shows how I completed all the dark bars and spots before going on to do the light brown of the bird's wings. I simply used cross-hatching to do this—hatch lines on top of the first ones but in a different direction.

The final pen work on the wings is shown at a larger scale in figure 4-48. First the black bars were put in place (48A). Then a tone was placed over them, leaving a line of white showing (48B). Finally, a narrow band of cross-hatching was added close to where the next feather overlaps (48C). The little strip of white along the edge of each primary feather makes the structure of the wing show up much better than simply toning the entire wing area and putting down heavy black lines to show the feather edges.

The finished product is shown in

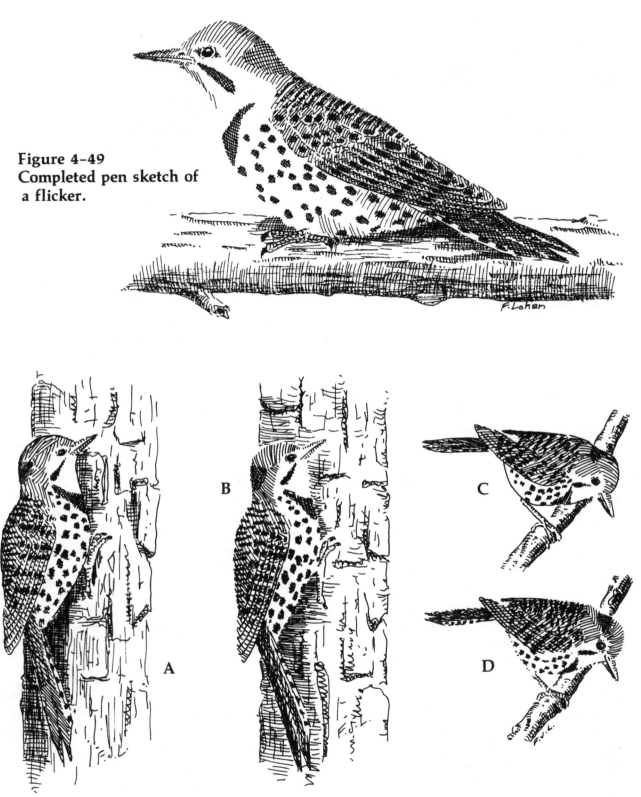

Figure 4-49
Completed pen sketch of
a flicker.

Figure 4-50
Sketches without unnecessary outlines look
better. A and C contain unnecessary outlines
on the bird's body; B and D do not.

figure 4-49. Few would notice that the bird's body is not outlined, and in this case, an outline really is not necessary. The lower part of the bird's body is formed simply by showing the shadow it casts rather than by drawing an outline. The spots and other markings on the bird's neck and breast are sufficient to indicate the edge of that area, while the toning of the head and back take care of the edge definition required there.

The four little sketches in figure 4-50 show the same poses of the flicker as the pencil sketches in figure 4-44, but here they are drawn in ink. In figure 4-50 you can easily evaluate the effect of including unnecessary outline. Compare sketches 50A and 50C with the softer, more artistic feeling in 50B and 50D. Strive to eliminate the "coloring book" look that complete outlines can give to your work.

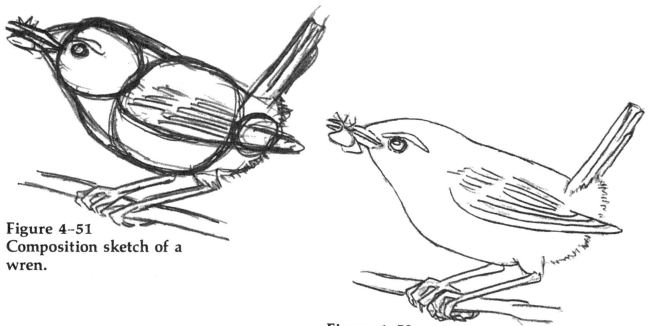

**Figure 4-51
Composition sketch of a wren.**

**Figure 4-52
Working drawing transferred from the composition sketch.**

Drawing Wrens

Pencil Sketch of a House Wren

This pencil sketch of a house wren was done using three pencils—an HB, a 2B, and a 4B—on 70-pound paper (not a particularly smooth paper).

The initial work in figure 4-51 shows how the three balls were used to form the head and body. The wren has a very blunt rear end and the tail looks like it was stuck on as an afterthought. Since the wren's head

and beak are quite pointed, I brought the forehead and chin out in front of the ball to help shape the head.

I transferred the clean, light outline shown in figure 4-52 from the composition sketch to the paper for my final sketch. (Remember—the outline shown here is dark just so that it shows up in this book. It should be very light on your working drawing.)

My first steps in making this sketch

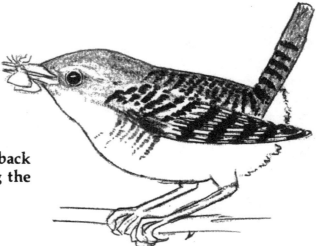

Figure 4-53
Initial pencil work.
Includes toning the back
and tail and drawing the
darker bars.

are indicated in figure 4-53. Using the HB pencil, I toned the head and back uniformly and lightly, being careful to leave a definite light eye ring and a light line over the eye. Then the eye was completed with the 4B pencil. Next, using a 2B pencil, I put the bars on the wren's back. I used a 4B pencil to do the dark markings on the tail and wings. Using the lighter HB pencil, I then did the markings on the bird's sides. These markings are shown just partially completed in figure 4-53.

The finishing touches included going over the tail, back, back of the head, and wings with the broad part of the 2B pencil. Then, using an HB pencil, I completed the light bars on the throat, sides, and rump. The broad surface of this same pencil was then used for the shading on the light throat, the undersides, and the legs.

At this stage, the drawing had a soft, somewhat indistinct edge—much as you see in figure 4-55A. As a matter of fact, most of my pencil sketches do, since I use the broad surface of the pencil so much. I used a sharp HB pencil to sharpen up the edges. I drew a light outline right at

the edge of the tone, and blended this outline into the tone, as shown in figure 4-55B. This way it does not look like the figure is outlined—like it does in figure 4-53, where the outline is darker than the toning of the subject. Then, using my kneaded eraser, I lightened the edge of the upper breast a little, also to eliminate an outlined appearance. The completed drawing is shown in figure 4-54.

The same subject, drawn in pencil on linen paper against a dark background, is illustrated in figure 4-56. To achieve this I first drew the wren against the white background of the paper. I did the study a little lighter than that of figure 4-54. Then, using a broad 6B pencil, I put the background dark tone in around the bird. I sharpened up the edge of the background dark with a sharp-pointed 3B pencil, and then used the kneaded eraser, pinched to a sharp edge, to trim up the wren's body here and there. Finally, I gave it three coats of spray enamel.

I like the texture of the linen paper where it shows through the dark background.

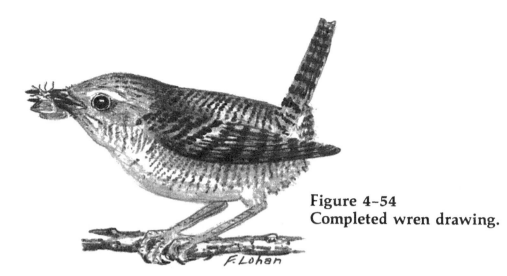

Figure 4-54
Completed wren drawing.

Figure 4-55
The final step is to
faintly sharpen the
outline by turning the
indistinct edge shown in
A to the sharper edge
shown in B.

A B

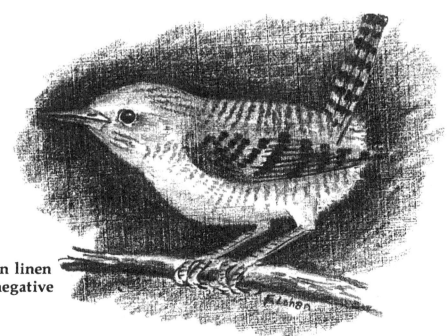

Figure 4-56
Wren sketched on linen
paper with the negative
space darkened.

**Figure 4–57
Working pencil sketch
transferred from my
composition sketch.**

Pen and Ink Sketch

As usual, I made a composition drawing using the three balls, then transferred it to the bristol board on which I wanted to ink the drawing. The working drawing is shown in figure 4–57.

I used my technical pen and the 3×0 point for this drawing. The first ink work I did was to locate the dark bars on the wren's tail, wings, and back and to ink the beak and eye as you see in figure 4–58. The transferred pencil drawing shows up considerably darker in this figure than it should on your paper. Yours should be as light as you can make it so it can be easily erased.

Figure 4–59A shows you the kind of short hatch mark I used to tone the light brown parts of the wren. The hatch marks are randomly placed so they do not form a pattern on the bird, but they are also more or less uniformly spaced to avoid a splotchy appearance. The objective is to get a *uniform* tone on top of the bars already

inked on the bird. Figure 4–59B shows how little groups of hatch marks, as long as they do not overlap, also can be used to achieve a uniform tone. Overlapping causes a checkerboard effect. The hatch marks in 59B are placed a little closer together than those in 59A, hence the resultant tone is darker. When you sketch your wren be careful not to get the tone too dark.

The finished sketch is shown in figure 4–60. After I placed the uniform tone over the tail, back, and wings I had to emphasize some of the bars that tended to get lost in the overall tone. I also put in a few lines on the wings and tail to suggest the edges of the feathers.

The very light bars on the bird's side and breast were made with very short hatch marks, not spaced too closely together. These hatch marks are so short they are practically just dots.

The ground is indicated with lines

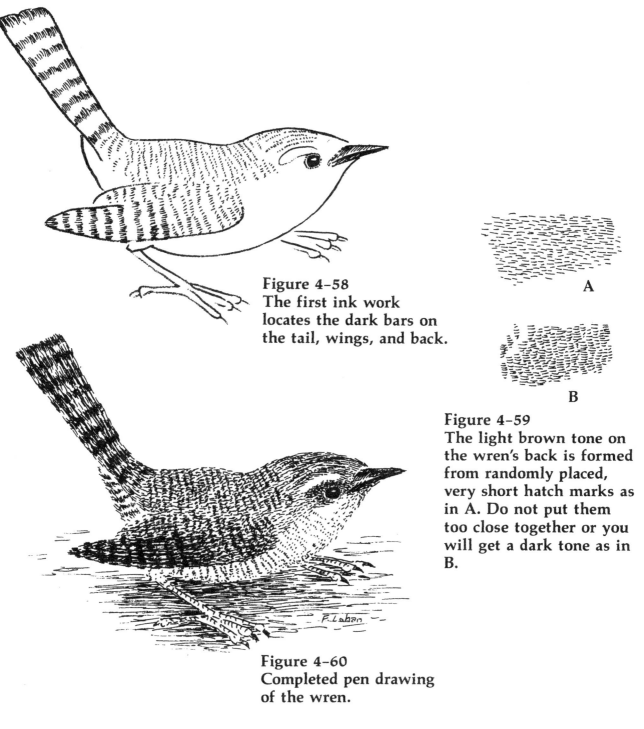

Figure 4-58
The first ink work
locates the dark bars on
the tail, wings, and back.

Figure 4-59
The light brown tone on
the wren's back is formed
from randomly placed,
very short hatch marks as
in A. Do not put them
too close together or you
will get a dark tone as in
B.

Figure 4-60
Completed pen drawing
of the wren.

that are very loosely done by rapid back-and-forth motions of the pen. I turn my paper sideways to do this since I can work rapidly and with maximum control when I am making lines that run up and down. These lines should be drawn horizontally, parallel to the bottom edge of your paper, because the ground is flat and horizontal. Lines in other directions would tend to destroy the impression of a flat horizontal surface. This same principle holds when drawing the surface of water.

Figure 4-61
A very small ink study of
two house wrens drawn
using hatching and cross-
hatching.

Figure 4-62
A pencil study of one of
the wrens in the previous
figure.

Figure 4-63
An ink study of the same
wren using stipple (dots)
to create the tone and
dark features.

Small Ink Sketches

The small ink study of two wrens
in figure 4-61 gives you two
additional wren poses you can try
with your pen. Small pen studies like
this can be very instructive—they
force a real economy of line and
permit almost no detail development
except the barest essence of the
subject. My original drawing was less
than 3" × 3". When the sketch scale is
tiny and you are doing a toned study,
it frequently is more effective to do
the study in pencil than in pen. Tiny
ink sketches do not allow much room
for the lines to create tone, whereas
larger ink sketches do. Compare
figures 4-61 and 4-62. Figure 4-62, a
pencil sketch made with a sharp 4B
pencil and a broad-point 2B pencil, is
by far the more effective of the two.

An ink stipple (dot) treatment of
the same subject is shown in figure
4-63. Stippling takes longer to
execute since so little ink is deposited
with each dot; but it can, in larger
sketches, produce a photographlike
result. In this illustration I covered
the wren's back, head, tail, and wing
with a uniform tone of dots. Then I
went back over it, dotting in the dark
bars and the lines to suggest the wing
feathers. Do not draw any lines in
your stipple sketches. A single such
line tends to really stand out.

Instead, use dots for your lines and
they will not be too prominent. The
converse is not true, however. In a
line sketch made with hatching and
cross-hatching, it does not seem
visually inconsistent to include a little
stippling to indicate delicate shading.

Drawing Robins

An Ink Sketch of a Robin

The robin is recognizable by its reddish breast and dark head and upper parts. Other than the white outer tips of its tail feathers, it has no particular markings that can be emphasized in a black-and-white drawing, so the tonal difference between its dark upper parts and its reddish breast becomes very important. Figures 4–64 and 4–65 show the composition sketch and the working drawing, respectively, of a robin studying something on the ground in front of it.

**Figure 4–64
Composition sketch of a robin.**

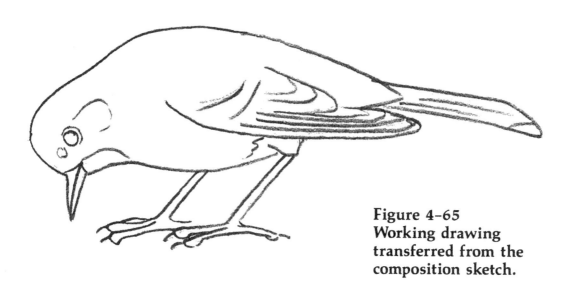

**Figure 4–65
Working drawing transferred from the composition sketch.**

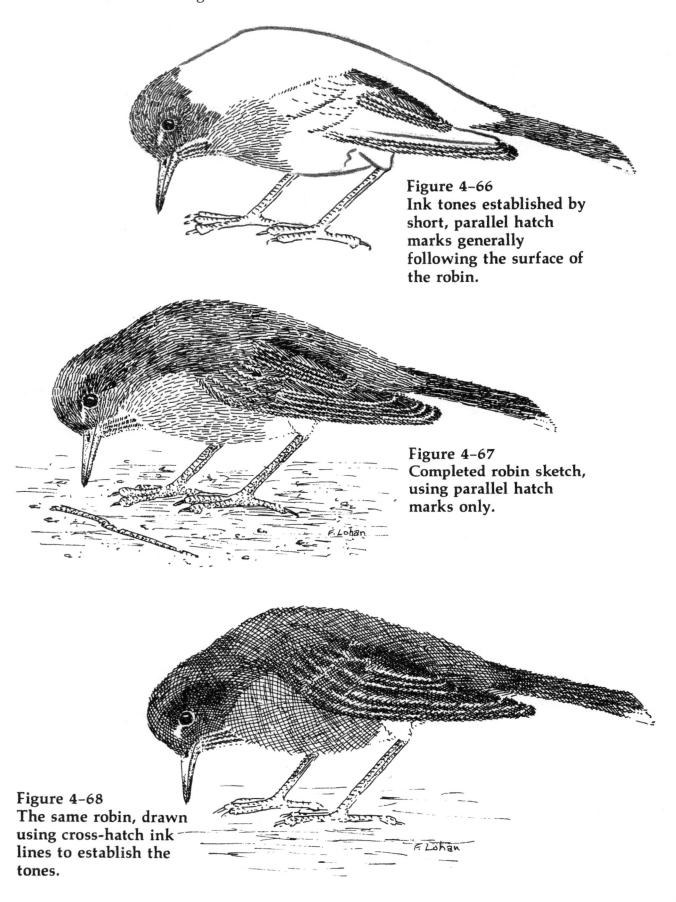

Figure 4-66
Ink tones established by short, parallel hatch marks generally following the surface of the robin.

Figure 4-67
Completed robin sketch, using parallel hatch marks only.

F. Lohan

Figure 4-68
The same robin, drawn using cross-hatch ink lines to establish the tones.

F. Lohan

Figure 4–66 shows you the approach I used to create the tones in this drawing. I used closely spaced hatch marks—the same as I used for the wren in figure 4–60. The hatch marks are closer together on the head, back, wings, and tail than they are on the breast. This difference in spacing is what creates the tonal difference between the dark areas and the lighter breast. This is a good technique to use with animals, also—hatch marks flowing in the direction of the fur help to visually suggest the texture. The completed sketch of the robin is shown in figure 4–67.

Parallel hatch marks are by no means the only way to render these tones. Figure 4–68 is the same robin rendered using cross-hatching—hatch lines on top of one another but in different directions. Here, too, if you space them more closely you get a darker tone. Compare the breast and the head of the robin in figure 4–68 to see what I mean. The darkest of the tones in figure 4–68 were prepared by placing a third layer of cross-hatching over the first two in a different direction.

Pencil Sketch of an Immature Robin

The immature robin is about the same size as an adult robin, but has big spots on its breast instead of the reddish brown coloring.

The three circles on which I based my composition drawing of this robin are shown in figure 4–69. I then transferred the outline shown in figure 4–70 from the composition drawing to my working paper.

For this sketch I used 6B, 3B, and HB pencils. The head, back, wings, and tail were started first, using the HB pencil for the lighter tones and the 3B pencil to establish the dark, hook-shaped marks that formed the wing feathers (fig. 4–71). I then went over the whole wing lightly with the broad-point HB pencil to slightly tone the white areas. The tail was done in a similar manner.

Figure 4–72 shows the completed sketch. I used the 6B pencil to do the spots and to shade the back of the head. I lightly shaded the breast and upper sides with an HB broad-point to indicate the tinge of reddish brown generally present in immature robins.

When I was satisfied with the toning of the sketch, I started on the edges, which resembled those of figure 4–71—they were slightly indistinct. To sharpen up the entire figure I took a sharp HB pencil and outlined the bird just enough to blend in with the adjacent tone. This means I put a lighter line on the throat and breast than I did on the head and back. Then I simply blended the tone and the line together until the line was no longer obvious. I then removed any pencil smudges in the white area with my eraser and gave the sketch two light coats of clear spray enamel.

Pencil Sketches of the Adult Robin

Two different ink treatments of the same adult robin were shown in figures 4–67 and 4–68. Figures 4–73 and 4–74 show that same composition rendered in pencil, first on linen paper, then on coquille board. The distinctive texture of each is quite apparent in the darker areas. To do these sketches I used the HB, 3B, and 6B pencils—the 6B just for some final darkening here and there. Just as I did in figure 4–72, I sharpened the edges of these sketches as the last step, using an HB pencil.

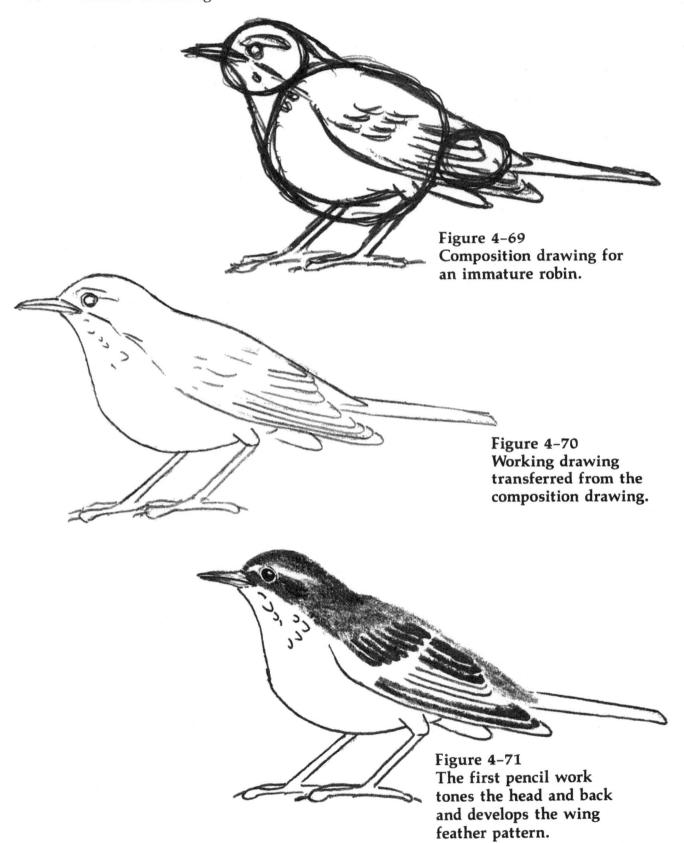

Figure 4-69
Composition drawing for
an immature robin.

Figure 4-70
Working drawing
transferred from the
composition drawing.

Figure 4-71
The first pencil work
tones the head and back
and develops the wing
feather pattern.

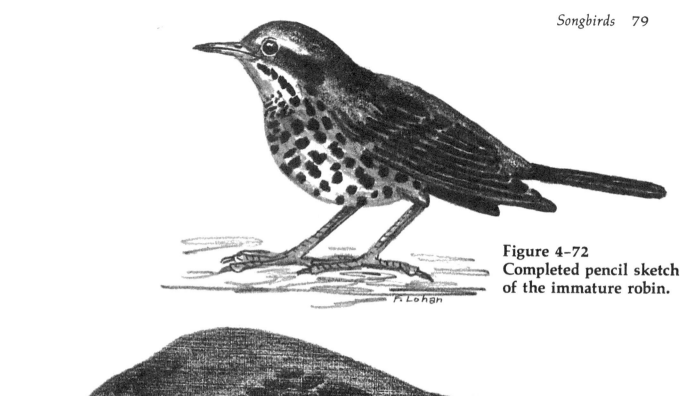

Figure 4-72
Completed pencil sketch
of the immature robin.

Figure 4-73
A pencil sketch of the
same robin as figure 4-
67, done on linen
paper.

Figure 4-74
The same robin done in
pencil on coquille paper.

Action and Foreground Interest

Up to now, I have concentrated on teaching you how to sketch the songbird itself—how to draw the basic bird, how to texture and tone it, and how to add enough coloration and pattern so the bird will be identifiable. Many of the compositions I used to show you how to achieve these effects were somewhat stiff. This was intentional so you would concentrate your sketching efforts only on the basics—just as you have to learn to play scales on the piano before you can play tunes.

As you practice, you will quickly become skillful in using the three balls to devise almost any songbird pose. You will also quickly learn how to use reference material to find details, and how to then incorporate those details on your bird. The next step is to strive for a little more interest in your sketches—make them show more action, and provide a little more foreground interest for your subject.

Earlier in this section I suggested that you do some quick action sketches based on observing birds firsthand—perhaps at a feeder or birdbath, or on a lawn. You will get hundreds of ideas for action poses this way.

Action, even when rendered in a simple way, holds the viewer's interest much longer than a well done but stiff sketch does. Figure 4–75 is a very simple two-tone sketch of a baby robin in a nest. The nest is barely suggested and there is no attempt to show the range of tones that actually exists: there is simply black and white. But this is a far more interesting sketch than figure 4–72 because of the action portrayed.

Figure 4–76 shows a pensive bird perched on an almost vertical twig. The detail developed in the twig lends more interest to this sketch than the bird alone does. In figure 4–77 I have drawn an English sparrow. It is the same basic composition as figure 4–16, but the branch is more detailed and includes some attractive foliage. These elements add interest to the sketch

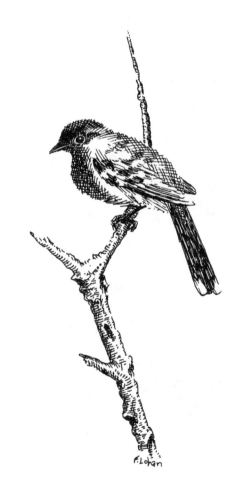

**Figure 4–76
An ink sketch with
interesting detail
developed on the twig.**

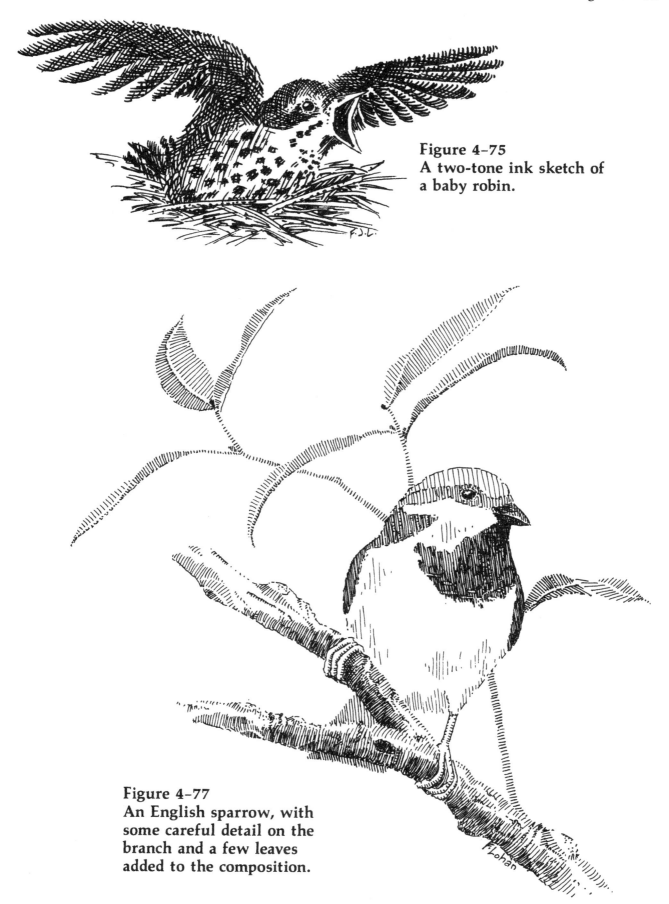

Figure 4–75
A two-tone ink sketch of a baby robin.

Figure 4–77
An English sparrow, with some careful detail on the branch and a few leaves added to the composition.

**Figure 4-78
Blue jay.**

**Figure 4-79
Chickadee.**

**Figure 4-80
Crow.**

**Figure 4-81
Barn swallow.**

**Figure 4-82
Meadowlark.**

**Figure 4-83
Red-winged blackbird.**

The action and foreground interest shown in figures 4-78 through 4-83 all attempt to get away from the stiff, plain poses of many of the early bird sketches. Figure 4-81 shows a bird in flight. When you draw flying birds, be sure to check photographs, paintings, or drawings of flying birds to get the wing shapes realistic.

The six birds in these sketches are all done with ink using just outline and vertical lines. I suggest you redraw them and try different pen techniques such as cross-hatching, horizontal lines, or stippling—or any of these without adding an outline. Also try rendering them in pencil. Put the skills you learned in sketching the wood thrush, flicker, wren, and robin to work on these compositions.

**Figure 4-84
A mallard duck feather sketched in pencil.**

Feathers

I picked up some duck feathers at the edge of a nearby pond. One of them is shown sketched in pencil in figure 4-84. The interesting two-tone pattern caught my fancy—I presume it was from the back of a female mallard. Simple objects such as this make excellent subjects for sketching practice. It is always better to sketch from life, from the real thing.

Figure 4-85 shows the development of a pencil sketch of three other feathers. Sketch 85A shows the outline and the kind of toning lines I used. In sketch 85B I developed the highlight on the quill by smoothing the first lines I used for tone, leaving the white highlight along the quill and also along the outer edge of each feather. Then, when the feathers

looked about right, I darkened the background all around them. The final step was to show the separations in the feathers by darkening them, as you can see in sketch 85C. The techniques used in figure 4-85 pretty well summarize the general way to develop your drawings—from outline to toning to finishing the details.

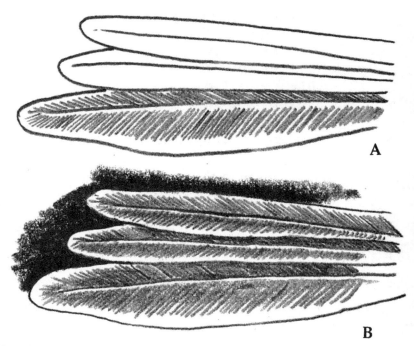

A

B

**Figure 4-85
Pencil development of
three feathers.**

C

F.Lohan

5
Trees

Basic Structure

Tree structure, although based more or less on geometric laws, is extremely variable because of external factors such as crowding by other trees or prevailing winds blowing from just one direction. The leaves, under the influence of sunlight, carry on the process of photosynthesis to produce carbohydrates from carbon dioxide and water. Trees work to maximize their efficiency in this process by growing so that leaves can get maximum exposure to sunlight, and by allowing those leaves that do not get enough sunlight to die. Thus, a specimen white oak on your lawn will produce a typical white oak silhouette such as shown in figure 5-1, while one that grows most of its life in close competition with nearby trees will grow so that the leaves are clustered near the top, where they can get sunlight. This becomes quite obvious when forested land is cleared for houses or a shopping center, and a few isolated trees are left standing with their long, slender, virtually branchless trunks supporting a tiny canopy of leaves at the top (fig. 5-2). Such isolated trees can make charming subjects for quick sketches, such as the six trees in figure 5-3. Each one has its own unique curve to the trunk and shape to the canopy of leaves.

Figure 5-1
A white oak growing under uncrowded conditions.

Figure 5-2
A white oak that grew up crowded by other trees.

Figure 5-3
Trees that grew under crowded conditions—
quick pencil sketches.

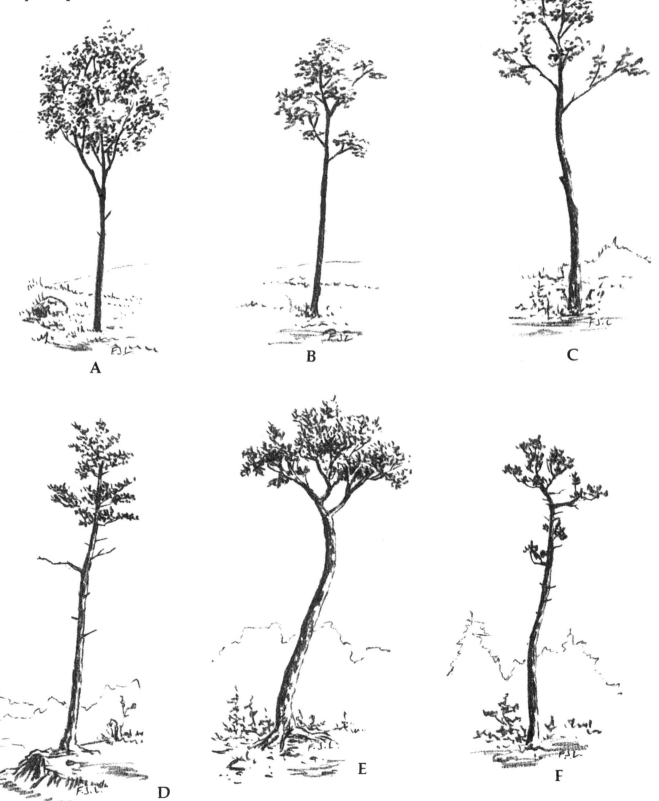

A

B

C

D

E

F

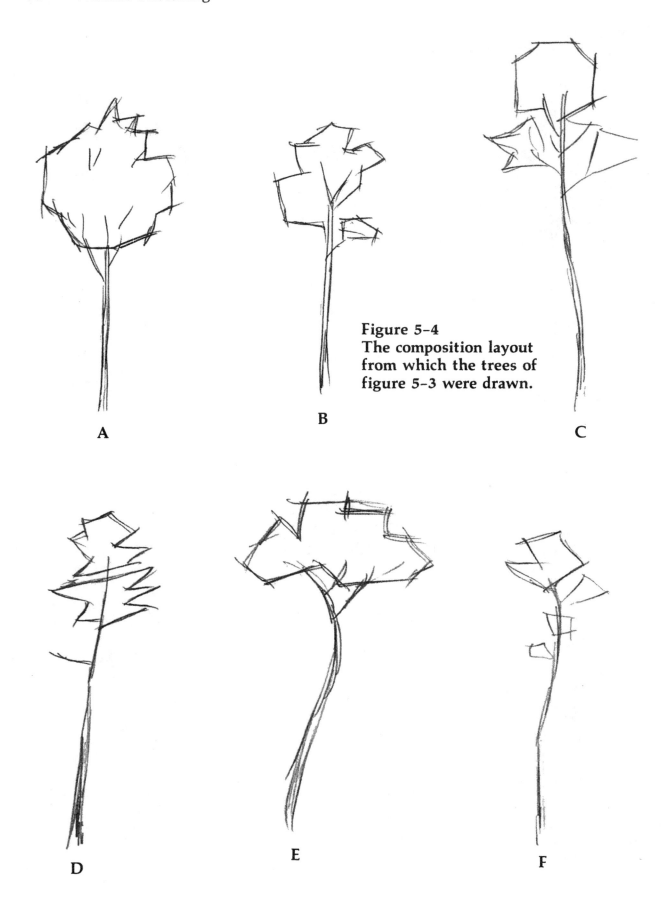

A

B

Figure 5-4
The composition layout
from which the trees of
figure 5-3 were drawn.

C

D

E

F

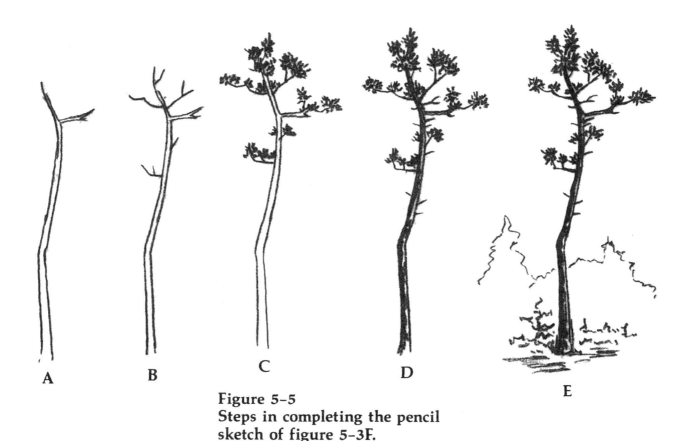

Figure 5–5
Steps in completing the pencil
sketch of figure 5–3F.

The sketches in figure 5–3 were done in two steps; none of them required more than two or three minutes total. Step one was to rough in the trunk line and the foliage envelope of each tree as shown in figure 5–4. They were all roughed in on one piece of paper. I then placed a piece of tracing vellum over these layouts and drew what you see in figure 5–3 using sharp HB and 3B pencils.

The steps in completing the sketch of figure 5–3F are shown in figure 5–5. First I established the trunk line (5A); I then added the primary branches, those that carry foliage (5B). The next step shows the foliage marks added (5C). For this tiny sketch the foliage is made with simple, very short lines from a sharply pointed 3B pencil, drawn in all different directions. Step 5D shows how I added a few dead branches (do not overdo this in your sketch) and finally shaded the trunk. In doing the trunk I used the 3B point again. I left some white paper along the right side of the trunk to suggest sunlight striking it.

The little tree looked out of place floating in midair, so in 5E I added a little toning for the ground (horizontal lines) and the simple outline of some background trees to provide a suitable setting.

A B

Figure 5–6
Steps in constructing a
tree with full foliage.

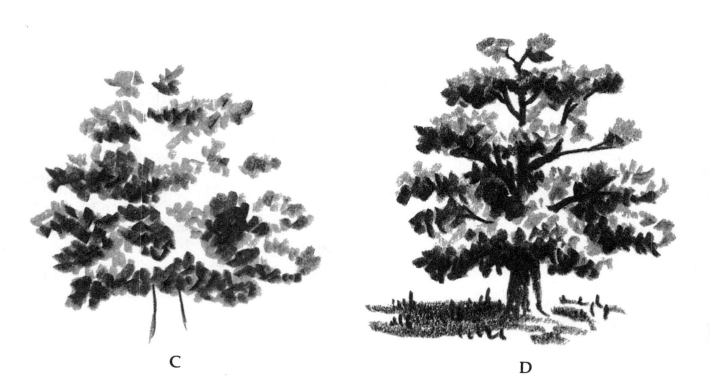

C D

All sketches are done in a step-by-step manner similar to figure 5-5—not necessarily using the same steps, but using the same logical approach to the construction. For instance, figure 5-6 shows a different sequence of steps used to construct a tiny sketch of a fully foliaged tree. In this case I first established the foliage masses, then added the trunk and main branches.

In sketch 6A I roughed in the foliage masses as I saw them. Then in 6B I used an HB broad-point pencil to indicate all the dark and medium tones of the foliage, leaving white paper for the lightest sunlit areas. Next, I took a broad-point 6B pencil and placed all the darkest foliage areas over the previous pencil work (6C). I had the advantage of looking at a tree while I was doing this sketch so I could see the masses of leaves and the holes where the trunk and branches showed. I indicated this in my composition sketch (6A). Finally, I added the dark branches and trunk and the indication of shadow on the ground (6D). Figure 5-6 is a simplified sketch, but these very same steps were used to produce the sketch in figure 5-1, a somewhat larger and more detailed study of a similar tree.

When I use the phrase *structure of a tree* in this book, I mean simply the way the foliage mass or masses are carried by the trunk and branches. There is a lot of geometric sense to the way trees grow; however, that subject is beyond the scope of this book. Those who may be interested, should try to find *The Artistic Anatomy of Trees*, by Rex Vicat Cole. It has more than 500 marvelous illustrations showing the geometry of the branch and leaf development of English trees. It is thorough and complete, and many of his drawings are worthy of close study. Originally published in 1915, the book was re-released in 1965 by Dover Publications (see bibliography).

Trees growing with reasonable freedom from crowding will tend to develop shapes that are typical of the species. Elms were once plentiful in the eastern half of the United States but now are threatened with extinction by Dutch elm disease. They show the characteristic umbrella shape typified by figure 5-7A. It has one straight, generally twig-free trunk for one quarter to one half its height. Then a number of main branches arch out, with the twigs at their ends drooping down and growing for the most part downward.

The black willow, also found in the eastern half of the United States, usually grows along streams or on lake shores. It has many main trunks clustered together as indicated in figure 5-7B. The branches generally grow in an upward and outward direction.

The oaks, primarily the black oak and the white oak, have stout trunks and massive branches. The lower branches frequently grow out horizontally from the trunk as shown in figure 5-7C.

The beech, illustrated in figure 5-7D, has light, smooth, silvery-colored bark and branches that grow horizontally outward. The lower branches frequently sweep downward from the trunk.

Observation will be your best teacher—especially organized observation. A notebook in which you can record your notes and sketches in spring, summer, fall, and winter will accumulate a wealth of information you can apply in later years. The

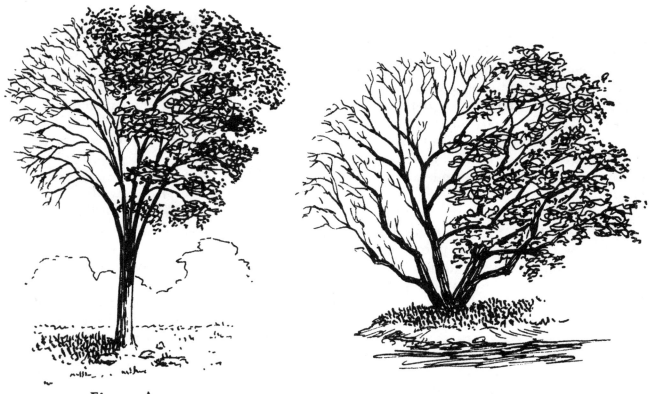

Figure A
Elm.

Figure B
Black willow.

Figure 5–7
Characteristic tree shapes.

Figure C
Black or white oak.

Figure D
Beech.

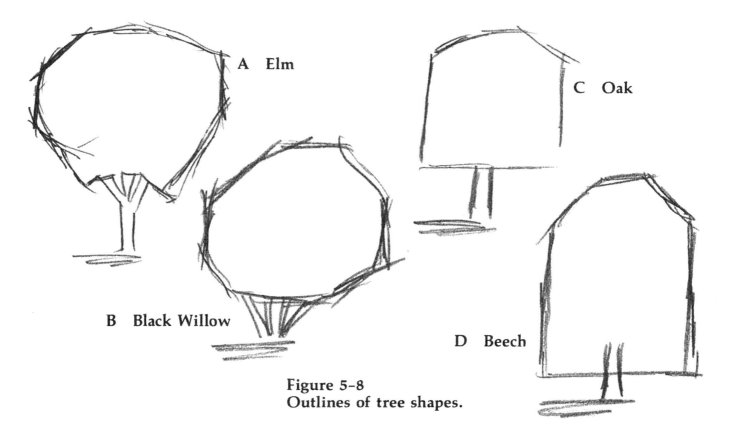

A Elm

C Oak

B Black Willow

D Beech

Figure 5-8
Outlines of tree shapes.

sketches in figure 5-7 show half of each tree as it might appear in winter and half in summer when it is fully clothed in leaves. You can make similar multiseason sketches for later use and supplement them with guidebook data.

The little ink sketches of figure 5-7 were done by first sketching the overall outline of the tree, main branches, and trunk in pencil. On the right-hand half of the sketch I indicated in pencil where the foliage masses would lie. I inked the foliage first, then the branches that showed between. Finally I inked the main branches and twigs on the bare left-hand side and added the foreground and background indications. When the sketch was good and dry I erased all the pencil lines. I used my artist's fountain pen for these sketches.

Observation—both from life and from reference sources—is important

to achieve realistic tree sketches, as trees generally tend toward a characteristic shape for each species. Look at actual trees and at guidebooks on trees. Look at photographs, paintings, and drawings until you can discern these characteristic shapes. Elms tend toward an umbrella or mushroom shape; black willows to a round shape; oaks toward a square shape, rounded on top; and beeches toward an oblong shape, also rounded on top. These shapes are shown in figure 5-8. You can see how the sketches of figure 5-7 conform to these outlines. On the other hand, there is nothing completely rigid about tree shapes. Trees are individual and subject to many external factors that affect the way they grow. You will be able to find examples in life that conform and those that do not conform to the general geometry of each species.

Figure 5–9
Pen sketch of a young elm tree.

Drawing Elms

Pen Sketch of an Elm

Figure 5–9 is an ink sketch of a relatively young elm tree. It has the characteristic arching branches and umbrella shape, but has just one main trunk—mature elms frequently have two to five main branches coming from the trunk as shown in figure 5–7A.

I used my technical pen and finest pen point, a 3×0, to make tiny circular marks for the leaves in this sketch and tried to achieve a very open, airy effect with the foliage. I started this sketch with the pencil composition shown in figure 5–10. This was *very lightly* sketched on the final paper. Masses of foliage are more often than

not bounded by straight lines as you see in this figure, not by sections of a curve. The first thing I did was ink in the foliage using small circles as you see in figure 5-11A. When the foliage was pretty well in place I erased the pencil lines I was using as guides, leaving only the pencil lines showing the trunk. I started inking the trunk with very short vertical lines (fig. 5-11B). Once the trunk was at this stage I erased the remaining pencil lines. Next I finished the trunk using very short horizontal lines to get the effect shown in figure 5-11C. Finally I added the foreground grass, rocks, shrub, and fence and the background tree line, as shown in the completed sketch (fig. 5-9)

Figure 5-10
Composition for the young elm tree.

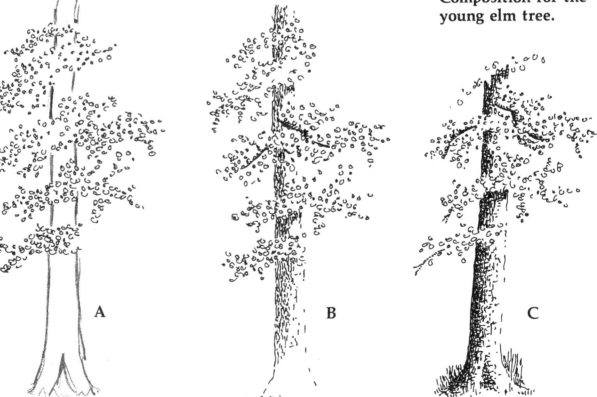

A B C

Figure 5-11
Steps in completing the young elm tree sketch.

Figure 5-12
Showing shadows on
horizontal and vertical
surfaces.

Figure 5-13
Showing shadow pattern
on tree trunk.

You can see when you do this sketch how important the preliminary pencil composition is to guide your work on the foliage. Without the preliminary layout it would be difficult to ink a subject as loose as this.

Note that the shadow on the grass is indicated by a lot of little groups of grass marks put together. This treatment maintains the visual texture of grass while creating the desired dark. When shadows fall on a horizontal surface such as a road or path, the lines representing the shadow should be horizontal. Also,

shadows on a vertical surface such as the side wall of a building generally look more appropriate when rendered with vertical lines. These techniques are illustrated in figure 5-12 where the shadow from a post falls on grass, a walkway, and the side of a building.

Foreground trees often require showing the foliage shadow and sunlight pattern on the trunk. This simply calls for leaving little patches of untextured area on the trunk to represent the sunlit spots (fig. 5-13). This is only practical when your sketch is large enough or the tree is fairly well in the foreground.

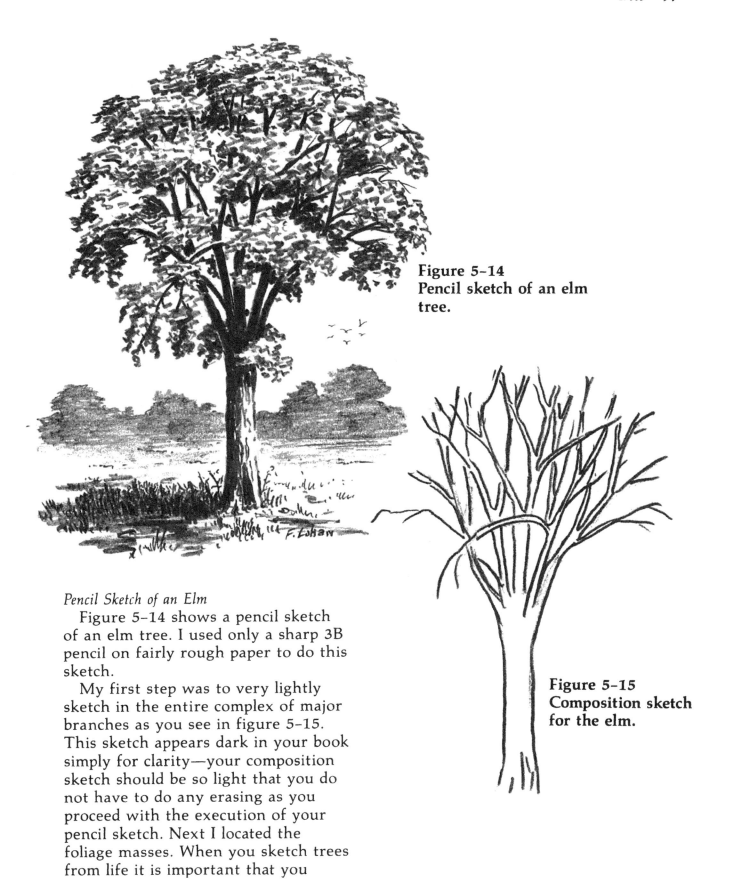

Figure 5-14
Pencil sketch of an elm
tree.

Figure 5-15
Composition sketch
for the elm.

Pencil Sketch of an Elm

Figure 5-14 shows a pencil sketch
of an elm tree. I used only a sharp 3B
pencil on fairly rough paper to do this
sketch.

My first step was to very lightly
sketch in the entire complex of major
branches as you see in figure 5-15.
This sketch appears dark in your book
simply for clarity—your composition
sketch should be so light that you do
not have to do any erasing as you
proceed with the execution of your
pencil sketch. Next I located the
foliage masses. When you sketch trees
from life it is important that you

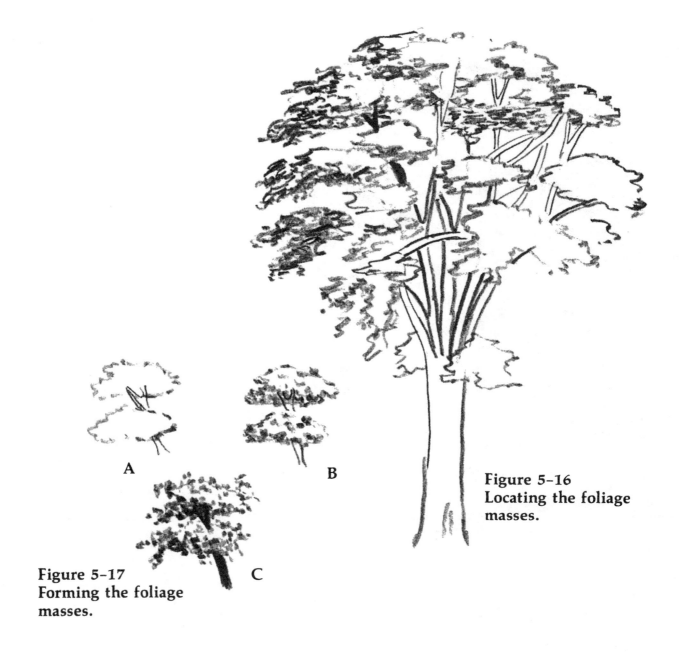

A

B

**Figure 5–16
Locating the foliage
masses.**

**Figure 5–17
Forming the foliage
masses.**

C

develop your observational skills to
see how foliage masses are put
together. In this case, even though
they overlap and intertwine a good
deal, the leaves are usually grouped in
masses that are supported by the twig
array growing from each major
branch. It is these main masses that I
next indicated on my sketch of the
elm (fig. 5–16). I developed the foliage
as shown in figure 5–17. As first

sketched, the leaf masses sort of
looked like blobs of cotton (17A). I
then indicated the darker areas of the
leaf masses (17B). Next I went back
and loosened up these masses by
showing sprays of leaves projecting
from them (17C). Finally, I darkened
in the branches and trunk and added a
simple foreground and background as
you see in the completed sketch,
figure 5–14.

Pen Sketch of a Black Locust

Figure 5-18 shows a pen sketch of a black locust tree. This sketch was developed following the steps in figures 5-19, 5-20, and 5-22. The trunk and main branch development for this tree is more complex than that of the young elm, but the progression of steps is exactly the same.

I first drew a light pencil composition showing the main branches (fig. 5-19). I next placed the main foliage masses on top of the branch layout (fig. 5-20). All this was actually done lighter than you see reproduced here. I then simply took the foliage masses one at a time and developed one before going on to the next. This sequence of steps is illustrated in figure 5-22.

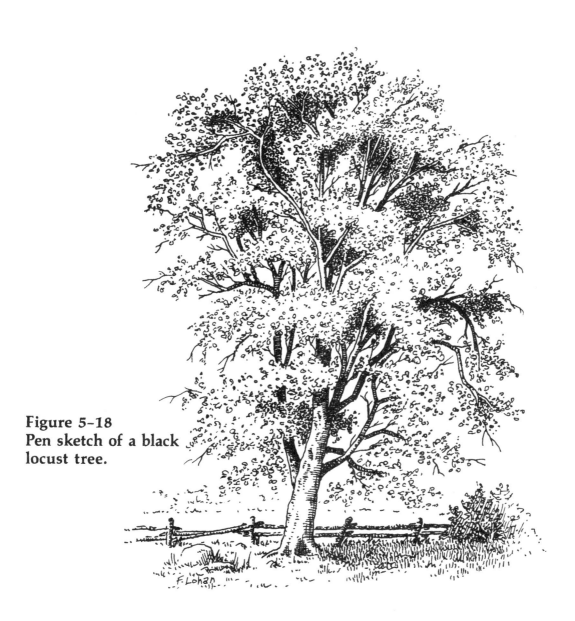

Figure 5-18
Pen sketch of a black locust tree.

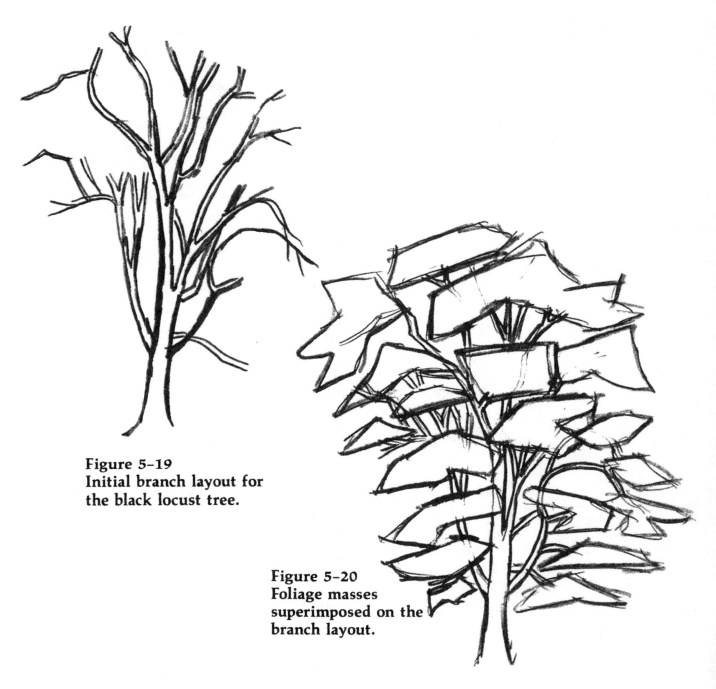

Figure 5-19
Initial branch layout for
the black locust tree.

Figure 5-20
Foliage masses
superimposed on the
branch layout.

The leaf masses sketched in figure 5-20 show only the foliage on the viewer's side of the tree. I didn't develop the foliage on the other side of the tree until after the near side was completed. Then I tucked the darker (shady) far-side leaf masses around the branches. Only this way could I see which branches I wanted to leave light (because they crossed a dark background) and which I wanted to darken (because they crossed light areas). After all leaf clusters were indicated, each leaf cluster was loosened up by inking leaf projections outside the cluster. Then the darker far-side foliage was completed before the branches and trunk were inked. The completed sketch is shown in figure 5-18.

Isolated Trees as Sketch Subjects

The three trees in figure 5–21 are based on a few minutes' sketching in the parking lot of a nearby community college. A 3B pencil and rough paper were used. The branch and leaf patterns of such trees make charming little subjects for either pencil or pen. Pencil is faster and can quickly capture the branch and foliage pattern of trees in the field for later, more leisurely development back at the studio.

I did a later studio ink sketch of the tree in figure 5–21A. The steps I took

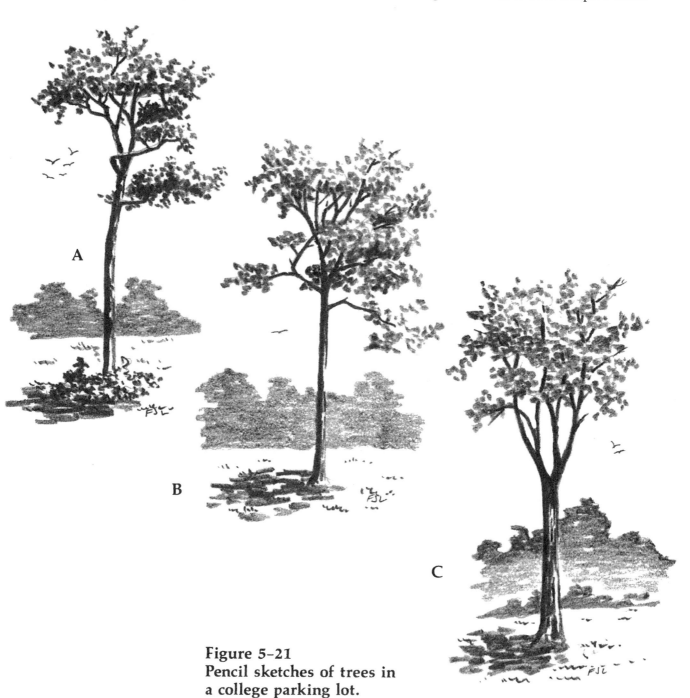

**Figure 5–21
Pencil sketches of trees in
a college parking lot.**

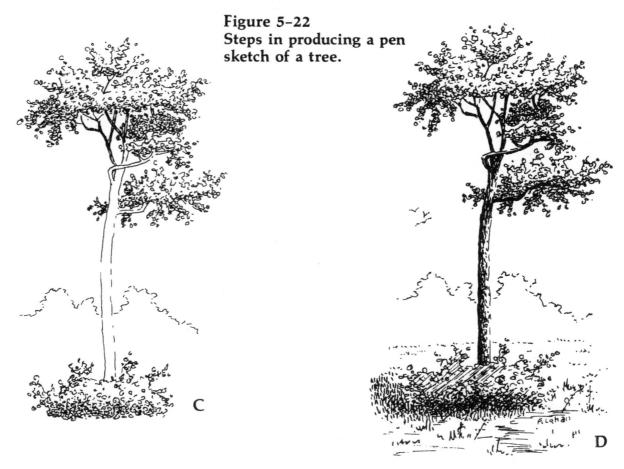

Figure 5–22
Steps in producing a pen sketch of a tree.

in producing the ink sketch are shown in figure 5-22. I used a 3×0 point in my technical pen and drew on tracing vellum for this sketch.

First I inked in the outline of trunk, branches, and foliage masses. As you see in sketch 22A, I did not use a solid ink outline of the sunlit right side of the trunk. A broken line is often much more effective for indicating the sunny side of objects.

Second, I added leaf marks to the foliage masses, making the bottom and left side of each mass dark, since I visualized the light coming from the upper right (22B).

When all the foliage masses were toned, I loosened them up by indicating sprays of leaves projecting from each mass (22C). This is what gives a lifelike look to sketched foliage.

Sketch 22D shows the final drawing. The trunk and branches were completed after the final work on the foliage, and then the foreground and background were added.

Silhouettes of Trees

Simple little tree shapes drawn in silhouette make excellent decorative motifs. The silhouette can be achieved in any number of ways, as shown in figures 5-23 through 5-26. In figure 5-23, stippling (dots) was used to produce a silhouette of the tree in figure 5-21A. The next sketch (fig. 5-24) shows a silhouette made of freehand horizontal lines. In figure 5-25, a combination of pen and charcoal pencil was used to produce a solid black silhouette of the same subject. The opposite of a solid black silhouette—one produced simply by outline—is shown in figure 5-26. These approaches are ideal for note paper applications, as they reduce and print very well.

The silhouette in figure 5-23 was produced using an artist's fountain pen. This pen leaves a fairly large dot of ink. The same approach using a

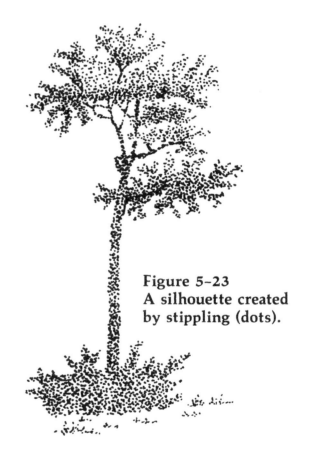

**Figure 5-23
A silhouette created
by stippling (dots).**

3×0 point in a technical pen is shown in figure 5-27. That point leaves a smaller dot of ink each time and produces a finer grained result. Compare figure 5-27 with figure 5-23.

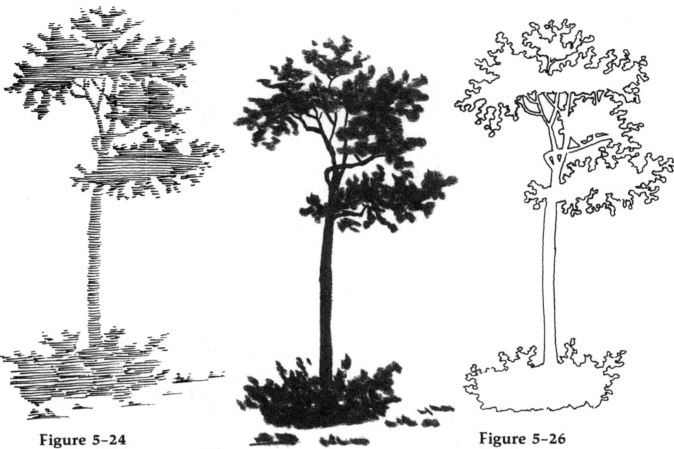

Figure 5-24
A silhouette created with
horizontal lines only.

Figure 5-25
A silhouette created with
charcoal pencil and ink.

Figure 5-26
A silhouette using pure
outline.

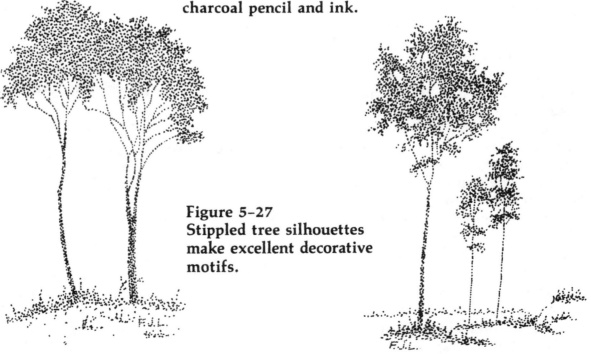

Figure 5-27
Stippled tree silhouettes
make excellent decorative
motifs.

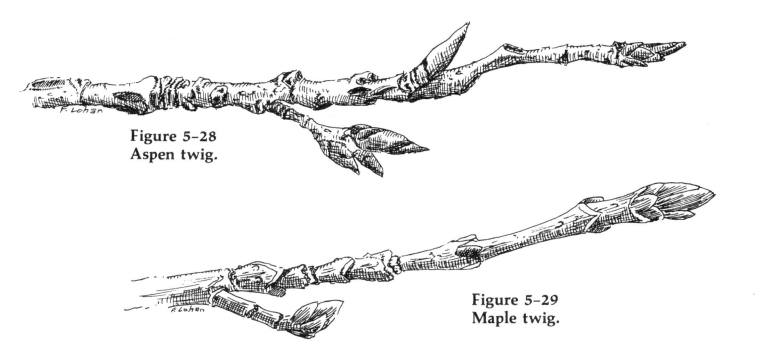

**Figure 5-28
Aspen twig.**

**Figure 5-29
Maple twig.**

Leaves and Branches

Parts of a tree make excellent sketch subjects, just as studies of the entire tree do. The structure of twigs varies considerably from species to species. Some are smooth, some hairy, some gnarled, with a dozen different textures to the surface. Almost all have leaf scars where leaves were dropped by the process of abscission— a layer of cells dies and allows the leaf to simply fall off the twig.

Twigs make good sketch material at any time of the year. Figure 5-28 shows an aspen twig in late fall. All the leaves had fallen and the twig itself had fallen from the tree in a fairly heavy wind. The big buds were hard and ready for winter.

The maple twig in figure 5-29 was cut and sketched in early spring. The buds were plump and moist, ready to pop open.

Figure 5-30 shows a white ash twig in late fall. The leaves and most of the seeds had fallen, except for the tenacious few shown.

All three twigs have lots of surface texture and what I call "character" to their surfaces. There are many surface features—bumps, leaf scars, and surface irregularities—to include in your pen sketches. I used a technical pen with a 3×0 point—a fine point—to capture all the minute detail. Visualizing the structure makes sketching such subjects much easier. See in figure 5-30 how the white ash resembles plumbing, especially where two twiglets branch out of one.

Figure 5-31A, a smooth little crab

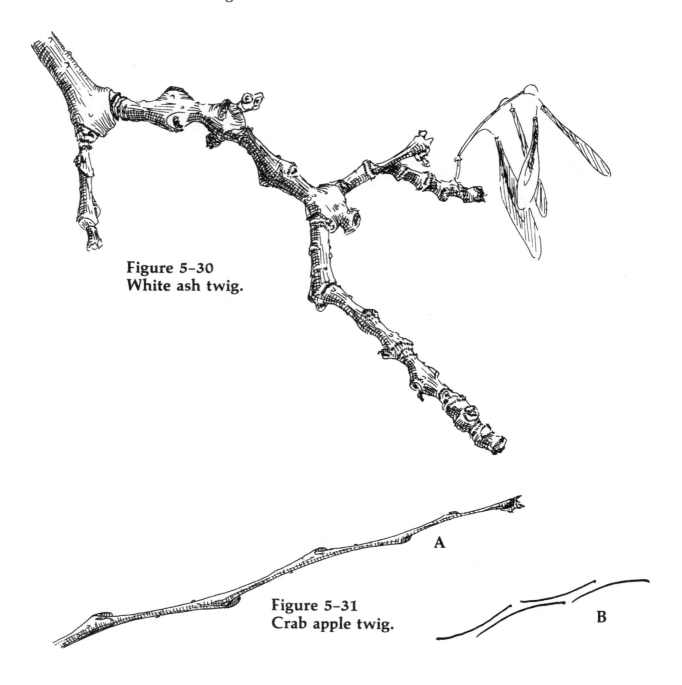

**Figure 5–30
White ash twig.**

**Figure 5–31
Crab apple twig.**

A

B

apple twig, has almost no surface texture, but it does show an interesting form. The twig can be drawn by drawing a series of overlapping arcs as shown in figure 5–31B.

Sketching twigs will help develop your observational skills as well as your sketching skills. This is good since good drawing is perhaps 70 percent observation and 30 percent technique.

An interesting exercise is to sketch the early spring development of tree buds. Such a study of a Norway maple is shown in figure 5–32. It spans a nine-day period when the buds swelled and popped open. Every few nights when I returned from work, I broke the last six inches from a

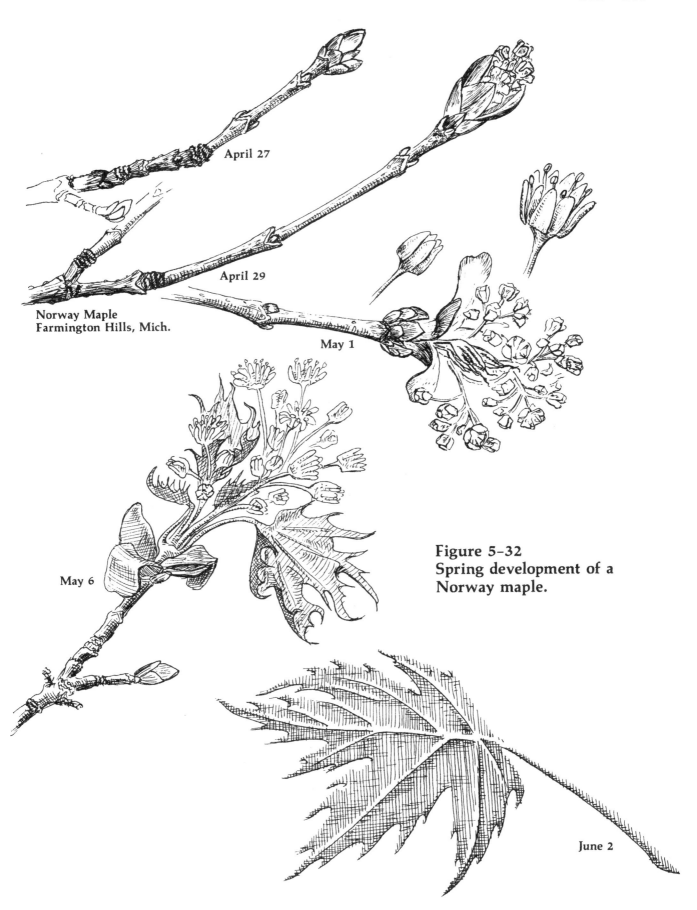

April 27

April 29

Norway Maple
Farmington Hills, Mich.

May 1

May 6

Figure 5-32
Spring development of a
Norway maple.

June 2

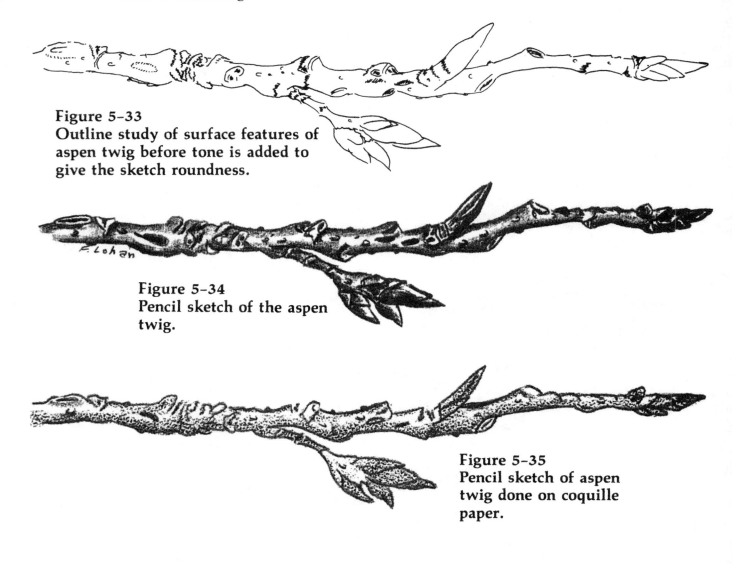

Figure 5-33
Outline study of surface features of aspen twig before tone is added to give the sketch roundness.

Figure 5-34
Pencil sketch of the aspen twig.

Figure 5-35
Pencil sketch of aspen twig done on coquille paper.

different branch on the tree, brought it into the house, and sketched it after supper.

There are basically two steps in sketching these twigs. First capture a good outline, including all the interesting surface features of the subject. Then use some toning to give it some roundness.

The outline for the aspen twig of figure 5-28 is shown in figure 5-33. A pencil study of the same twig is shown in figure 5-34. This was done on tracing vellum (which is quite toothy) placed directly over the pen outline of figure 5-33. I used sharp 2B

and broad-point 2H pencils to complete it. You need to use highlights as well as dark tones and intermediate tones to show the dimension and roundness that exists in such a subject. I started with the outline, then filled in the tone.

Figure 5-35 is a pencil/coquille paper sketch of the same subject. I used a sharp 2B point to do the outline and a broad 6B pencil to produce the shading. See Chapter 1 for a description of coquille paper.

Figure 5-36 shows a pencil sketch of a cluster of leaves on the end of an aspen twig. My first step was to place

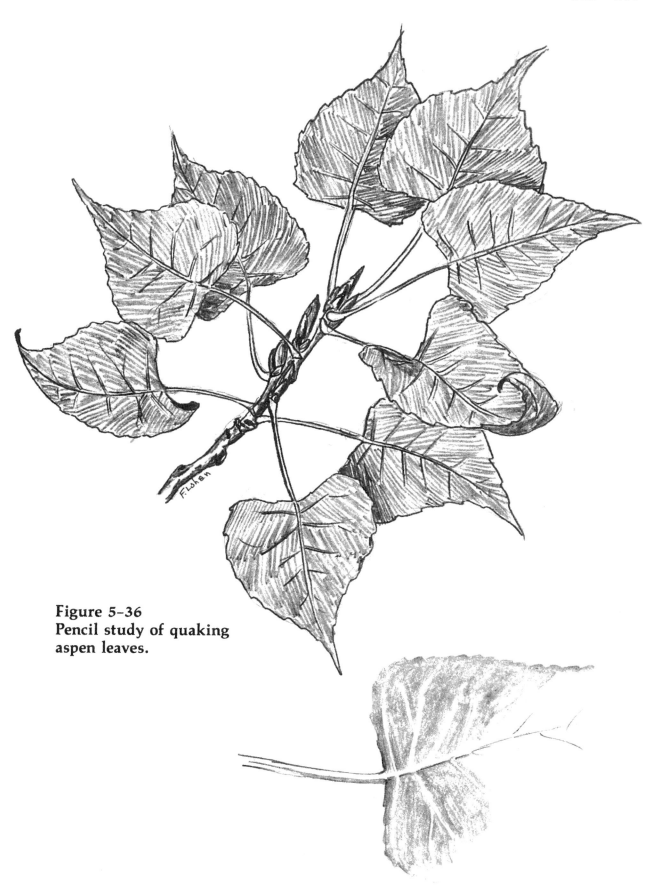

Figure 5-36
Pencil study of quaking
aspen leaves.

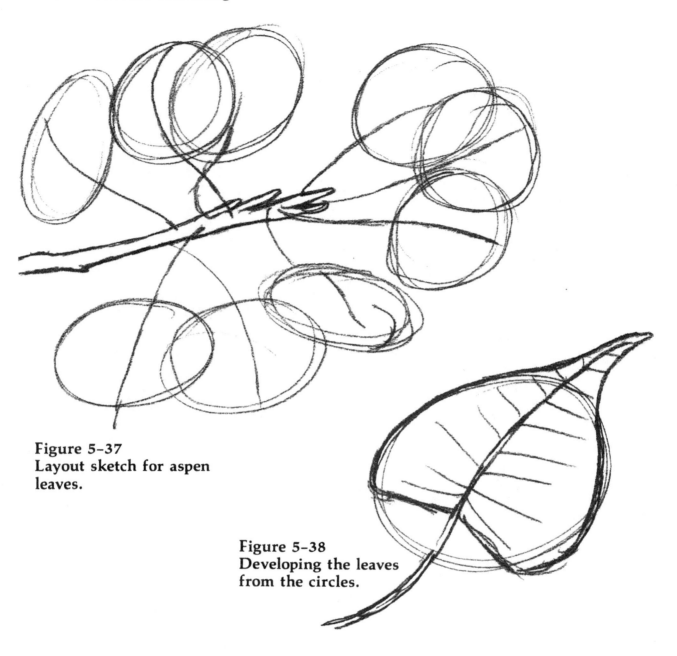

**Figure 5–37
Layout sketch for aspen leaves.**

**Figure 5–38
Developing the leaves from the circles.**

the subject in front of me propped up to present the view I wanted. Then I *lightly* roughed in the twig and used light circles to show the leaf locations. This layout looked like figure 5–37. My sketch at this point was as light as I could make it. I used a 4H pencil held gently to draw these lines since, unlike a pen sketch done over a similar layout, I could *not* erase all the layout lines once I completed the

sketch in pencil. This step is shown dark here just for clarity in printing.

I developed each leaf from the circle as shown in figure 5–38. This, too, was done lightly. I did not make dark marks on the paper until I drew in the toothed edges of the leaves.

A spray of horse chestnut leaves is drawn in figure 5–39. This is the kind of illustration you find in tree identification books. It is flat so that

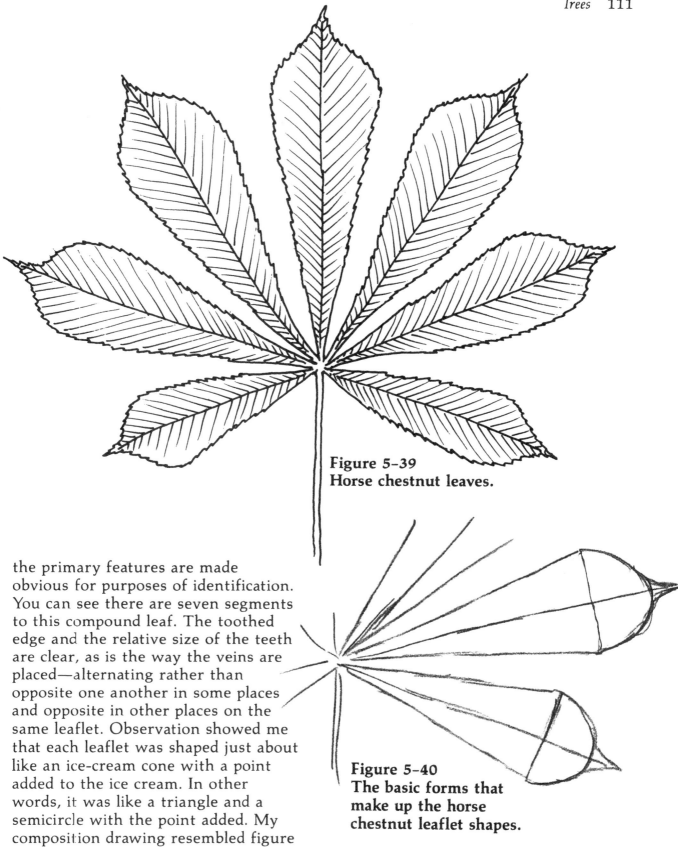

**Figure 5-39
Horse chestnut leaves.**

the primary features are made obvious for purposes of identification. You can see there are seven segments to this compound leaf. The toothed edge and the relative size of the teeth are clear, as is the way the veins are placed—alternating rather than opposite one another in some places and opposite in other places on the same leaflet. Observation showed me that each leaflet was shaped just about like an ice-cream cone with a point added to the ice cream. In other words, it was like a triangle and a semicircle with the point added. My composition drawing resembled figure 5-40.

This sketch was done on tracing

**Figure 5-40
The basic forms that make up the horse chestnut leaflet shapes.**

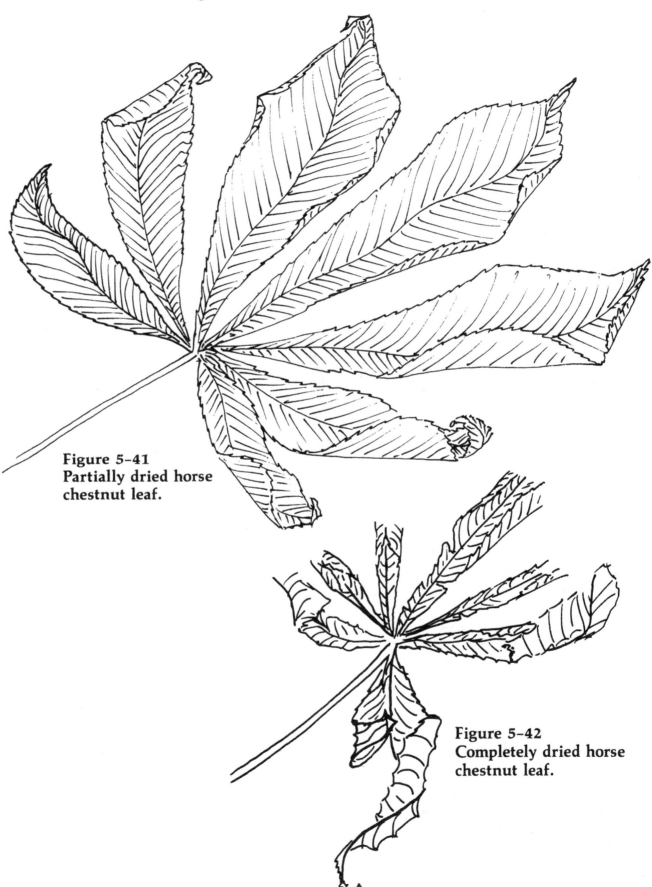

**Figure 5-41
Partially dried horse
chestnut leaf.**

**Figure 5-42
Completely dried horse
chestnut leaf.**

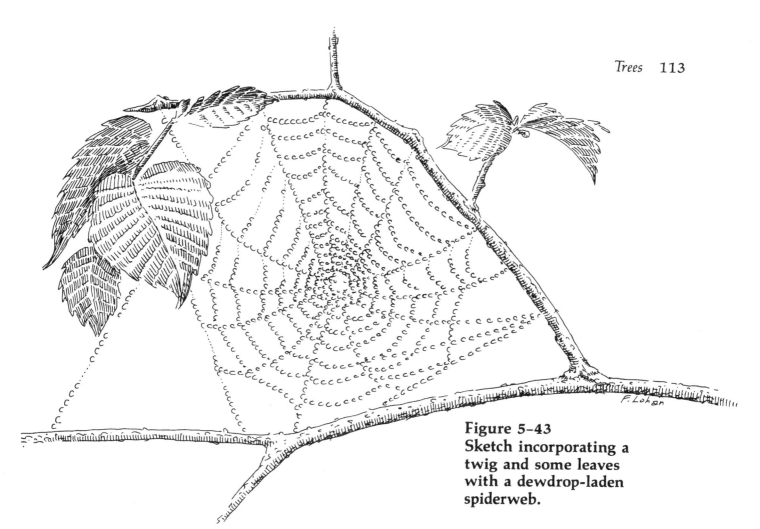

**Figure 5-43
Sketch incorporating a
twig and some leaves
with a dewdrop-laden
spiderweb.**

vellum placed directly over my composition sketch. I used my artist's fountain pen.

Actually, the leaves on a horse chestnut tree do not grow as if they had been starched and ironed flat— they have more the shape of a potato chip, especially when they dry out a little after being picked. The same leaf I used for the illustration in figure 5-39 is shown in figure 5-41 as it actually looked to me. A subject such as this is great to sketch. You must concentrate on "seeing" what is really there rather than letting your brain tell you what should be there, as happens when doing a symmetrical sketch like figure 5-39.

Several days later (in my warm house) the horse chestnut leaf finally curled up, broke in places as it dried, and looked like figure 5-42. This very irregular shape is an even better

subject for practicing your observational skills.

Whether you idealize your subject (fig. 5-39) or present reality as you see it (figures 5-41 and 5-42) depends on your purpose. Idealization is associated with more scientific purposes (such as technical drawings or identification guides) or with pure design (such as stencil design). The more realistic representations are associated with artistic endeavors. For instance, if I wanted to draw a bird on the ground in late fall and wanted to show typical dry curled leaves to embellish the setting, I would get some leaves and draw what I saw, as in figure 5-42.

Always look around you for opportunities to sketch something a little different. Figure 5-43 is the result of something I saw one cool morning in the fall. The pearly little

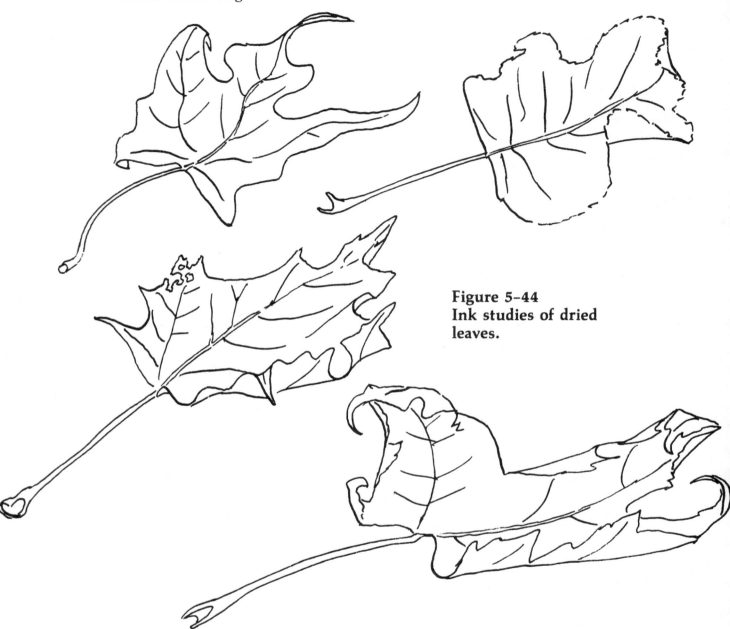

Figure 5-44
Ink studies of dried
leaves.

droplets of dew strung on a small spiderweb looked pretty as a picture, so I sketched it that evening. You, too, can make mental notes when something captures your imagination and use those notes later when you have a chance to put something on paper. Everything in this composition was done lightly in pencil before I started to ink it. I used a fine pen point on bristol board for this sketch.

An excellent way to practice freehand pen and pencil drawing is to collect a few leaves and make outline studies in ink, as in figure 5-44. Then place tracing vellum (*not* tracing paper, which is thin and meant just for temporary use) over the outlines and try different methods of drawing and toning the leaves with pen and with pencil. Some examples done just this way are shown in figures 5-45 through 5-48. Such studies are quickly done and allow you to experiment with various techniques in toning.

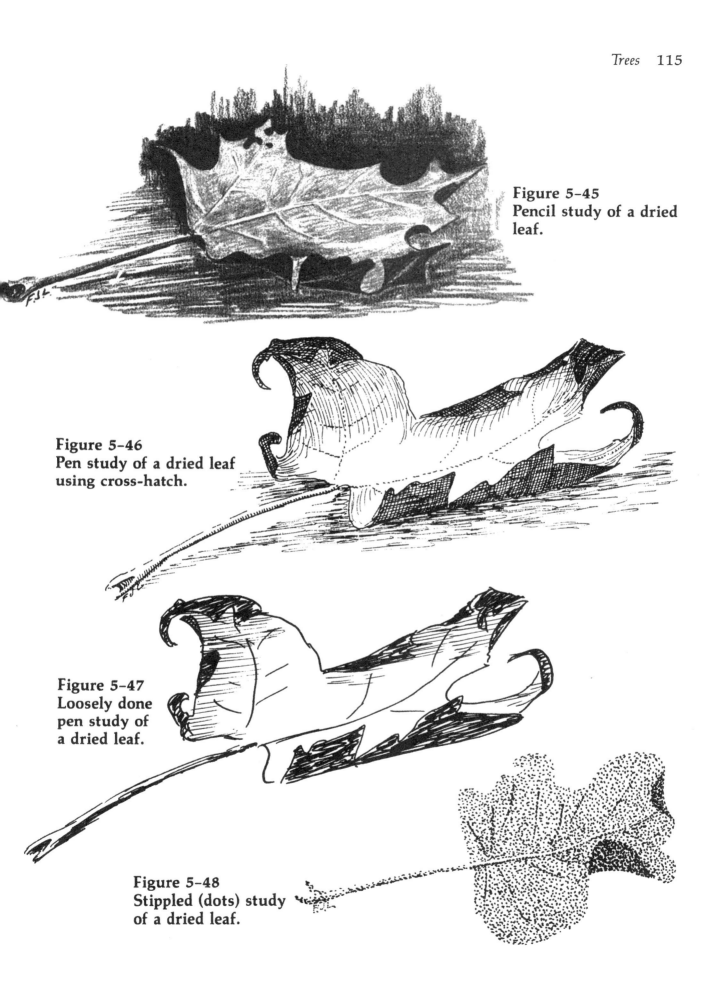

**Figure 5-45
Pencil study of a dried leaf.**

**Figure 5-46
Pen study of a dried leaf using cross-hatch.**

**Figure 5-47
Loosely done pen study of a dried leaf.**

**Figure 5-48
Stippled (dots) study of a dried leaf.**

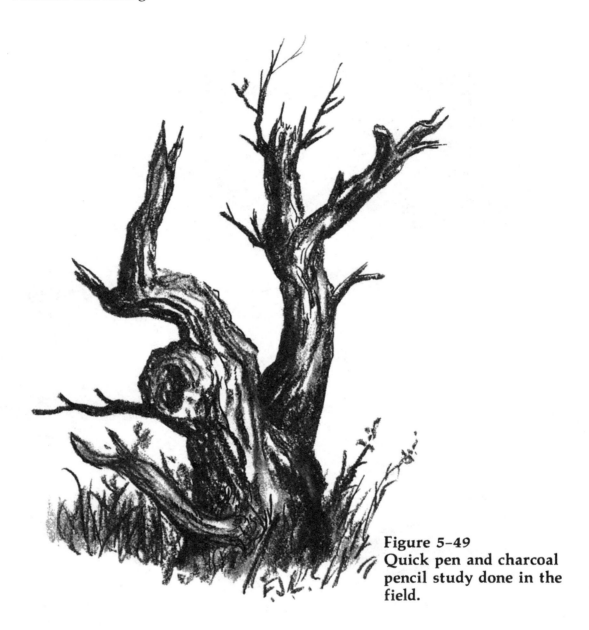

**Figure 5-49
Quick pen and charcoal
pencil study done in the
field.**

Tree Trunks and Stumps

There can be real charm to an old
weather-battered tree stump when
rendered in ink. It is not always
convenient, however, to sit on
location long enough to complete such
a study. One way around this problem
is to photograph the subject—and
another is to make a quick study, then
work from the study and your
memory when you get home.

Figure 5-49 is a study done with
charcoal pencil and ink in a few
minutes. I tried to get the essence of
the stump—its coarse bark and
twisting trunk and branch patterns—
drawn with a few strokes of the
charcoal pencil. Then I used my
artist's fountain pen to sharpen up a
few edges. Some time later (about two
years, in fact) I did the pen and ink

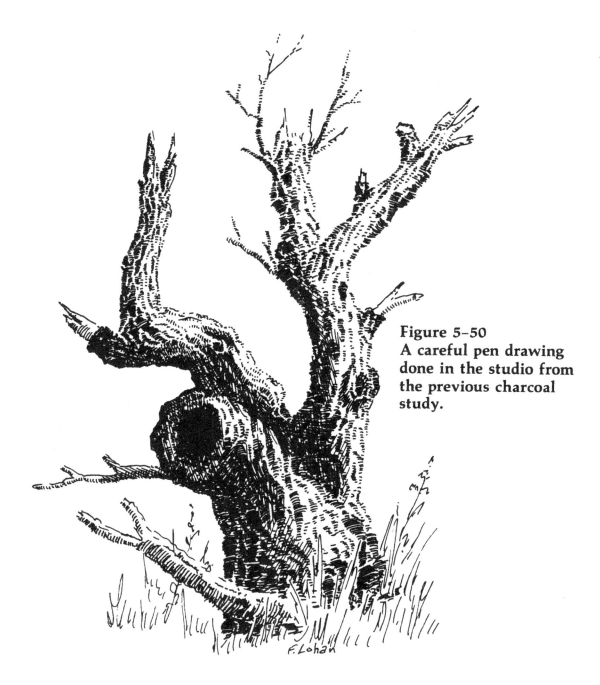

**Figure 5–50
A careful pen drawing
done in the studio from
the previous charcoal
study.**

drawing in figure 5–50 from the charcoal study.

In drawing figure 5–50, I first textured the entire stump with little groups of hatch marks to show the coarseness of the bark (see fig. 5–51). Where I wanted shadow, I made these groups of lines wider and closer together, leaving little white space. In the sunlit areas I made the groups narrower and left noticeably more white paper to represent the glare of the sun. This difference is evident in figure 5–51A. When the entire stump was completed, I cross-hatched to deepen the shaded side as you see in figure 5–51B. When you do this, do not cross-hatch too close together as you want the underlying texture to show a little.

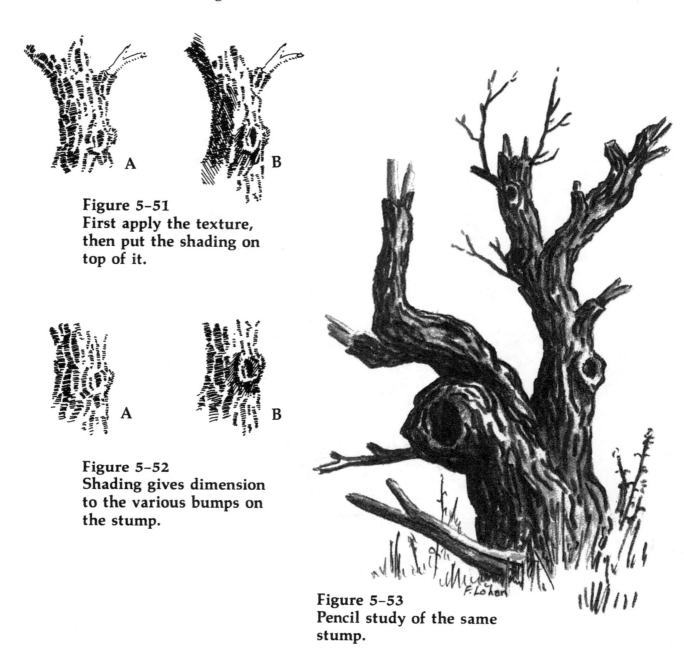

Figure 5–51
First apply the texture, then put the shading on top of it.

Figure 5–52
Shading gives dimension to the various bumps on the stump.

Figure 5–53
Pencil study of the same stump.

The development of the bump on the right side of the vertical section of trunk is illustrated in figure 5–52. I curved the bark lines around that area (52A), then shaded it to make the bump stand out (52B).

Figure 5–53 shows a pencil study of the same stump. I used a 3B pencil for the long, wavy marks indicating the rough bark. As with the previous pen and ink sketch, I put these texture marks close together in the dark area and further apart, with fewer of them, in the light areas. Then I used a broad-point HB pencil to further tone the dark areas right over the texture marks. I did the same with a broad-point 2H pencil over the light areas. Where necessary, I sharpened the outline with a sharp HB pencil.

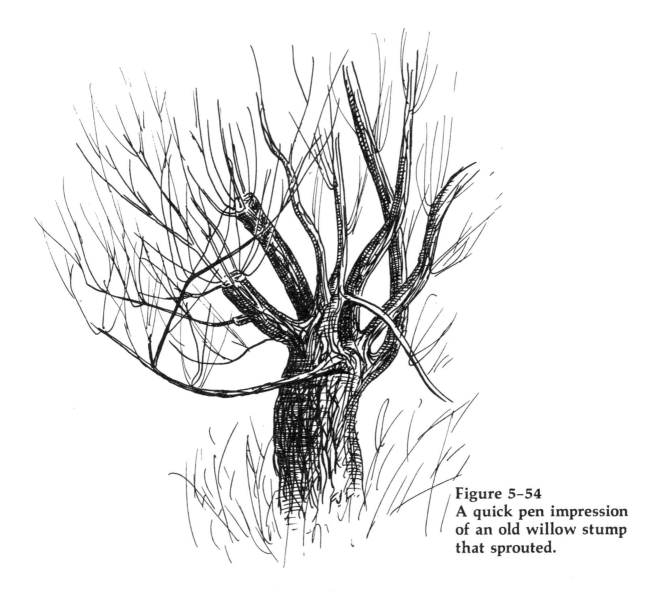

Figure 5-54
A quick pen impression
of an old willow stump
that sprouted.

Quick Impression Sketches

Quick impression sketches of trees are also fun to do and are instructive by forcing you to see main features at a glance. The pen sketch of an old willow stump that sprouted (fig. 5–54) was done to try to capture the mass of upward-thrusting branches left leafless in the early winter. You do not do a sketch like this by throwing random vertical lines on your drawing of the stump and branches. If you do, it will look like a haystack. The upward lines representing the newer growth must be logically attached.

Each line has to start from a branch. They should be clustered just as they are on a willow. You must look hard enough to really see the structure before you start to draw.

Quick sketches can also be done from a car, either while parked or moving. A glance from the car at a particularly interesting shape—say, a novel twist to a young tree—can be transferred to your sketchbook for future use and elaborated on at your leisure. Figure 5–55 shows four such quick sketches.

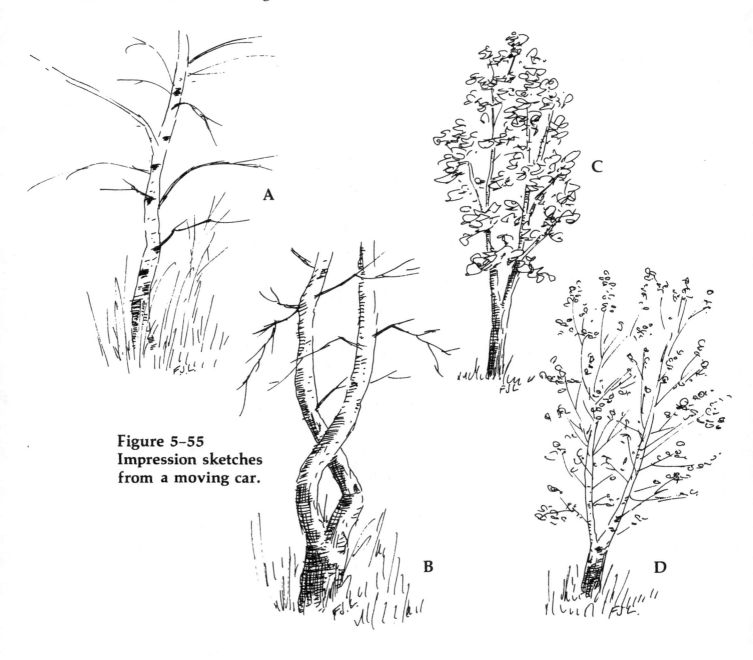

**Figure 5-55
Impression sketches
from a moving car.**

Drawing Evergreen Trees

It is a challenge to take a five- or six-inch piece of evergreen tree, prop it up in front of you, and draw it. The challenge is not so much in the drawing as it is the *seeing*—and in the *organizing* of what you see.

Figure 5-56 shows five different evergreen sprigs and cones drawn on one sheet of watercolor paper with a fine technical pen (3×0 point). These were all drawn from life. Such a montage makes an intriguing framed picture—I recommend you try one from your own choice of items.

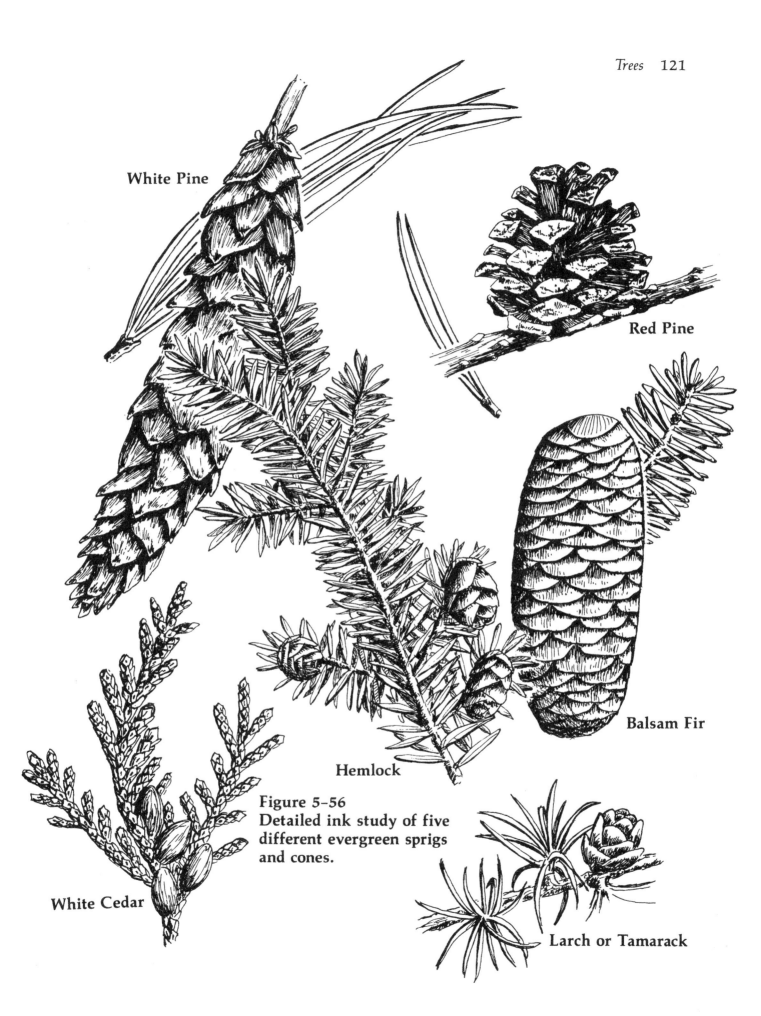

White Pine

Red Pine

Balsam Fir

Hemlock

White Cedar

Larch or Tamarack

Figure 5-56
Detailed ink study of five
different evergreen sprigs
and cones.

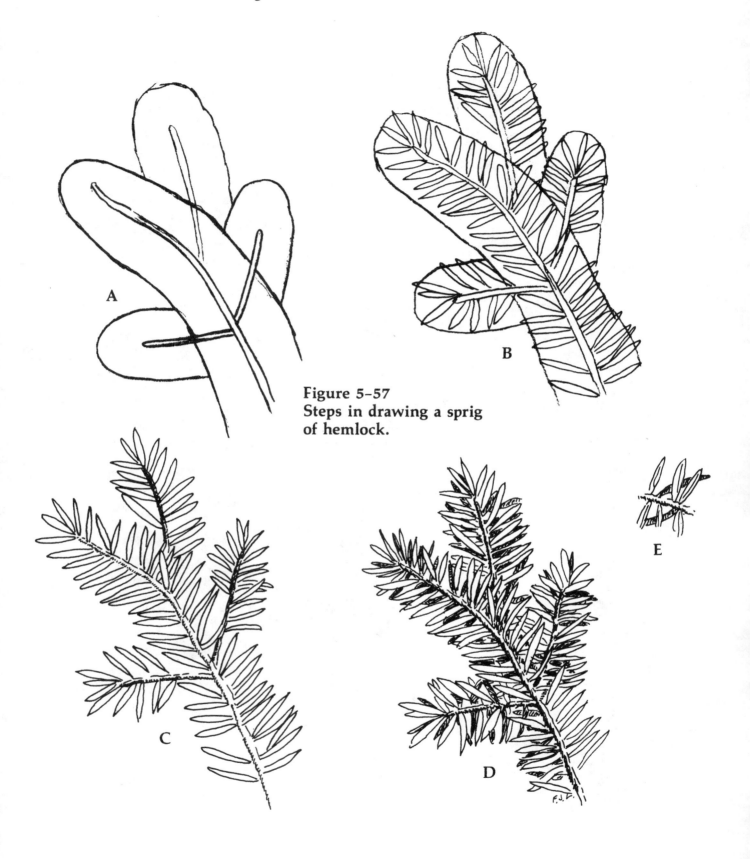

Figure 5-57
Steps in drawing a sprig
of hemlock.

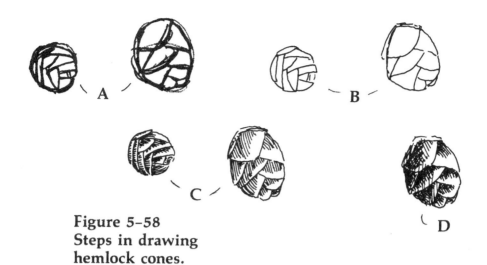

Figure 5-58
Steps in drawing
hemlock cones.

The key to successful portrayal of such a seemingly complex subject as a sprig of pine is in determining the basic structure of what you want to sketch and then methodically building on that. I can show you what I mean by taking you through the process I used to draw the hemlock sprig in the center of figure 5-56. The steps are shown in figure 5-57.

In the first step I lightly penciled in the outline form and the central twig from which all the needles grew. This is shown in 57A. I drew in all the pine needles in front (57B), carefully staying within the pencil outline to retain the proper proportions in the finished drawing. Then I drew in the twig, making it darker on one side than the other to give the impression of roundness. When this was completed I erased the pencil lines and was left with what you see in 57C.

Next I put in the needles that were behind the front ones. I shaded most of these, as you can see in 57D. In doing this step I took one part of the hemlock sprig at a time and added just enough needles to give the subject some thickness. I did not draw every needle I could see, as that would have made a confusing jumble on the paper. I put enough of them in the drawing to show the fullness and let the viewer's imagination go to work. It is like drawing a brick wall—you don't have to draw every visible brick, just enough to get the viewer's mental participation. The final step on the hemlock sprig was to put a line down the middle of most of the untoned needles (57E). This line was very evident on the sprig I was using as a subject.

I completed the hemlock cones as you see in figure 5-58. I inked over the pencil lines of 58A and then erased them, leaving the ink outline of 58B. I then shaded each segment as you see in 58C, being careful to leave some white paper at the edge of each segment. Then I cross-hatched a little to darken the tone where each segment went under the one that overlapped it. Finally, I applied a few lines over the left side of the entire cone to give it some roundness (58D).

Figure 5-59 shows various views of

Figure 5–59
White pine cone segments
drawn in different views.

one segment from a white pine cone. Whereas the hemlock cones are small—about one-half inch long—the white pine cones are about six or seven inches long, so each segment is larger than an entire hemlock cone. Sketch 59A shows a top view, 59B and 59C show the segment from the side, and 59D shows part of the underside in a side view. 59E shows a front view with part of the underside visible. I did these little studies before drawing the full white pine cone in figure 5–60.

Figure 5–60A shows my pencil outline and the cone segments I drew within it. After I completed this outline work in ink, I erased all the pencil lines and started to tone each segment of the cone, one at a time, as you see in figure 5–60B. I then went back and completed each segment before going on to the next. Using cross-hatch, I darkened the back part of each segment where it was deeper inside the cone, and added some texture dots and short lines in the lighter areas. Basically I was showing each segment as you see in figure 5–60D, except that some were in profile—I referred to my preliminary studies in figure 5–59 for them.

Pencil provides a much quicker way

to sketch some subjects than pen and ink does. Of course, speed is not always the objective. Being faster, the pencil produces a different impression than the pen, and what medium you use will depend on the end result you are after. Pen sketches can be reproduced inexpensively since no screen is required. Pencil drawings, showing delicate differences in tone, must be prepared for printing with the use of a screen dot pattern to capture tonal differences.

The white pine cone just studied in ink is drawn in pencil in figure 5–61. This was done by placing a sheet of vellum directly over the drawing in figure 5–60C and doing the pencil work directly. In doing this pencil drawing I used the same approach as shown in figure 5–60B—I started toning each segment of the cone with parallel pencil marks. I used a 3B point which, being soft, did not hold a sharp point very long on the toothy vellum. The result is a softer, warmer sketch than the one completed with ink. Is one better than the other? No; it is just that the different media produce different results. Sometimes one is more suitable than another. Look at the pencil drawing of the hemlock sprig in figure 5–62 and

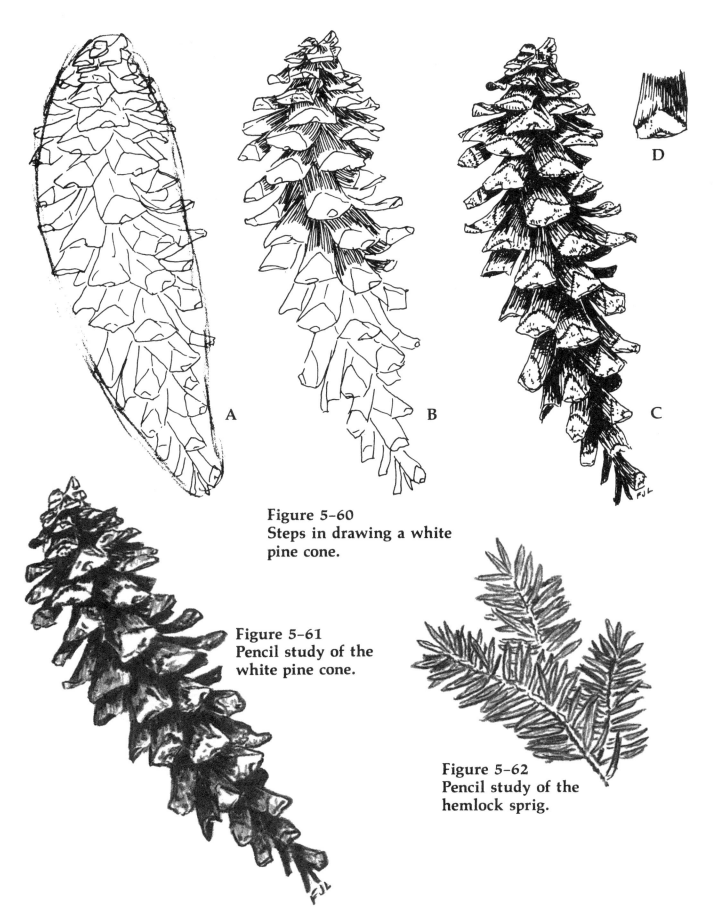

A

B

C

D

Figure 5-60
Steps in drawing a white
pine cone.

Figure 5-61
Pencil study of the
white pine cone.

Figure 5-62
Pencil study of the
hemlock sprig.

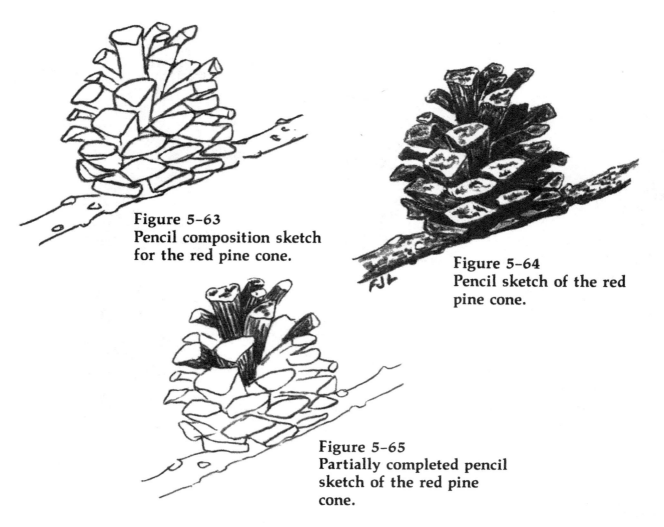

Figure 5-63
Pencil composition sketch
for the red pine cone.

Figure 5-64
Pencil sketch of the red
pine cone.

Figure 5-65
Partially completed pencil
sketch of the red pine
cone.

compare it with the pen version in figure 5–57D. In this case I think the pen version is more effective.

The red pine cone in figure 5–56 was done with a pen on a composition drawing like that in figure 5–63. Such a composition is the starting point for either a pen or pencil sketch. The same cone is shown completed with a 3B pencil in figure 5–64. The initial steps of the pencil sketch are shown in figure 5–65.

The foliage of evergreen trees, when far enough from the viewer so that details of needle and cone structure are not visible, should be rendered with a short, choppy, needlelike stroke to suggest the actual texture to the viewer. Figure 5–66

shows two basic types of foliage strokes: 66A is generally used for deciduous trees, and 66B for texturing pine trees. Figure 5–67 typifies an ink sketch of a fully foliaged deciduous tree, with loops used to define the foliage masses and to complete the texturing. Figure 5–68 shows a typical pine tree ink drawing, with the foliage depicted by little clumps of needle strokes as in figure 5–66B. When using this means of portraying pine foliage, pack the clumps tightly together to show the foliage in shade, and just use the upward part of the cluster to show the upper surface of the foliage masses in bright sunlight. Figure 5–68 illustrates both of these lighting treatments.

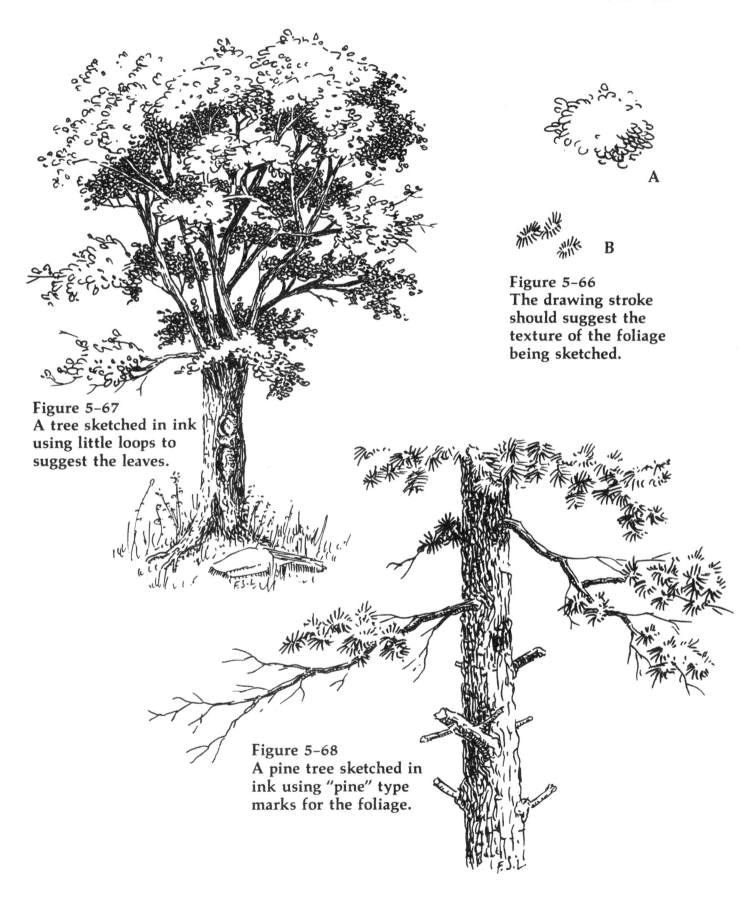

Figure 5-66
The drawing stroke should suggest the texture of the foliage being sketched.

A

B

Figure 5-67
A tree sketched in ink using little loops to suggest the leaves.

Figure 5-68
A pine tree sketched in ink using "pine" type marks for the foliage.

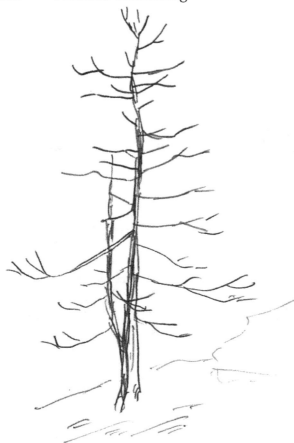

Figure 5-69
A pine tree structure.

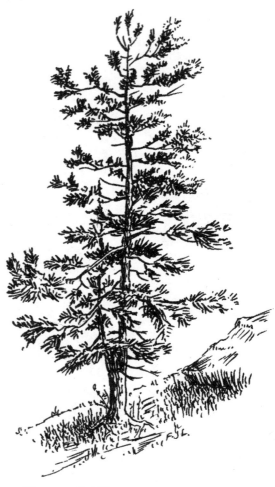

Figure 5-70
Pine tree inked over the
structure.

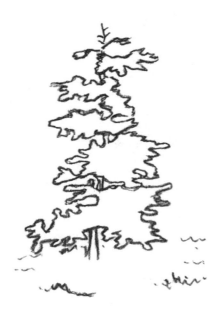

Figure 5-71
A small pine tree layout
sketch.

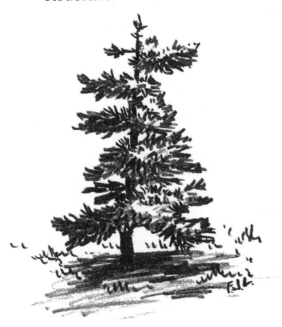

Figure 5-72
Pencil version of the
small pine tree.

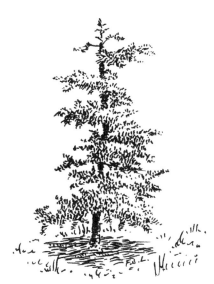

Figure 5-73
Pen version of the small
pine tree, depicting a
short-needled species.

Figure 5-74
Pen strokes representing
a longer-needled species.

Figure 5-75
An old pine on land that
has been cleared.

To sketch evergreen trees I generally proceed one of two ways. One is to lightly rough in the branch structure in pencil, and then put the foliage on this structure; when the foliage is complete I put in the branch and trunk details. The other way is to lightly outline the foliage masses in pencil, showing at that time where the major branches and trunk are visible between them. The first of these methods is illustrated in figures 5-69 and 5-70. The final drawing was done in ink. The second method is shown in figures 5-71 and 5-72 with the final drawing done in pencil.

It does not matter whether you are going to finish a drawing in ink, pencil, wash, or watercolor—an initial composition and structure sketch, carefully but lightly drawn, will allow you to concentrate on the problem of rendering the textures, shades, and forms, without having to worry about location, proportion, and size at the same time. Either of the approaches in figures 5-69 and 5-71 may be used.

Figure 5-73 shows a pen and ink version of the layout sketch in figure

5-71. The short pine-type strokes used suggest a hemlock, spruce, or fir—one of the short-needled species. To suggest a young white pine, Scotch pine, or other long-needled species, the lines used to texture the foliage should be longer, as in figure 5-74. Also look at figures 2-1, 2-2, and 2-3 in Chapter 2 for drawings of longer-needled pine trees in the foreground and middle ground of a composition.

Pines, just as deciduous trees, do not develop lower limbs when they grow under crowded conditions. Figure 5-75 is a pencil sketch of a tall pine tree on cleared land with foliage just near the top. Compare figure 5-75 with figures 5-3, 5-21, and 5-27 in this section.

Aerial Perspective Effect: Drawing Distance

When you look off into the distance things become smaller, bluer, lighter, and less distinct. This is known as aerial perspective. Artists use this to help show distance in representational (realistic) landscape painting. The distant mountains are almost invariably colored a pale blue, just as they usually appear to the eye.

Working in black and white, you obviously can't make distant features appear bluer, but you can make them smaller and somewhat lighter to help the viewer perceive them as being more distant. Figure 5-76 shows a simple little pencil landscape with a road in the foreground, a little hill with some trees on it in the middle ground, a clump of trees farther off toward the background, and a low range of hills in the far background. Let's examine how the aerial perspective is worked into this sketch.

First notice the amount of visible detail. The foreground shows rocks, grass, vegetation marks, and small pebbles. The nearest trees are drawn with a foliagelike texture and some small grass marks are included on the hilltop. The farther clump of trees, however, is drawn in a flat, almost textureless manner, and is noticeably lighter in tone than the closer trees. The background hills are lighter yet and featureless.

The farthest clump of trees and the background hills were toned down (made lighter) by pressing a kneaded eraser on the finished pencil work. This produces a very noticeable reduction of tone, as shown in figure 5-78. 78A in this figure shows the as-drawn tone of this clump of trees from the 3B pencil I used. 78B shows the result after a couple of applications of the kneaded eraser—I just pressed it on the pencil work with no back-and-forth erasing motion. After each pressing I kneaded the dirty part into the eraser and used a clean surface for the next pressing.

A similar aerial perspective effect was achieved with the kneaded eraser on the three distant pine trees in figure 5-77. The size and tonal difference indicate that the smaller pine trees are farther away. Figure 5-79 shows the pine trees and birds before and after using the kneaded eraser. In pencil drawing the kneaded eraser is as invaluable a tool as the pencil.

Achieving aerial perspective with pen and ink is a little more difficult than with pencil because ink is not as easy to tone down—the kneaded eraser will not work. Tonal differences are created by covering more or covering less of the paper with ink—by spacing lines or dots closer or farther apart. Figure 5-80 is a pen and ink version of the pencil landscape in

Figure 5-76
A pencil landscape
showing trees in the
middle distance.

A B

Figure 5-78
Aerial perspective in
pencil with distant
objects lighter.

Figure 5-77
A pencil sketch showing
some pine trees in the
distance.

A B

Figure 5-79
Aerial perspective in
pencil.

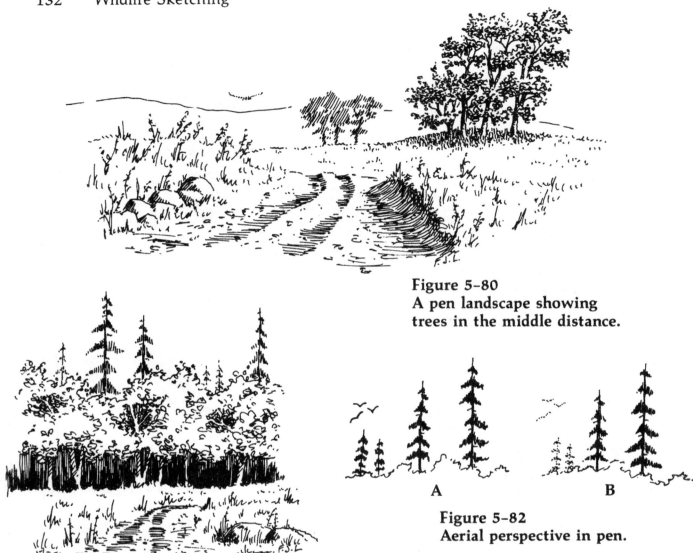

Figure 5-80
A pen landscape showing
trees in the middle distance.

Figure 5-81
A pen sketch showing some pine
trees in the background.

Figure 5-82
Aerial perspective in pen.

A B

figure 5-76. I used diagonal lines to show the farther clump of trees in silhouette, and I used dots to indicate the hovering hawk. For the background hills I simply used a slightly broken outline and no tone at all. Any tone I might have used on the hills would have conflicted with the trees and would have tended to bring the hills closer.

Figure 5-81 duplicates in ink the pencil study in figure 5-77. Here the treatment of the birds and distant pine trees, using dots and very short lines not too close together, does make them lighter than the closer pine trees. This is illustrated in figure 5-82. 82A is drawn with all lines and spacings equal, and the trees and birds all appear the same distance away. When the birds and farther trees are dotted instead, you have a sense of aerial perspective (82B).

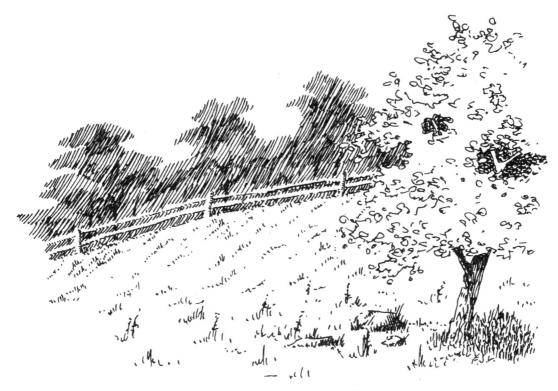

Figure 5-83
One way of drawing
background trees in ink.

Background Trees

Generally you will want the background trees in your sketches to be a slightly modulated tone, and to only hint at the lights and darks of the foliage masses, with little detail such as branches and trunks. Too much detail will tend to bring the trees forward toward the viewer, rather than leaving them in the background where you want them.

One way to produce background trees is shown in figure 5-83, a study done with the 3×0 point in a technical pen. In this study there is a tree in the foreground and a hillside, with the beginning of a wooded area just on the other side of a rail fence that runs along the hilltop. The step-by-step process of producing this background is shown in figure 5-84.

84A shows the start of the sketch—a pencil outline of the tree line and the fence. In the next step (84B), I started to hatch the tree line, being careful to leave the fence white except for the shadows shown on the right side of the posts and the bottom of the rails. Once the hatching was complete, I erased the pencil lines and added some hatch marks to indicate tree trunks (84C).

To complete the background I varied the flat tone of the trees by hatching over some of the tree tone in the same direction. This produced darker patches, as you see in 84D. At this time I also trimmed the thickness of the rails in the fence (they were too thick in 84C) and established that it is a hillside by drawing the little clumps

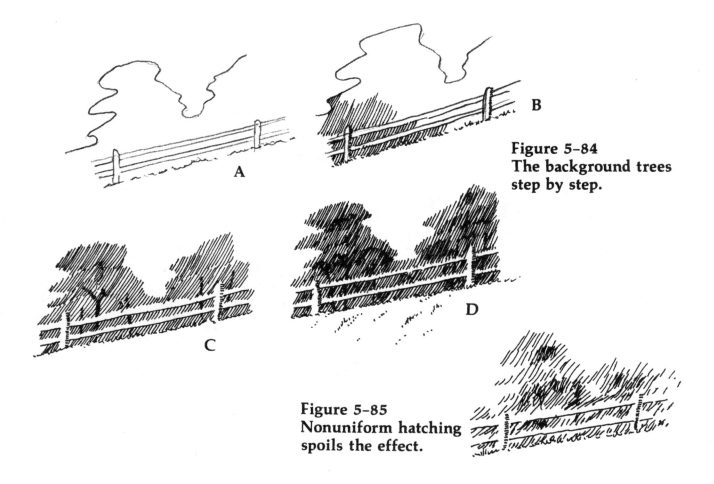

Figure 5-84
The background trees
step by step.

Figure 5-85
Nonuniform hatching
spoils the effect.

of grass at an angle from lower left to upper right. To indicate that the land is flat at the bottom of the sketch I show the grass clumps as a horizontal row of marks.

It is vital that you use a uniformly spaced line when doing hatching like this to establish a background tone. If you get too irregular in your hatching you will end up with a confused mass of lines and tone blobs, as in figure 5-85. It is worth spending a little time practicing hatching to gain some proficiency at doing it rapidly and uniformly. This little band of background trees makes an excellent subject for such practice.

Sometimes you will want to include some prominent individual trees in the line of background foliage. Figure

5-86 shows three steps I took to accomplish this. First I drew the light pencil layout (86A); then I produced the first layer of hatching (86B). This time I used predominantly horizontal lines to produce the tone, rather than the slanted lines of figure 5-84. For the final step I simply added a little cross-hatching for the dark areas, lines for the trunks, little circular squiggles for the lower shrubbery, and some short lines to indicate the grass (86C).

Figures 5-83 through 5-86 were drawn with a technical pen, 3×0 point. This point gives a nice fine line for this kind of small work. A larger point gives a coarser, less delicate result, as shown in figure 5-87. When you try to repeat some of these

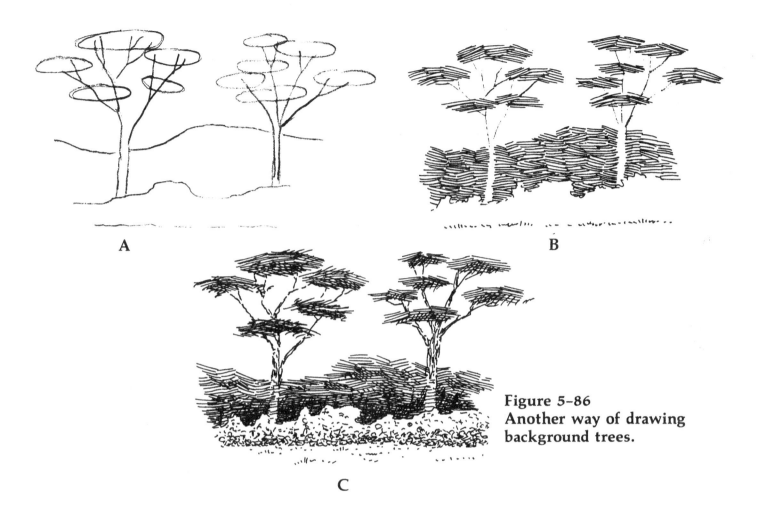

A

B

C

Figure 5-86
Another way of drawing background trees.

Figure 5-87
A coarser pen gives a different, less delicate impression.

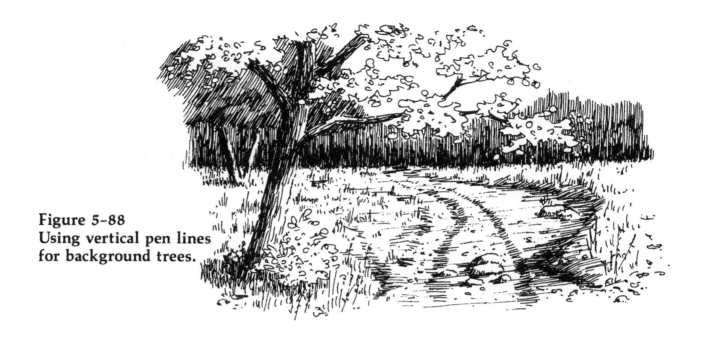

**Figure 5-88
Using vertical pen lines
for background trees.**

**Figure 5-89
Pine trees in the
background.**

A B C

**Figure 5-90
Drawing pine trees for
the background.**

**Figure 5-91
Many different strokes
work in drawing
background trees.**

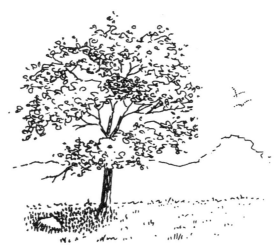

Figure 5–92
**The simplest way to indicate background trees
with the pen—broken outline and no toning.**

exercises you will not get the same
effect if your pen point is much
coarser than the one I used.

Vertical ink lines may also be used
to produce background tones for
trees, as shown in figure 5–88.
Whatever direction line you use,
uniformity of line spacing is essential
to establish the uniformly toned band
that represents the trees along the
background.

Sometimes your background trees
will be pines. These are easy to
simulate with the pen as shown in
figure 5–89. As I have said with many
other subjects in this book, if you get
a feeling for the structure of your
subject, execution of a drawing of it
becomes much easier. The same
advice holds for background pine trees
such as these. The structure that I use
for background pine trees is shown in
figure 5–90A. This is simply a series
of wiggly lines representing the
primary boughs of the pine tree. To
complete such a pine tree portrayal, I
then add a few more wiggly lines in
the center of the tree (fig. 5–90B). I
leave the ends of the primary lines
prominent to suggest the typical

evergreen boughs. Once mastered,
this method only requires a few
minutes to produce an effective
result. Sometimes you will want to
add one or two tall pine trees of a
different kind as shown in figure
5–90C.

Figure 5–91 shows a looser way of
quickly indicating background trees.
Here a free back-and-forth continuous
line was used instead of more
carefully drawn parallel hatch marks.
The same kind of line was also used
to show the foliage of the two more
prominent trees. This approach makes
a dark background. There may be
times when you just do not want that
much attention called to your
background; for instance, when the
subject of your sketch is very simple
or very simply drawn so that it would
not dominate if the background was
so heavy. In such cases, the simplest
rendition of background trees is a
broken line with no tone at all, as
shown in figure 5–92. There will be
many times when this method will be
the most appropriate one for your
sketches.

Bark

Certain trees have very distinctive bark. You've heard the Boy Scout pun about being able to identify a dogwood tree by its bark—well, it's true. The dogwood bark is made up of small, almost round chunks of bark, each surrounded by a deep fissure. This characteristic makes it one of the easiest trees (next to the white birch) to identify in winter, spring, or summer. There may be times when you will be featuring either a whole tree or part of one in your sketch, or you will be showing a tree fairly prominently in the foreground. At such times you should pay some attention to drawing the details of the bark in a realistic manner.

Figure 5–93 shows nine different tree bark patterns drawn with a technical pen, using a 3×0 point. Figure 5–94 shows a pencil rendition of the same nine textures. For the pencil drawings I used a sharp 3B pencil and a flat HB. The bottom quarter of each of the pen and pencil sketches (except for the birch) shows how I started the sketch by drawing the major feature of the bark pattern for each tree.

If the major bark pattern of a tree you want to draw is not immediately obvious to you, study the tree (or a photograph if that is what you are using as a reference). Ask yourself what would be the minimum you would draw to represent that bark. You will see cracked, large scales if you study a white pine tree. So that is what I first drew all over the white pine tree trunks in figures 5–93 and 5–94. This major pattern is shown in the bottom quarter of the white pine sketches. Then, over this pattern, I drew the secondary detail of all the smaller scales that covered each of the larger ones. As this smaller detail masked the lines I initially drew for the major scales, I reemphasized the major lines so that the dark furrows remained predominant.

I followed these same steps— identifying the major pattern, then superimposing the smaller detail—for all of the remaining bark sketches. The dogwood had small circles as the major pattern; the beech was all smooth, so I showed the old healed wound, then simply added the little horizontal bumps and the shading. The American elm showed deep and wide vertical grooves with each end of the grooves pointed, so I drew these first. The sycamore is a smooth-barked tree, but the bark comes loose in both small and large flakes. This gives the sycamore its characteristic multi-toned appearance. In drawing the sycamore I drew in the pattern of the large dark sheets of bark, then added smaller lighter ones in between, being sure to leave some very light underbark showing. The white birch is one of the prettiest of the trees. Its chalky white bark has inverted Vs of black rough bark over each of the branch scars as well as small circumferential dark marks here and there. The black oak has many deep, parallel vertical furrows spaced closely together, while the sugar maple has very shallow parallel vertical furrows with random slanted furrows. Finally, the coconut palm bark is completely

White Pine

Dogwood

Beech

Figure 5-93
Drawing different kinds
of bark with the pen.

American Elm

Sycamore

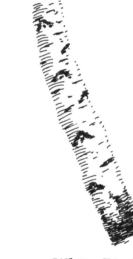

White Birch

Black Oak

Sugar Maple

Coconut Palm

White Pine

Dogwood

**Figure 5-94
Pencil drawing of
different kinds of bark.**

Beech

American Elm

Sycamore

White Birch

Black Oak

Sugar Maple

Coconut Palm

covered with horizontal scars from the branches that came off as the tree grew.

Initially you may find it difficult, but if you first study a thing to determine its structure, you will have a much easier time drawing it realistically and you will achieve much more gratifying results. As I have said before (and I am not alone) it isn't the *drawing* that's hard, but rather the *seeing* what to draw.

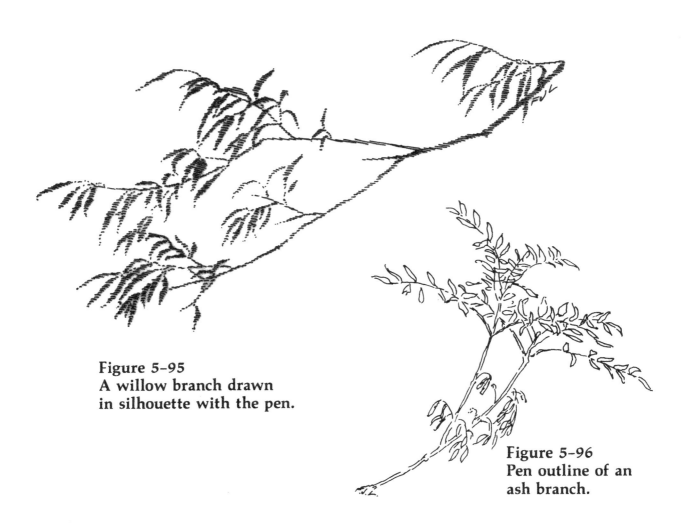

**Figure 5-95
A willow branch drawn
in silhouette with the pen.**

**Figure 5-96
Pen outline of an
ash branch.**

Decorative Tree Parts

When drawing tree branches as decorative vignettes, you can make it easy on yourself if you prop your subject up to draw it. First draw the main branch; then take each secondary branch and its leaves one at a time and make your careful pencil composition. Or—which is really fun—simply draw it with no preliminary composition. For small vignettes, silhouette and outline both work very well. The silhouette approach to a willow branch is shown in figure 5-95, and the outline approach to an ash branch in figure 5-96. You should use your finest point for this kind of sketching. For these illustrations, I used a 3×0 technical pen point on tracing vellum placed directly over my pencil compositions.

6
Animals

Basic Animal Structure

Animal anatomy is quite variable. Animals come with long, thin bodies (weasels, dachshunds), short thick bodies (porcupines, pigs) and every variation in between. While most cats have roughly the same shape and proportions, dogs have varied shapes. The subject of animal anatomy and how to draw almost any animal is admirably treated in Jack Hamm's book, *How to Draw Animals* (see bibliography). However, if you don't wish to make as serious a study of the subject as wildlife illustrators do, a very few basic principles will allow you to achieve reasonably realistic drawings.

Consider a nonspecific animal, maybe a mongrel dog. No particular animal, just one that is not too extreme in any of its proportions. The body of such an animal can be approximated in the side view by a rectangle with proportions of two to one; two squares accomplish this, as in figure 6–1A. Add a short neck line and a head box, then mark off the top outside corners of the two square body boxes by connecting the midpoints of two adjacent sides of each square with a line, as I did in figure 6–1A (see arrows).

The front leg-line of your animal will connect where this corner line meets the front side of the rectangular body box. The back leg line will connect just above this junction in the rear square. Each leg is made up of four sections—three leg bones and the toe bones. For the rear legs these are shown as A, B, C, and D while the front leg bones are shown as 1, 2, 3, and 4. Hind leg bone A will always slant downward and forward, except when the animal is sitting up, as shown in figure 6–1G. Bone 1 in the foreleg will always slant downward and backward except, again, when the animal is sitting up (fig. 6–1G).

Notice in sketches 1B, 1C, 1D, and 1G how rear leg bones A, B, and C fold up when an animal lowers its rear end to sit or lie. Also note in sketch 1D, the lying dog, that sometimes the front legs are straight out and sometimes they are folded.

There are only these four main sections of each leg to be concerned about for casual drawing. Obviously, there is much more to animal structure that this—but I am simplifying to the most basic, elementary level here to show you how easy it is to make credible beginning sketches. For even more realism you should refer to the Jack Hamm book, *How to Draw Animals*.

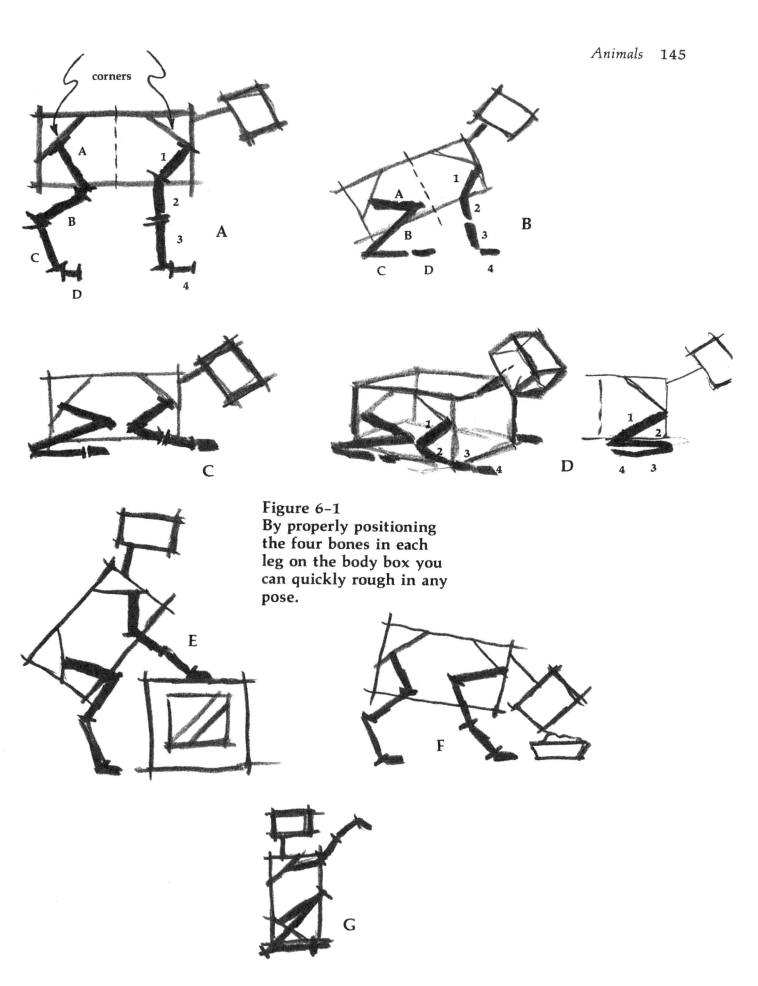

corners

A

B

C

D

1

2

3

4

Figure 6–1
By properly positioning
the four bones in each
leg on the body box you
can quickly rough in any
pose.

E

F

G

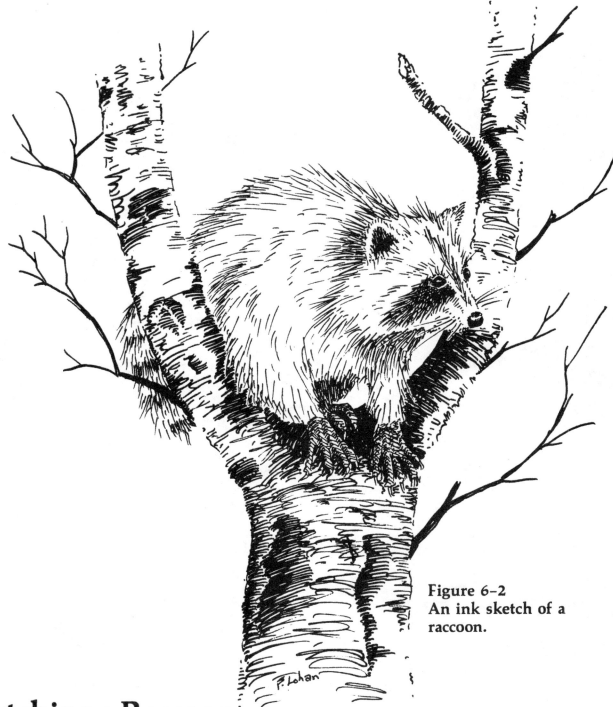

Figure 6–2
An ink sketch of a
raccoon.

Sketching a Raccoon

Raccoons are familiar to most people who live in the suburbs. They are bold enough to raid garbage cans even when the can is in your garage. They are very good climbers and are frequently chased up trees by dogs. Figure 6–2 is a pen sketch of a raccoon up in the broad fork of a tree. I used a fine point for this sketch, my 3×0 technical pen point.

This sketch has reasonably accurate proportions, even though it was invented for purposes of this book and not drawn from life or a

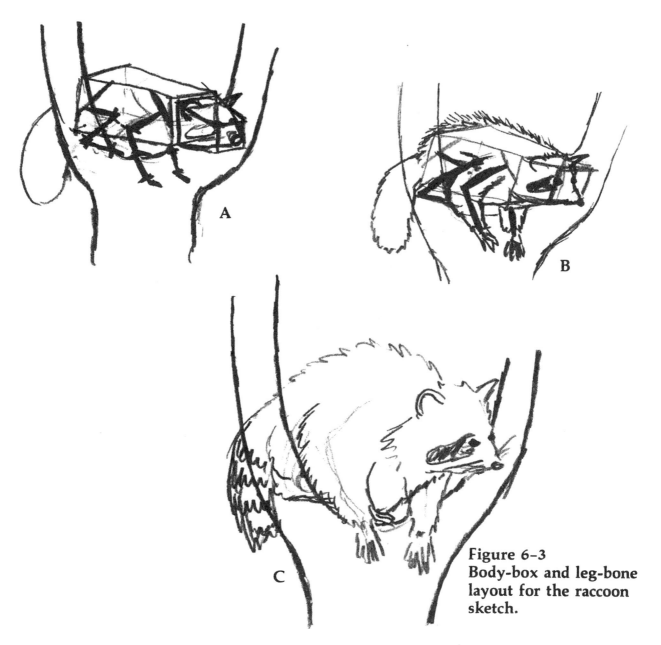

**Figure 6–3
Body-box and leg-bone
layout for the raccoon
sketch.**

photograph. It is not difficult to obtain *reasonably* lifelike poses and proportions if you take just a few preliminary minutes to properly rough in the basic structure of the animal before starting on the fur.

My preliminary drawings for the raccoon sketch are shown in figure 6–3. The basic figure is a body box made up of two cubes with a head box drawn on the front and with the leg bones attached as shown in 3A.

Around this box and stick representation of the legs I roughed in the fur, flesh, ears, eyes, and nose as shown in 3B. I compared my outline sketch with photographs, other drawings, and good paintings of raccoons. When I felt my proportions were correct, I transferred the rough outline to my final paper *lightly* in pencil, about as it appears in 3C (see Chapter 2 for ways to transfer the drawing).

Next I started the ink work. Generally I will ink the animal first. This way I can tell where I want dark and where I want light in the setting that surrounds the animal. Even if you are working from a photograph you should not use more than just the composition. The photograph is just a jumping-off place. You, as an artist, must choose the darks, lights, and patterns that bring emphasis where you want it and that avoid tonal conflicts that could make your sketch vague.

All this is learned by experience, but while you are experimenting you at least can avoid some gross distortions in proportions by faithfully using a preliminary body box, head box, and legbone construction for every animal sketched.

Drawing Animals with Similar Shapes

The raccoon, the opossum, and the woodchuck all have a somewhat similar shape. The primary visible differences are in the tail and in the shape and size of the head. Figure 6-4 shows you how the same composition can be used to draw such different animals. Figure 6-4A shows my basic three-quarter view and 6-4B my basic side view. The raccoon in 4C and 4D is recognized as such because of the face shape, the "mask," and the bushy ringed tail. The opossum in 4E and 4F is recognized by his thin, bare tail, pointed face, and light nose. The eyes also are a little smaller than a raccoon's and the ears are rounder.

The woodchuck has a shorter, stubbier face than either the raccoon or the opossum, and its tail is short and furry. Working these features into the basic block drawing changes the animal into a woodchuck.

I took the same pose as the raccoon in the ink drawing (figure 6-2) and, applying the principles just reviewed about head and tail size and shape, converted it to an opossum in figure 6-5 and woodchuck in figure 6-6. For each of these drawings I used a fine pen, my 3×0 technical pen. Naturally, I did not put the woodchuck up in the tree.

The raccoon and the opossum both have rather long hair, so I used longer lines to represent their fur than I did for the woodchuck. Things like fur length, ear and eye size, and nose size and color, as well as how close to the toes the fur extends, must be noted from life or from your reference material before you start to finalize your drawings.

Figure 6-4
Some animals have approximately the same body proportions. The shape of the head and tail tell the story.

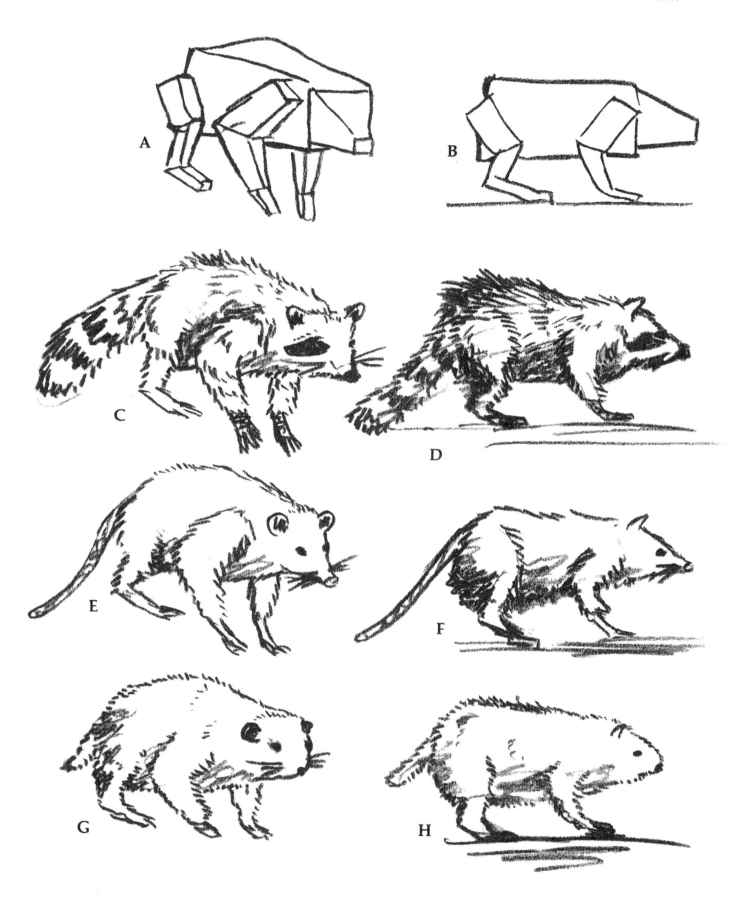

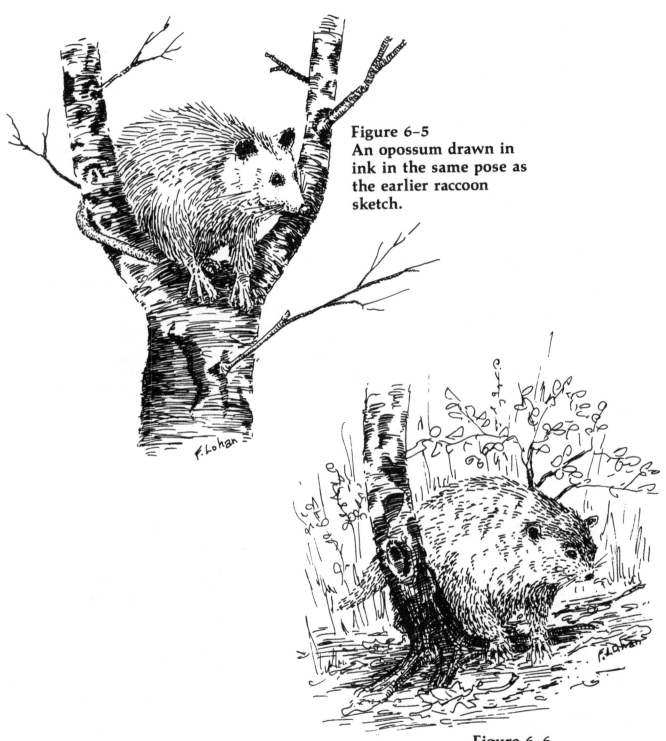

Figure 6-5
An opossum drawn in
ink in the same pose as
the earlier raccoon
sketch.

Figure 6-6
A woodchuck drawn in
ink from the same layout
sketch.

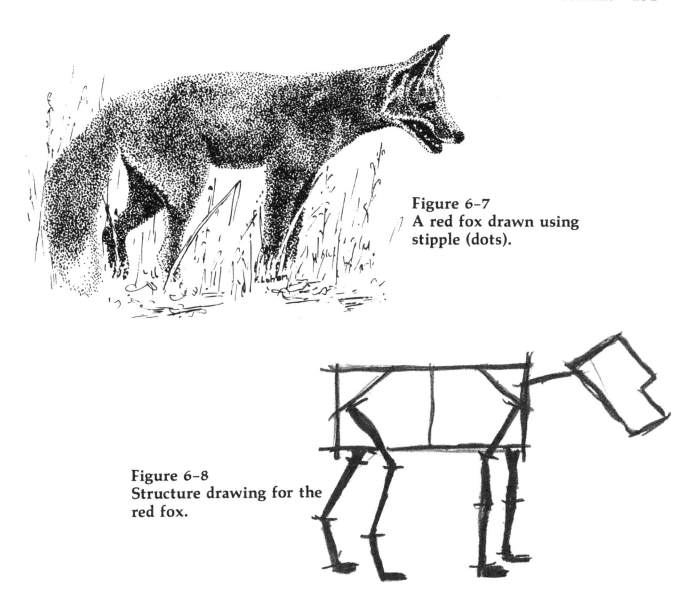

Figure 6–7
A red fox drawn using stipple (dots).

Figure 6–8
Structure drawing for the red fox.

Fur

Fur frequently is drawn as shown in figures 6–2, 6–5, and 6–6, with short or long lines pointing in the direction that the hairs lie. This is not the only way to draw furred animals, however. You can draw just tone and allow the viewer's imagination and knowledge to supply the fact that the animal is furry. Such an ink sketch of a red fox is shown in figure 6–7. For this sketch I used stipple (dots) to create roundness by tonal differences.

The structure sketch for the fox is shown in figure 6–8, and the outline superimposed on this structure in figure 6–9. You can very lightly sketch the structure on your final paper, or sketch it on another piece of paper and transfer it to the final paper. I prefer the latter method because I usually make some trial and error lines before I have what satisfies me. I do not like to roughen up my final paper with much erasing before I ink

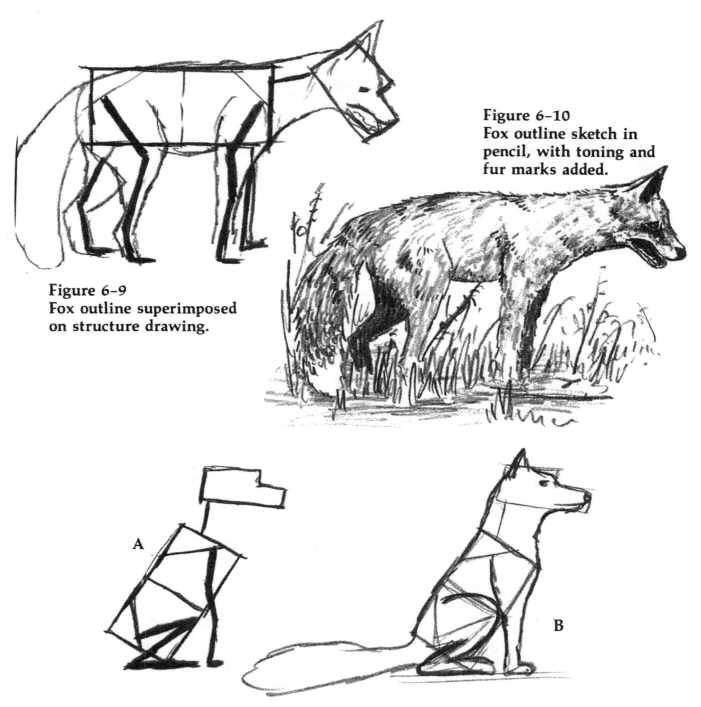

**Figure 6-9
Fox outline superimposed
on structure drawing.**

**Figure 6-10
Fox outline sketch in
pencil, with toning and
fur marks added.**

A

B

it, since this can cause unwanted feathering of an ink line. Also, if I am doing the sketch in pencil, erased areas often make the pencil line darker than in unerased areas.

Figure 6-10 shows a pencil version of the ink-stippled fox in figure 6-7. This is essentially an outline sketch on which I used a 3B pencil. The

outline is broken with fur marks shown here and there and a little toning added with the broad point.

A sitting fox is drawn in figure 6-11. Sketch 11A shows the structure over which I drew the outline (11B), adjusted until things looked proper when compared with my reference material.

Drawing Cats

The same preliminary box construction holds regardless of the particular animal you want to draw. However, you will have to adjust the box proportions depending on the particular animal you choose to draw. This is where a lot of reference material comes in handy; it allows you to study your subject in different poses and to determine the basic body and leg proportions. Then a few trial and error constructions will show you how to properly proportion that particular animal.

Figure 6–12 shows the box construction and resulting sketch of a walking cat. Notice that the legs on opposite corners of the cat work together. The right front and left rear legs are supporting the cat's body, while the other two legs are ready to come forward for the next stride. However, this cat looks too short and stubby.

In figure 6–13 I added about half a square to the cat's body length, then drew the outline over it. This looks better, more in proportion to cats I have known. These few minutes of structure sketching and adjusting gave me the proportions I will use in any further cat sketches: I will always

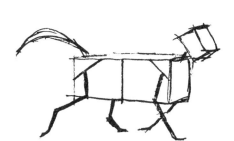 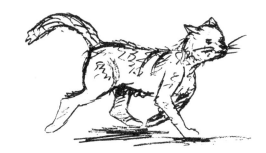

Figure 6–12
Cat body is too short.

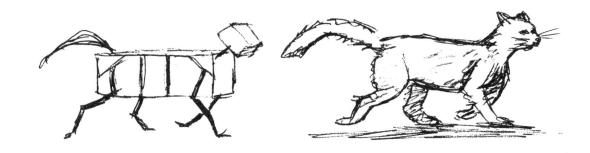

Figure 6–13
Box structure adjusted to
provide longer body.

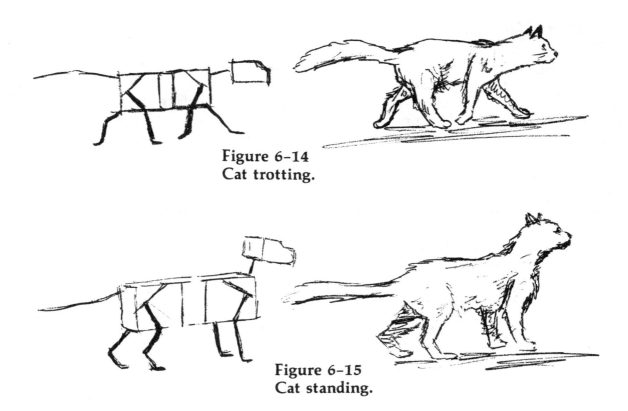

**Figure 6-14
Cat trotting.**

**Figure 6-15
Cat standing.**

add an additional half box to the body in the construction drawing. I generally do this type of construction sketching on tracing paper. I do the box construction, then put tracing paper over it and sketch the outline figure. I might try two or three quick outline sketches before I adjust the box figure a little to get it looking just right.

Figure 6-14 shows a cat trotting. This differs from figure 6-13 in that the head is stretched forward more and the tail is not carried as high.

The standing cat in figure 6-15 carries the head higher than that in figure 6-14 and the playful cat in figure 6-16 carries its head back over its shoulders. You can see how the attitude of the head is shown in each of the box construction drawings.

When you make these quick

construction sketches, be sure to follow through and sketch the fur outline over the construction. You really can't tell if things are right until you do this. The box construction just gives you some easy guidelines for getting the outline and proportions correct in seconds, and eliminates time-consuming trial and error.

In figure 6-17 I show a cat lying on its side and the box construction that the sketch was based on. Observe in a case like this that the hip and shoulder areas stick up above the soft middle, which sags because the cat is lying down.

Figure 6-18 shows a cat lying on its back, playing. Regardless of the pose, the construction sketch is essential in getting the action and proportions correct.

Figure 6–16
Cat playing.

Figure 6–17
Cat lying down.

Figure 6–18
Cat lying on back.

Sketching a Chipmunk

The next subject is a small, striped chipmunk I drew from a photograph. The body box made of two squares still serves perfectly well for the body and leg framework. This construction is shown in figure 6-19. This chipmunk was halfway between standing and sitting up, so I indicated the arched back with a dashed line in the construction sketch.

Figure 6-20 shows how I drew the outline of the animal around the construction lines. Either draw the construction sketch very lightly on your final paper, or draw it heavy and black on your preliminary paper so you can see through your final paper. Otherwise transfer just the outline of the construction sketch to your working paper.

A quick pencil value sketch is shown in figure 6-21. This indicates where I want darks, lights, and medium tones in any final sketch I do from this pose.

Figure 6-22 shows a pencil study of the chipmunk. I used only an HB pencil for this study, and lightened the head a little by pressing a kneaded eraser on the final work.

A pen study of the same subject is shown in figure 6-23. This is a somewhat coarse treatment with a medium pen, using small dash lines to show the direction of the fur in the toned areas.

A charcoal pencil was used to do the sketch in figure 6-24. A pen was then used to apply the outline fur marks and other fine detail, as you can see in figure 6-25.

In figure 6-26 I drew a simple outline study of the chipmunk with my artist's fountain pen, which has a medium point.

**Figure 6-19
Construction drawing for
a sitting chipmunk.**

**Figure 6-20
Outline of chipmunk
superimposed on
construction drawing.**

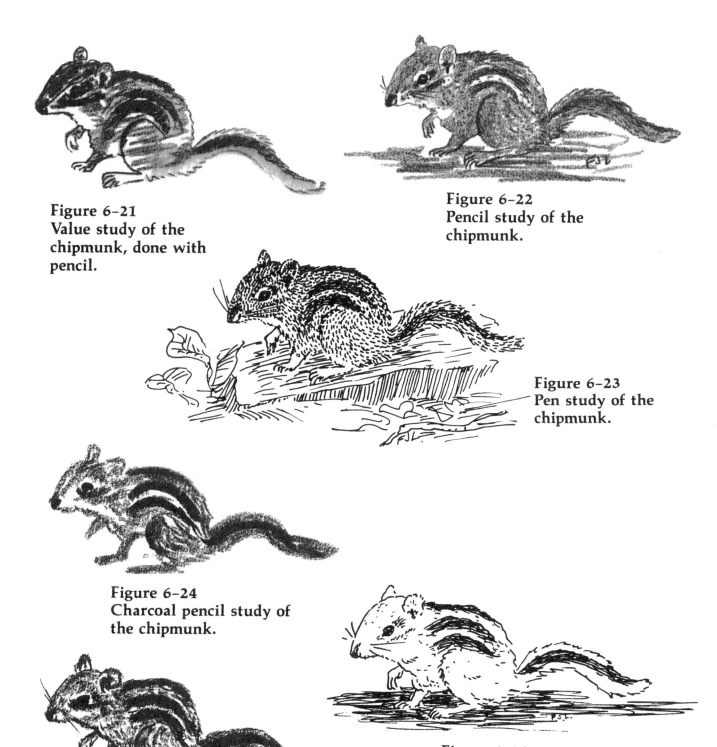

Figure 6–21
Value study of the
chipmunk, done with
pencil.

Figure 6–22
Pencil study of the
chipmunk.

Figure 6–23
Pen study of the
chipmunk.

Figure 6–24
Charcoal pencil study of
the chipmunk.

Figure 6–26
Pen outline study of the
chipmunk.

Figure 6–25
Pen details added to
charcoal pencil study of
the chipmunk.

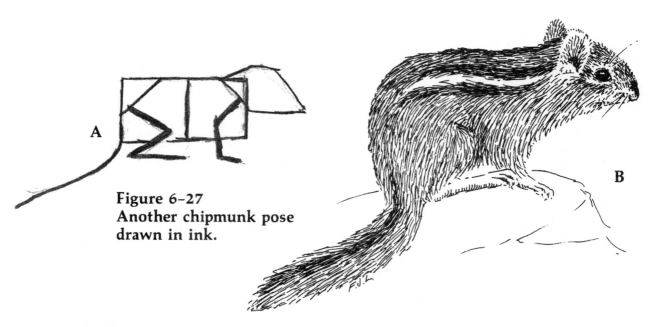

**Figure 6–27
Another chipmunk pose
drawn in ink.**

Larger-Scale Chipmunk Sketches

In figure 6–27 I made a larger drawing of a standing chipmunk. I used the same toning technique as in figure 6–23—short, hairlike lines in the direction of the fur. I just piled more of them on top to get the darker areas and left lines out where I wanted lighter tones.

Figure 6–28 is my construction sketch for a larger-than-life ink drawing of a chipmunk's head. When doing a head sketch like this, there are few hard-and-fast working rules to guide you. You will have to study your reference photographs, drawings, and paintings and figure out for yourself just what geometry will assist you in making your sketch. In this case a square was the basis for the head, with the upper right corner lopped off to give the forehead line. I drew three diverging lines from the nose to help me locate the eye and the nearest ear. I noted from my photograph that the eye was approximately halfway between the edge of the ear and the tip of the nose. You have to study your subject matter and make observations such as

this to get your working drawings accurate and lifelike.

The three steps in completing the pen sketch of the chipmunk's head are shown in figures 6–29, 6–30, and 6–31. First I used hairlike dashes to show the outline and the ears, and started the eye as you see in figure 6–29. Then I used short dashes to put a uniform tone all over the head, except in the light areas above and below the eye, around the nose, under the chin, and on the throat. When this uniform tone was completed I began to develop the darker patterns by laying hair lines on top of the lines used for the uniform tone. This can be seen in figure 6–30. This figure also shows how I completed the eye by laying more radial lines on top of those used to start the eye.

The completed portrait of a chipmunk is shown in figure 6–31. When I had the dark patterns the way I wanted them, I grayed some of the medium light areas on the side of the nose and the ears by using dots (stippling). Then I added the whiskers. This sketch was done with my 3×0 technical pen.

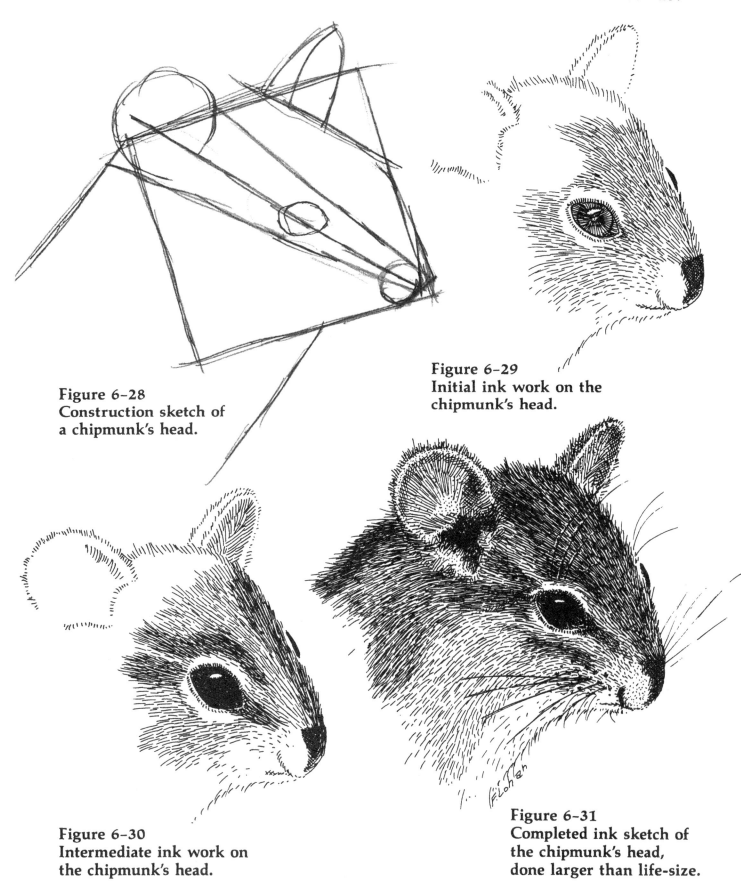

Figure 6-28
Construction sketch of
a chipmunk's head.

Figure 6-29
Initial ink work on the
chipmunk's head.

Figure 6-30
Intermediate ink work on
the chipmunk's head.

Figure 6-31
Completed ink sketch of
the chipmunk's head,
done larger than life-size.

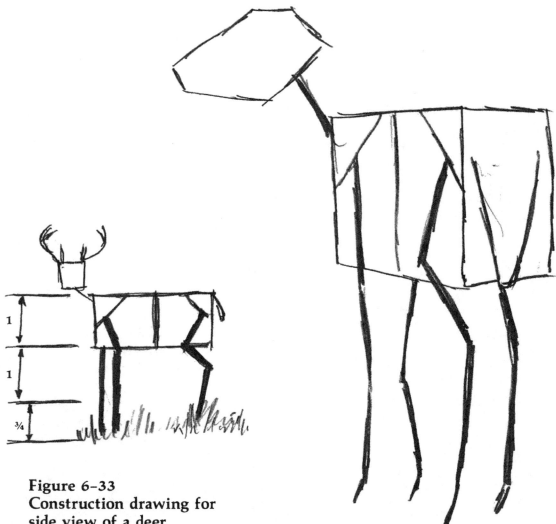

Figure 6–33
Construction drawing for
side view of a deer.

Figure 6–32
Construction drawing for
a deer sketch.

Sketching Deer

Figures 6–32 and 6–33 show the construction diagrams for two deer poses. Actually these are the same pose but from two different viewpoints.

My study of some deer photographs showed that, in general, a deer's legs are about one and three quarters times the dimension from the back to the chest. This is indicated in figure 6–33, the side view. I used these proportions in sketching both construction diagrams.

The outlines I sketched around each construction drawing are shown in figures 6–34A and 34B. These outlines were used to make the pencil tone sketches in figures 6–35A and 35B. I often make such quick tone sketches to double-check shapes and proportions before I begin the final work.

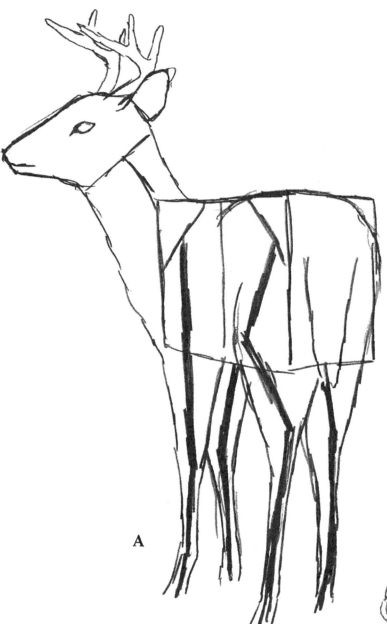

A

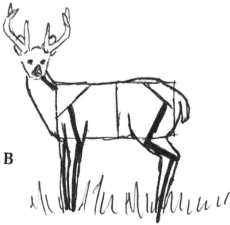

Figure 6–34
Outline added to both
deer construction
drawings.

B

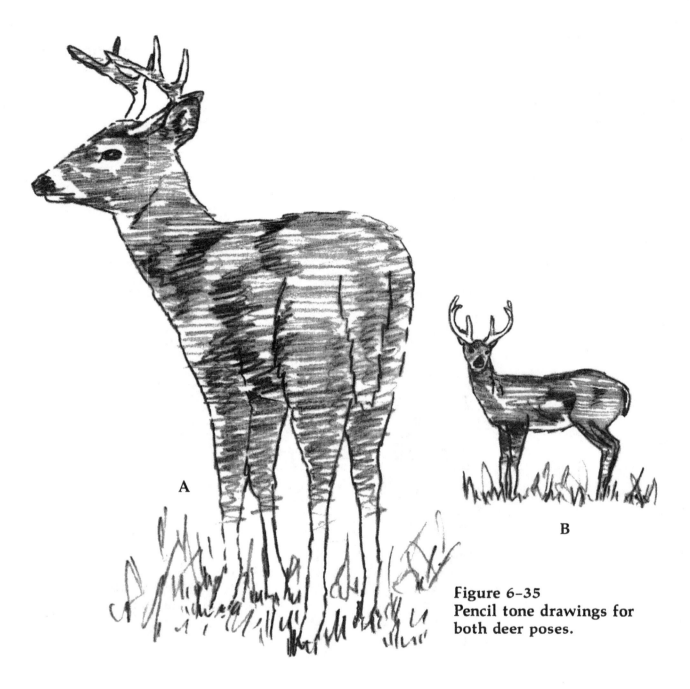

A

B

**Figure 6-35
Pencil tone drawings for
both deer poses.**

Figure 6-36 shows the smaller sketch completed in ink using a simple outline, with stippling (dots) for the tone. Since it was such a small sketch, I used my 3×0 technical pen point to get the finest lines and dots.

Figure 6-37 shows the initial ink work on the larger deer sketch. I used a broken line for the outline, although a fur-type mark would have done as well. At this stage I indicated, with horizontal dash marks, where the dark areas on the fur would be. Then,

as shown in figure 6-38, I used short fur dashes to tone the entire animal, being careful to leave the white patterns on the face, throat, and tail untoned.

The final step was to bring out the shading by toning over these dashes with others, in the same direction as the original ones. This was done to show form and roundness. The completed drawing is shown in figure 6-39.

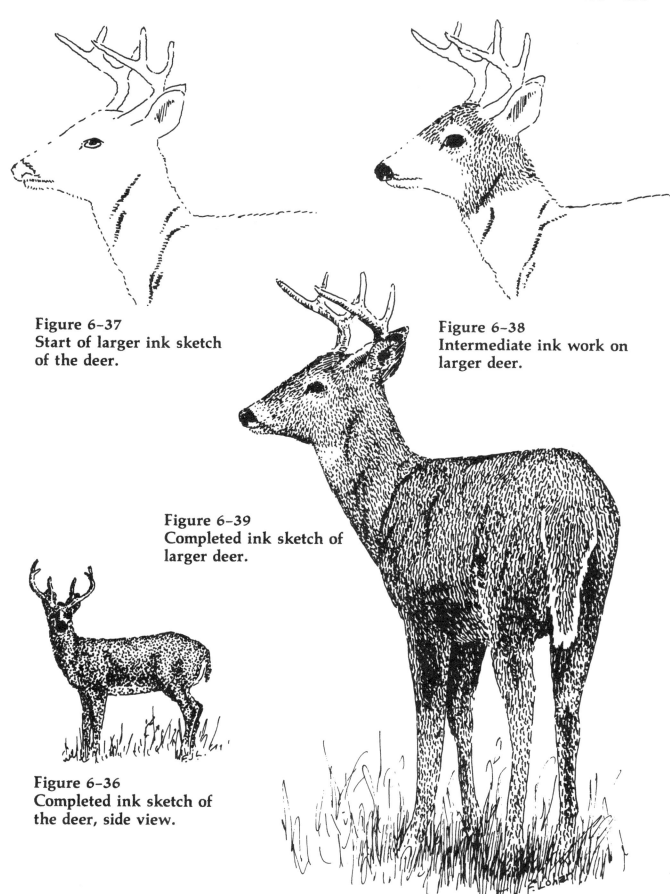

Figure 6-37
Start of larger ink sketch
of the deer.

Figure 6-38
Intermediate ink work on
larger deer.

Figure 6-39
Completed ink sketch of
larger deer.

Figure 6-36
Completed ink sketch of
the deer, side view.

**Figure 6–40
Structure sketch for
the black bear.**

**Figure 6–41
Outline formed around
the structure sketch.**

Sketching Bears

A bear's body is very heavy and its head is usually carried lower than its shoulders. These are the key observations necessary to rough in a structure sketch of a generalized bear as shown in figure 6–40. Each species of bear has characteristic body and facial differences that you must observe in your reference material in order to make your bear drawing specific.

Black Bear

In figure 6–41 I sketched the outline of a black bear around the structure sketch. Then in figure 6–42 I made a tone and shading study with an HB pencil as a guide for my pen studies.

A pen study of the black bear is shown in figure 6–43. Short fur-type marks were used to create the shading, were and horizontal lines were used to show the shadow on the ground. (Refer to figure 5–12 in Chapter 5 to see how to indicate shadows on horizontal and on vertical surfaces.) Notice in figure 6–43 that a

very minimum outline was used—the little fur marks carried most of the outlining that was necessary.

A different pen study is shown in figure 6–44. Here I abstracted the drawing to just three tones: white, black, and one intermediate gray. I made no attempt to show fur as such in this sketch. This kind of simplification and partial abstraction is a good technique for poster work where you just want the barest essence of the subject displayed.

A conventionally toned pencil study of the black bear is seen in figure 6–45. This was done on very toothy vellum with an HB pencil. After the toning, I used a sharp point to put in a few hair marks.

Pencil on coquille paper was used for figure 6–46. I reversed the image of the bear for this illustration. You have to use a broad-point pencil for drawings on coquille paper to retain the texture created by the raised bumps on the paper.

Figure 6-42
Tone and shading study
done quickly in pencil.

Figure 6-43
Fine-point ink study of
the black bear.

Figure 6-44
Medium-point, three-
tone ink study of the
black bear.

Figure 6-46
Pencil study on coquille
paper.

Figure 6-45
Pencil study of the black
bear.

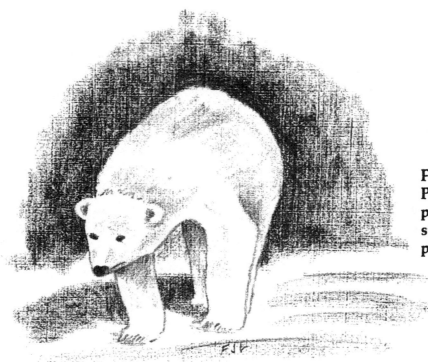

**Figure 6-47
Pencil study on linen
paper of the same bear
structure converted to a
polar bear.**

Polar Bear

A polar bear, as shown in figure 6–47, differs from a black bear in more than color. Its face is more pointed, its ears are round rather than triangular and are on the side of its head, and its hindquarters are higher than its shoulders. With the black bear, shoulders and hindquarters are almost on the same level. I worked these differences into my outline sketch over the reversed structure of figure 6–40 to produce the pencil polar bear drawing in figure 6–47. This was done with a 4B broad-point pencil on linen paper; then the edges were sharpened up with a sharp 3B pencil.

Drawing Dogs

Your use of reference photographs, your powers of observation, and your patience in working out preliminary construction sketches for both body and face are the keys to making reasonably realistic-looking dog sketches.

I have used a golden retriever as the primary example here for drawing dogs. Figure 6–48 shows my first structure sketch. When I roughed in the outline over this structure (using a piece of tracing paper directly over the structure sketch) I saw immediately that the two squares for the body were too short. So I quickly made another structure sketch with about one-third of a square added, as you see in figure 6–49. The outline then looked correct, so I proceeded to complete the tone study shown in figure 6–50.

Figure 6–48
First structure sketch for golden retriever.

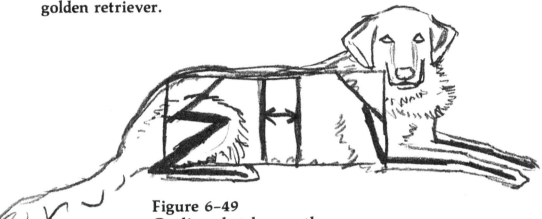

Figure 6–49
Outline sketch over the adjusted structure sketch.

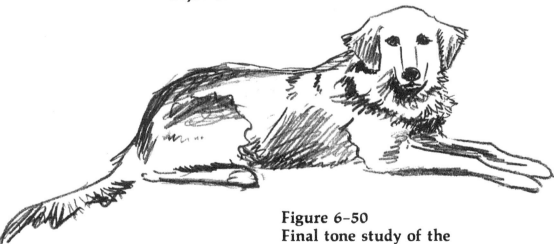

Figure 6–50
Final tone study of the golden retriever.

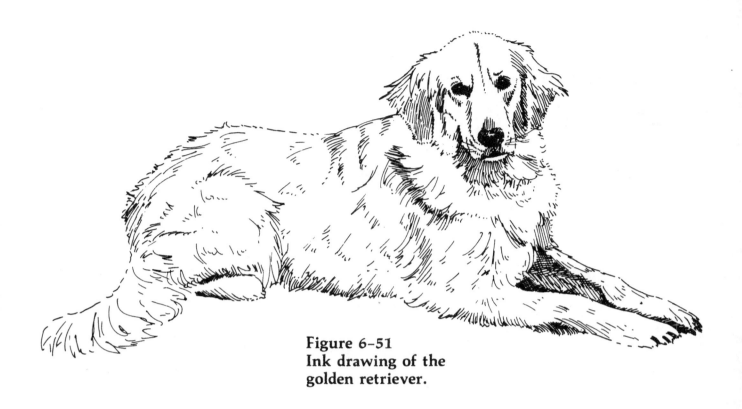

Figure 6-51
Ink drawing of the
golden retriever.

I made a larger outline sketch over a lightly drawn, larger structure diagram, and referred to the tone study to complete the ink drawing of the golden retriever that you see in figure 6-51. I worked from a good, clear photograph of a retriever in a similar pose to draw the details of the face and the layered areas of the fur. I used my fine 3×0 technical pen point for this drawing. I started with the most difficult part—the eyes, nose, and the face—since, if the face did not look right, I would waste the least amount of time by discarding the drawing and starting over. It's not a good idea to do the easiest part of a drawing first—if you then get into trouble on a harder part, you can waste a lot of time if you must start over.

Figure 6-52 shows the structure diagram for a dog in a similar pose, but with his hind quarters lying on one side. See how the structure boxes are twisted in such a pose. Figure 6-53 is a small pen sketch based on this variation of the golden retriever pose.

I used an HB pencil on toothy vellum for the pencil study of the retriever's head in figure 6-54. After the dog's head was finished I took a 3B pencil and darkened the background to emphasize the light color of the dog.

Each breed of dog has a unique head shape and facial features. You

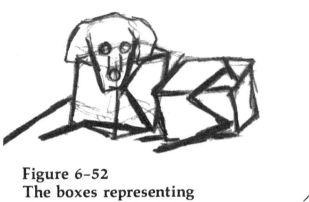

Figure 6-52
The boxes representing
the structure of a lying
dog are often twisted.

Figure 6-53
The lying golden
retriever.

Figure 6-54
Pencil study of the golden
retriever's head.

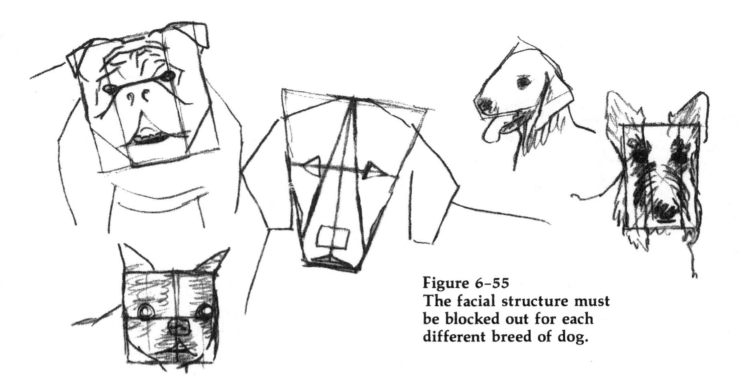

**Figure 6-55
The facial structure must
be blocked out for each
different breed of dog.**

will have to look at a lot of photographs of dogs in different poses to determine if the one you want to draw has a square face, a triangular face, or a rectangular face. See if the eyes are basically triangular (as they are on the retriever) or round as on a Boston terrier, or more almond-shaped. Make quick little structure diagrams of the head and face, as in figure 6-55, to see just how the nose and eyes are related and how the mouth properly fits in.

The size of your sketch is important. You cannot get as much fine detail into a tiny 2″ × 2″ sketch, figure 6-53, as you can in a 5″ × 10″ sketch, figure 6-51 (although reduced a little for layout purposes in this book, that was the original size of this drawing).

Patience, careful observation, and numerous small, quick pencil structure sketches will pay off for you in realistic drawings of all things in nature, not just dogs.

7
Flowers

The Structure Problem

Some flowers are simple in shape and others have a more complex geometric structure. A little attention to structure goes a long way in preparing a basic flower study for realistic sketching.

Figure 7–1 shows a simple cattail—basically just a cylinder on a stalk. Line work and shading that says "cylinder" does a good job of indicating the shape of this plant.

The grass-seed head of figure 7–2, however, has a more complicated structure that requires a blueprint before it can be effectively sketched. Figure 7–3 shows the blueprint I created for the grass-seed sprig. Before I could begin drawing in the individual elements, I had to observe how the little shoots holding the seeds were arranged—which was in a flat disk at the lower part and in inverted cones as the groups approached the tip.

Similar analysis and understanding is necessary with all flower forms before you can make a realistic drawing. There are two aspects to a realistic drawing: first comes the composition, which must contain a realistic positioning of the parts of the subject. Second comes the technique used to turn that composition into a finished work. If the composition—and hence the structure—is correct, any technique may then be used to complete the work. It may be completed in abstract with just the barest essentials of structure shown, or it may be done representationally. It may be done in pen, pencil, brush, or whatever. The technique is logically secondary to the structure/composition.

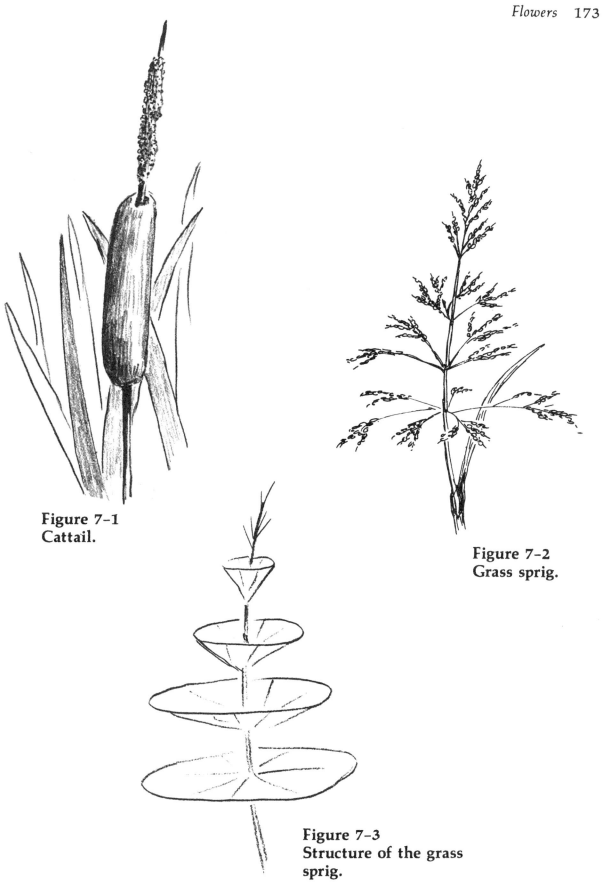

**Figure 7–1
Cattail.**

**Figure 7–2
Grass sprig.**

**Figure 7–3
Structure of the grass
sprig.**

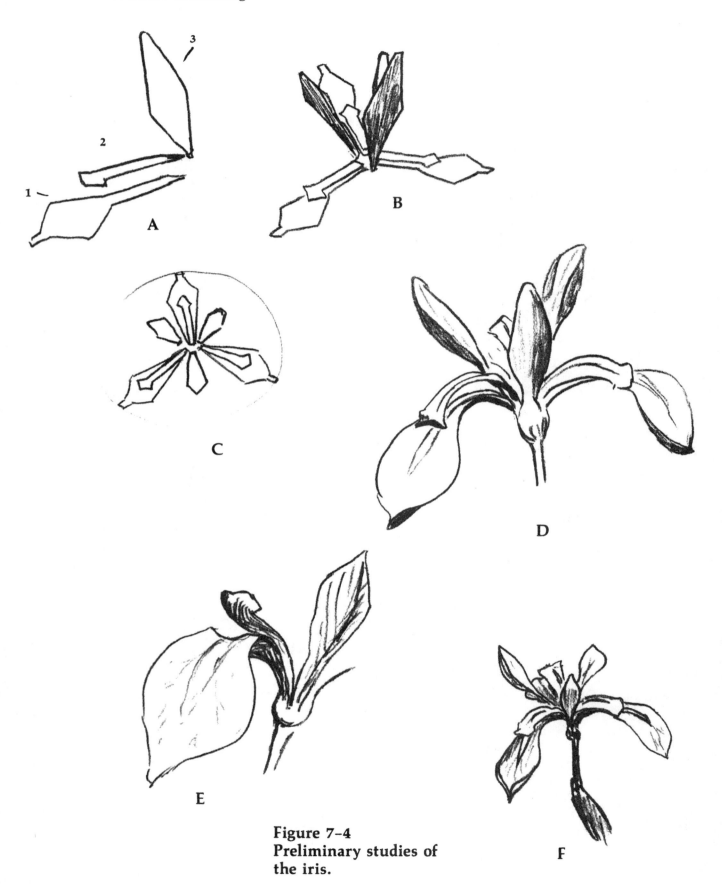

Figure 7-4
Preliminary studies of
the iris.

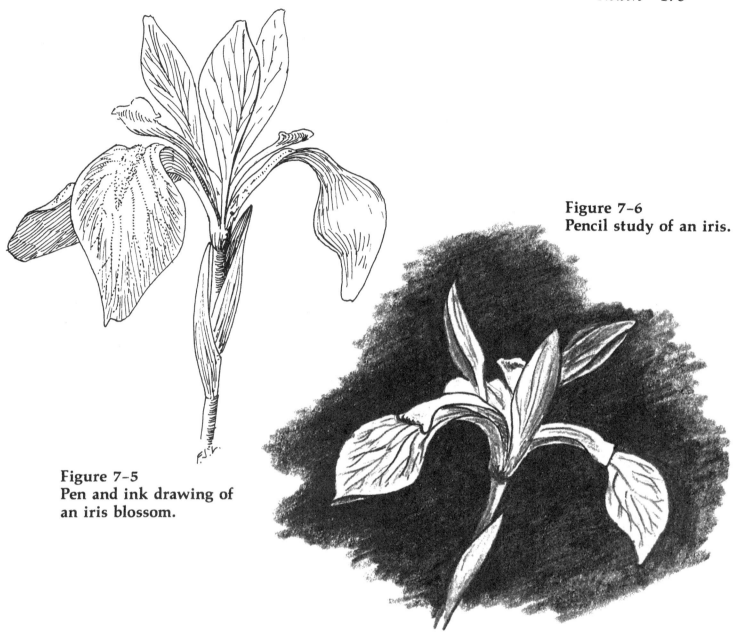

Figure 7-6
Pencil study of an iris.

Figure 7-5
Pen and ink drawing of
an iris blossom.

Sketching an Iris Blossom

The iris blossom is somewhat
complicated. It consists of three
elements, each of which is composed
of three pieces. (I am speaking here,
obviously, of lay observations
describing a complicated subject—not
as a naturalist naming and describing
the stamens, petals, sepals, calyx,
anther, etc.) My studies of an iris
blossom, prior to proceeding with a
drawing, are shown in figure 7-4.
These were done from guidebooks
and about a dozen photographs, since
the snow lies about three inches deep
as I write this chapter and the real
thing is not at hand. Based on these
studies, I did the pen drawing in
figure 7-5 and the pencil study in
figure 7-6.

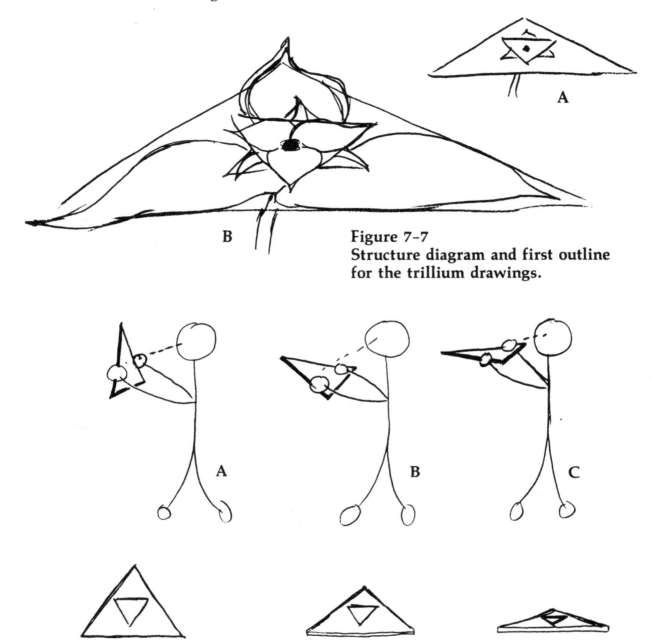

Figure 7-7
Structure diagram and first outline for the trillium drawings.

Figure 7-8
Foreshortening of the structure diagram of a trillium blossom and leaves.

Sketching a Trillium

The trillium is a white early spring wildflower found in the eastern half of the United States. It is easily recognized by its three leaves, three sepals, and three waxy white petals. The entire structure is that of three triangles, as shown in figure 7-7A.

The composition drawing in figure 7-7B, showing the three triangles and the leaves, sepals, and petals roughed in, is foreshortened. The viewing angle is not directly straight on, as in figure 7-8A, but more like figure 7-8B with the triangle tipped *away*.

**Figure 7–9
Ink sketch of the
trillium.**

**Figure 7–10
Completed pencil sketch
of the trillium.**

The base of the triangle remains the same length in this foreshortened view but the other two sides become shorter as the triangle tips further and further away. You can see this progressive decrease in length in figures 7–8A, 8B, and 8C.

I made a full-size freehand sketch of the three triangles shown in figure 7–7A; then I placed the petals, sepals (the little green points showing between the petals), and the leaves on this framework. When I felt the proportions were correct I transferred the outline to my working paper. (See Chapter 2 for ways to transfer drawings.)

Figure 7–9 shows an ink sketch of the trillium using my 3×0 technical pen point. A pencil study from the same composition is shown in figure 7–10.

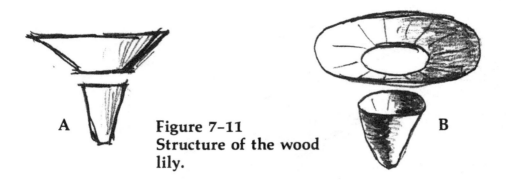

**Figure 7-11
Structure of the wood
lily.**

A

B

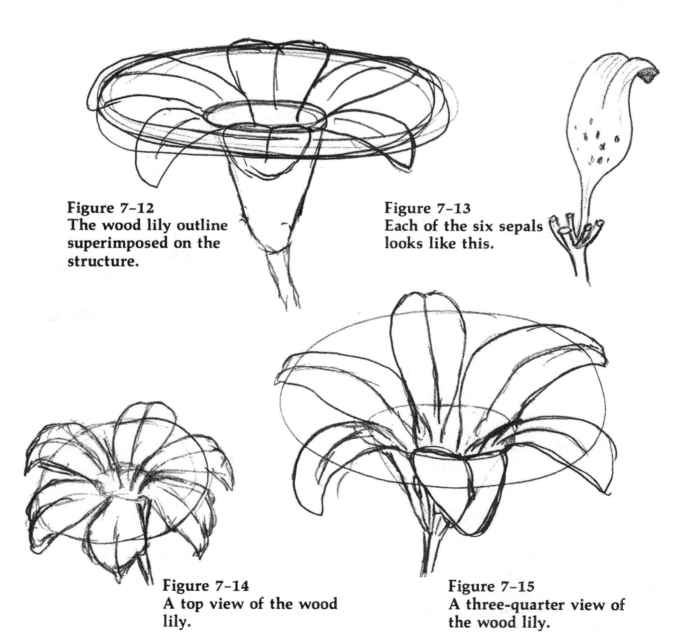

**Figure 7-12
The wood lily outline
superimposed on the
structure.**

**Figure 7-13
Each of the six sepals
looks like this.**

**Figure 7-14
A top view of the wood
lily.**

**Figure 7-15
A three-quarter view of
the wood lily.**

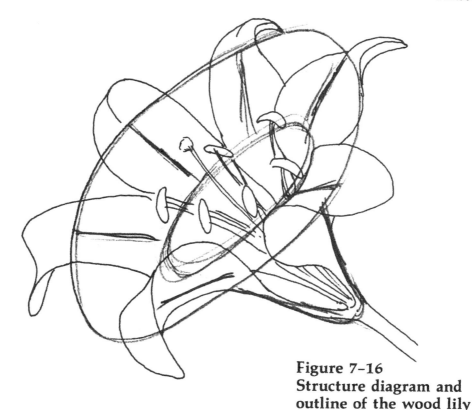

**Figure 7–16
Structure diagram and
outline of the wood lily
blossom.**

Drawing a Wood Lily

The structure of the beautifully colored wood lily can be visualized most simply as funnel-shaped (figure 7–11). There are two truncated cones involved in the funnel—a narrow one at the bottom and a wider, flatter one at the top. The top cone is where the sepals fan out (they are colored and look like petals).

In figures 7–12, 7–14, and 7–15 I used the funnel-type diagram to prepare outline sketches of this flower from slightly different angles. Figure 7–13 shows how each petal-like sepal is constructed.

Figure 7–16 shows my outline drawings, in ink, of the wood lily blossom over a quick pencil structure sketch. The stamens and large, dark pollen-carrying anthers are prominent and the shape toward the base of each sepal is properly shown. I had several different photographs of the wood lily

to guide me in this simple composition.

My pen sketch of the blossom is shown in figure 7–17. The anthers are dark, as are the spots on the inside of the blossom toward the base of each sepal. For this sketch I used a size 1×0 technical pen point for the outline and a 3×0 point (finer than the 1×0) for texturing the blossom.

The leaves on this plant are in whorls around the stem—as if a disk carrying the leaves was pierced in the middle by the stem. This structure is shown in figure 7–18 and the resulting pen drawing in figure 7–19. In doing accurate drawings of natural items such as this lily, you must pay attention to details—such as the existence of *six* sepals and *six* anther-carrying stamens on the blossom, but just *five* leaflets in each whorl.

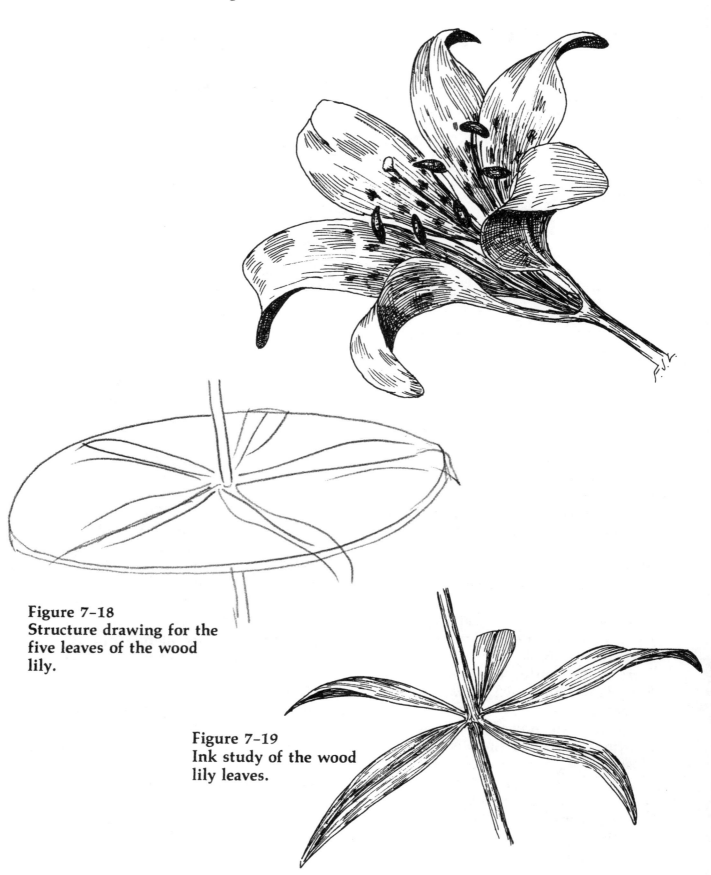

**Figure 7–18
Structure drawing for the
five leaves of the wood
lily.**

**Figure 7–19
Ink study of the wood
lily leaves.**

Sketching a Jack-in-the-pulpit

The jack-in-the-pulpit, a spring wildflower, has an interesting shape— it is a combination of an open cylinder and a flap that acts as a hood. The structure simplifies to that shown in figure 7-20. Using this as a guide, I made an outline drawing in ink with my 1×0 technical pen point; then, in pencil, I lightly drew all the vertical stripes and other designs inside the hood. Using these pencil lines as guides, I used my fine 3×0 technical pen point to cross-hatch the dark patterns, leaving the light lines and areas completely uninked. The last thing I did was to hatch over these white areas to tone them down. The leaves were finished using hatching all in the same direction. To get a darker tone, I simply piled up more hatch lines. The completed sketch is shown in figure 7-21.

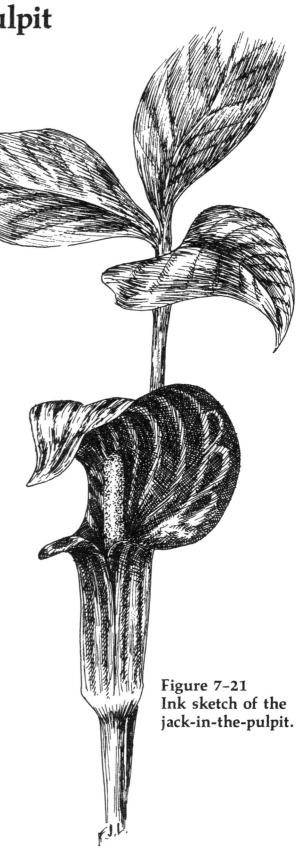

**Figure 7-21
Ink sketch of the
jack-in-the-pulpit.**

**Figure 7-20
Structure of the jack-in-the-pulpit.**

I used the same composition and structure to do the pencil sketch shown in figure 7–22. This was done with an HB and a 6B pencil on linen paper. As with the previous pen version, I proceeded with the darkest marks first with the broad-point 6B pencil; then I went over the light areas with my HB pencil, also broad-point. Finally I used a sharp HB point to trim up the outline and the dark marks on the flower. The drawing just was not sharp enough before I did this trimming.

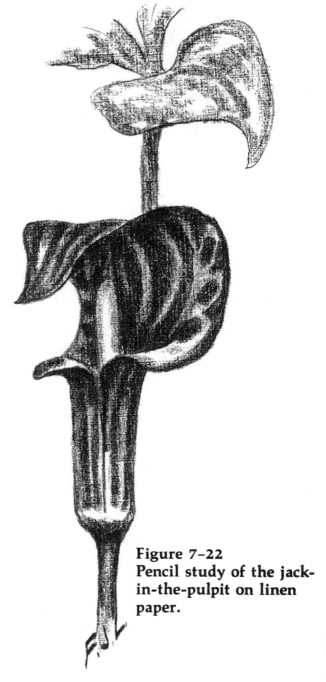

Figure 7–22 Pencil study of the jack-in-the-pulpit on linen paper.

Many-Petalled Flowers

Flowers with many petals, such as black-eyed Susans, asters, chicory, and others, may be drawn based on a structure diagram roughly like that of figure 7–23. You have to use more divisions for a purple coneflower or a chickory blossom and fewer, wider ones for a black-eyed Susan. These are details you have to determine from your study of the subject itself or of reference photographs. The same basic structure diagram holds for a number of different many-petalled blossoms, however.

A five-petalled flower such as the buttercup is still based on concentric circles; but the divisions are, for me, most easily made by quickly sketching a star within the circle as in figure 7–24. The star points locate the spaces between the petals.

A relatively flat many-petalled flower such as the purple coneflower may be easily drawn as shown in figures 7–25, 7–26, and 7–27. Figure 7–25 shows the structure disk and figure 7–26 shows the petals placed according to the structure disk. The finished pencil drawing is shown in figure 7–27. An HB sharp point was used for this sketch.

Figure 7-23
Head-on structure of a
many-petalled blossom
such as black-eyed Susan,
aster, chickory.

Figure 7-24
Head-on structure of a
five-petalled blossom
such as the buttercup.
The spaces can be located
by a quickly sketched
star.

Figure 7-25
Structure disk of figure
7-23 in perspective.

Figure 7-26
Petals drawn over the
structure sketch.

Figure 7-27
Pencil sketch of a purple
coneflower from the
structure of the previous
figure.

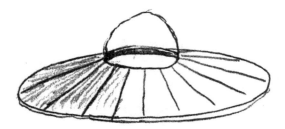

**Figure 7-28
Modified structure disk
for black-eyed Susan
blossom.**

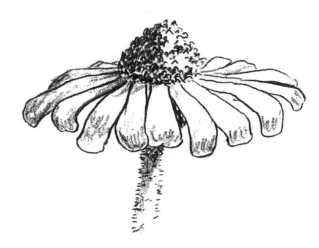

**Figure 7-29
Pencil sketch of black-
eyed Susan blossom.**

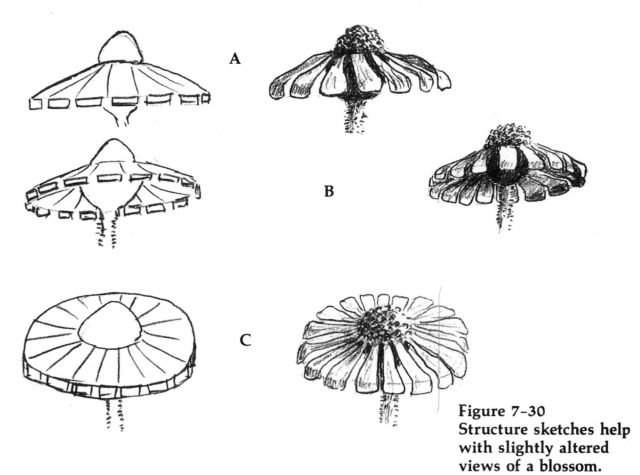

A

B

C

**Figure 7-30
Structure sketches help
with slightly altered
views of a blossom.**

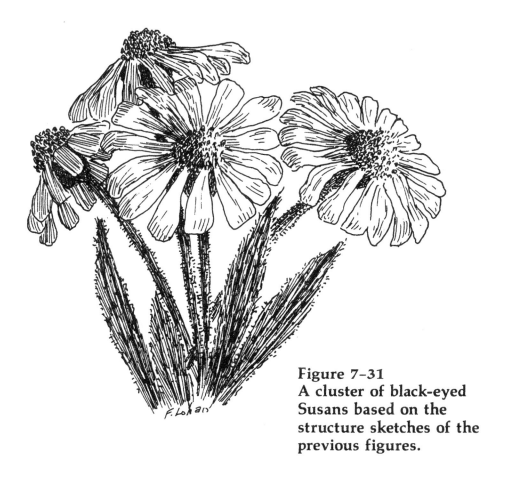

**Figure 7–31
A cluster of black-eyed
Susans based on the
structure sketches of the
previous figures.**

Figure 7–28 shows the structure sketch for black-eyed Susan. In this case the petals were not in a flat disk, but rather were sloping back in the form of a truncated cone. The resulting pencil sketch is shown in figure 7–29. When you try sketches such as this, make the petals vary a little so the sketch does not end up looking too much like a drawing of an artificial flower.

When drawing a grouping or bouquet of blossoms, they all must be shown at different angles. This is easily done if you rough each one in with its own slightly different structure diagram first. Such slight variations of position are shown in figure 7–30A, 30B, and 30C.

A pen drawing of a cluster of black-eyed Susans is shown in figure 7–31. The blossoms are based on the structure diagrams of figures 7–23 and 7–30. The blossoms are tipped to show more realistically how they would be positioned in a vase, but they are nothing more than the structures just described above. I pictured the light coming from the right, so I shaded the petals and entire blossoms accordingly. Note how you leave a highlight even on the dark centers of flowers when the light is striking them, as in the middle and right-hand blossoms in figure 7–31. The two blossoms on the shaded side are completely toned with no highlights.

Drawing a Buttercup

The buttercup is a common, butter-colored wildflower that frequently blooms well into autumn. It has five broad petals. The structure is basically that of figure 7–32A, with the star serving to divide the large circle into five equal parts to make placement of the petals easier. The head-on sketch of a blossom, based on this structure, is shown in figure 7–32B.

Figure 7–33A shows a three-quarter structure view of a similar buttercup blossom. The cup shape becomes apparent when the blossom is tilted somewhat, as in this view. The star still helps me to divide the blossom properly into five equal parts as in figure 7–33B. A side view of the same

blossom is shown in figure 7–34, with 34A showing the structure on which 34B was based.

These three views of a buttercup are combined into a small grouping of blossoms in figure 7–35. I used my 3×0 technical pen point for this ink sketch.

I used the same composition for the pencil version in figure 7–36. I drew the outline very lightly, then I filled in the dark background with a broad-point 6B pencil, using the sharp edge to get in the tight areas. I then used a sharp HB pencil to sharply define the outline of the blossoms and stems. Finally I did the toning of the blossom with an HB pencil.

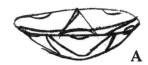

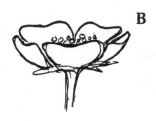

Figure 7–32
Structure and sketch of buttercup blossom, head-on view.

Figure 7–33
Structure and sketch of three-quarter view of a buttercup.

Figure 7–34
Structure and sketch of side view of a buttercup.



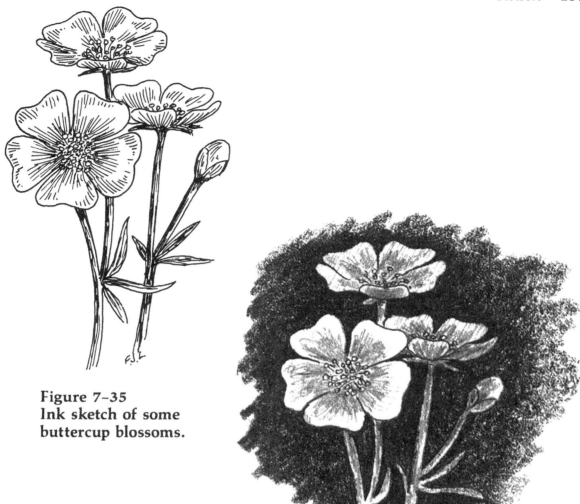

Figure 7–35
Ink sketch of some
buttercup blossoms.

Figure 7–36
Pencil version of the
buttercup sketch.

Drawing Goldenrod and Queen Anne's Lace

Both goldenrod and Queen Anne's lace blossoms have tiny flowers that are carried in clusters. The challenge in drawing these flowers is to *suggest* the innumerable little individual flowers by drawing just a few, and to make the structure of the groupings of these flowers obvious.

Figure 7–37A shows a simplified structure diagram for Queen Anne's lace. The blossom is made up of small individual clusters of the very tiny flowers, each cluster supported by a separate stem. When the flower passes maturity it dries up and forms sort of a cup or bird's nest shape. Figure 7–37 shows both of these structures.

A pen and ink version of Queen Anne's lace is shown in figure 7-38. The circles of figure 7-37A are each drawn as a separate cluster of flowers, each as shown in figure 7-39. A few of the little stems that support each cluster are shown in the final drawing. In the dried specimen it is primarily the lines that mold the hollow bird's nest shape by flowing in the direction of the outer and inner surfaces.

The sketch in figure 7-38 is greatly simplified. The thousands of tiny flowers are only suggested by drawing a few dozen little circles. This kind of simplification and suggestion is absolutely essential when very complicated structures such as Queen Anne's lace are considered.

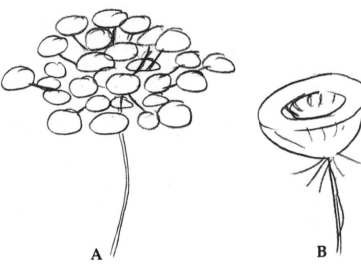

A B

Figure 7-37
Structure of the blossoming and the dried Queen Anne's lace.

Figure 7-39
Typical individual clusters, many of which make up Queen Anne's lace.

Figure 7-38
Pen drawing of Queen Anne's lace.

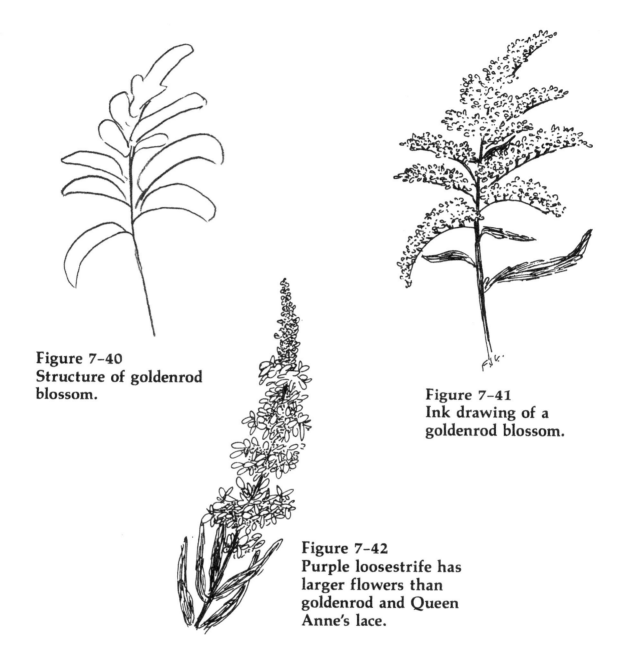

**Figure 7–40
Structure of goldenrod
blossom.**

**Figure 7–41
Ink drawing of a
goldenrod blossom.**

**Figure 7–42
Purple loosestrife has
larger flowers than
goldenrod and Queen
Anne's lace.**

Goldenrod is similarly composed of thousands of tiny flowers, grouped into characteristic shapes. In this case, instead of being arranged in a flat disk, the flowers are arranged in sprays. These sprays are arranged as in the structure diagram in figure 7–40. The inked version is shown in figure 7–41. The same little circles are used as in the Queen Anne's lace drawing to indicate the massed, tiny flowers.

In some cases of massed flowers the individual flowers are larger than those of goldenrod and Queen Anne's lace. You must make the flower indications larger in such cases to suggest the relative size of the flower. Figure 7–42 illustrates this for the purple loosestrife flower.

The Structure of Various Flowers

Seeing the basic, underlying shapes is half the battle for making a realistic drawing of both simple and complex flowers.

The jewelweed is a pretty plant usually found near streams. It has a bottle-shaped flower with five petals on the open end and a curled "tail" on the closed end. I simplified this flower to a cone, the curled tail, and five petals, as you see in an exploded view in figure 7–43A. Assembling these seven parts and adding some toning produced the sketches in figures 7–43B and 43C.

The violet is a five-petalled flower, but the petals are not equally spaced. I used the structure diagram of figure 7–44A to guide my drawing in figures 7–44B and 44C. You can see by reference to photographs of violets, or by observing living ones in the spring, that two of the petals are opposite each other, one at three o'clock and one at nine o'clock. Then there is just one petal in the lower half of the structure circle, while there are two in the upper half.

The leaves of the blue violet are heart-shaped and somewhat bumpy rather than smooth, and sometimes they are curled on the edges. Ink drawings of typical leaves are shown in figure 7–45.

The delicate, pretty columbine blossom is, at first glance, a somewhat complicated subject. However, it is basically just five bowling-pinlike shapes connected together as shown in figure 7–46A. This basic structure allowed me to quickly draw the blossom in figure 7–46B. When you make a drawing like this your toning

must be done in a way that lets the edges of each element of the flower remain evident. If you do not do this you can easily lose all visual identity. Your toning must serve *your* purpose, rather than being exactly as you see in a photograph or in the subject itself.

The common teasel is familiar to almost everyone during the winter. The hard, dried pods remain on the tough, woody stalks when everything else is covered with snow. The basic shape of the teasel pod is like an elongated egg with a flat area on the large end. Figure 7–47A shows this. The spiny, dried pod is sketched in figure 7–47B.

Another common wildflower is the Canada thistle. This flower has, basically, a vase shape as shown in figure 7–48A. The base of the vase is covered with pointed green scales while the colorful flowers pour out of the top like so much fuzz. The blossom is sketched in figure 7–48B.

Take note in figures 7–47B and 7–48B how the use of shading and highlights help create the illusion of roundness in the form.

The staghorn sumac is a beautiful fall specimen of brilliant reds when the leaves turn from their dark green and the fuzzy seed clusters harden. The seed cluster is roughly pear-shaped and fastened to the furry branch at the wide end. Figure 7–49 shows a pen sketch of the seed cluster and a compound leaf. Note the pen strokes used to indicate the furry texture of the branches and the seeds. The seedpod was first sketched with circles of radiating lines, as shown in

Figure 7-43
Jewelweed flower.

Figure 7-44
Blue violet.

Figure 7-45
Leaves of the blue violet.

Figure 7-46
Columbine.

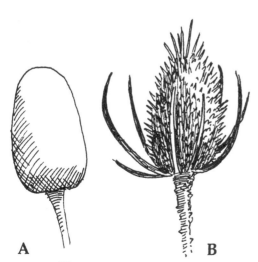

Figure 7-47
Common teasel.

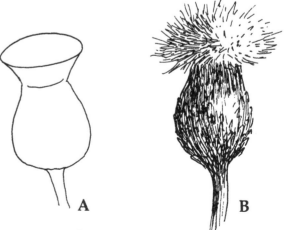

Figure 7-48
Canada thistle.

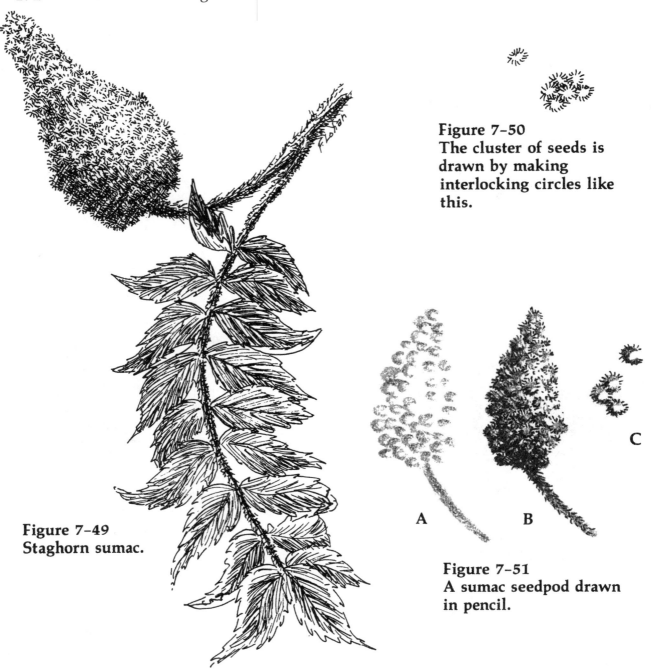

**Figure 7-50
The cluster of seeds is
drawn by making
interlocking circles like
this.**

**Figure 7-49
Staghorn sumac.**

A B C

**Figure 7-51
A sumac seedpod drawn
in pencil.**

figure 7-50, before I started any
toning. This approach helped to
capture the feeling of hundreds of
furry little seeds.

　　To render this subject in pencil, first
make little partial circles with a flat-
point 3B pencil as shown in figure
7-51A. Be sure to leave a highlight
area as I did near the right side. Then
rim each of these circles with

radiating lines, using a sharp pencil. I
used a sharp HB pencil to complete
the seedpod you see in figure 7-51B.
Figure 7-51C shows how I put the
radiating pencil lines on each of the
partial circles. When this was done, I
used the sharp HB pencil to go in and
emphasize some of the circles as I
shaded the left side and lower part of
the seedpod.

Drawing a Yucca Plant

The yucca plant is essentially a ball of long narrow leaves with one or more protruding stalks that carry the flowers. To properly draw the ball of leaves you must use the principle of foreshortening, since the leaves must be drawn in every position between side view and head-on view. Hold your pencil up in front of you and look at it with one eye closed. Now slowly move it so you are looking directly at the end of the pencil. In this position you see only a circle, whereas you saw a succeeding series of shorter and shorter pencil shapes as you rotated it from the upright position. The same idea holds for the ball of yucca leaves, since you see them in all positions between head-on and full profile.

Figure 7-52 is a drawing of a yucca plant done with a fine point, my 3×0 technical pen point. The kind of strokes I used to obtain the foreshortening are shown in figure 7-53. I first lightly drew a circle in pencil to maintain the proper shape of the ball of leaves as I drew them.

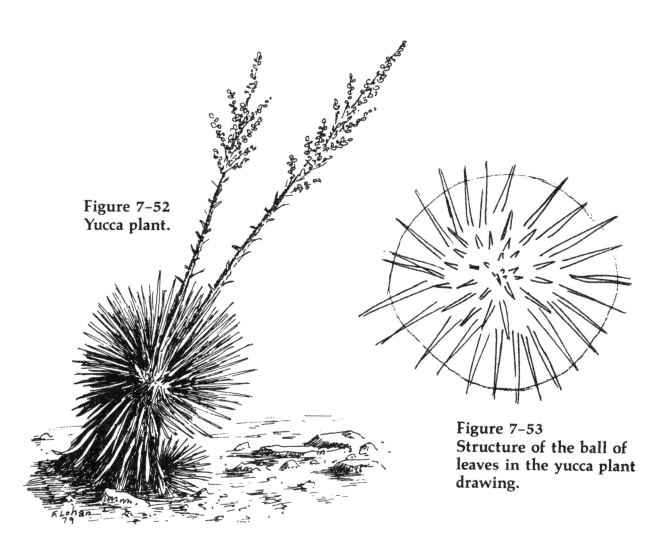

Figure 7-52
Yucca plant.

Figure 7-53
Structure of the ball of leaves in the yucca plant drawing.

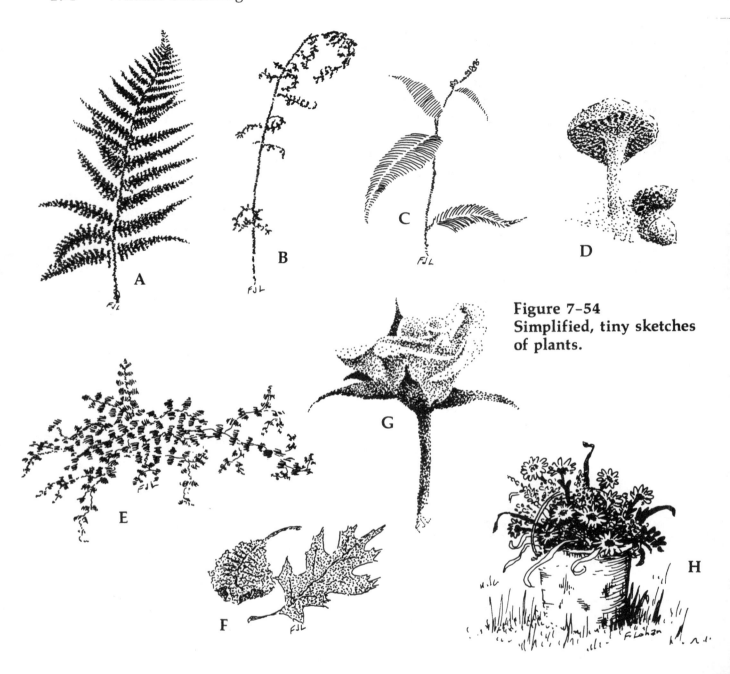

Figure 7-54
Simplified, tiny sketches
of plants.

Tiny, Simplified Plant Sketches

Great simplification is necessary when making tiny sketches of plants (an inch or two in size). Figure 7-54 shows eight different pen sketches of plants and flowers, some done only with dots, such as the ferns in 54A and 54B, and the rose in 54G. Others are drawn only with lines but with no outlining, as in 54C and 54E. Others are drawn both with outlines and either dots or cross-hatching to produce the tone as in 54D, 54F, and 54H. As simple as these sketches are, I found it very useful to make some basic, light structure drawings to guide the ink work. In each of these sketches I worked from photographs and used my 3×0 technical pen point.

**Figure 7–55
Dried flowers.**

Sketching Dried Flowers

Dried flowers and seeds make great subjects for small sketches. Figure 7–55 shows you ten such subjects done with my 3×0 technical pen point. Sometimes the flower parts are so tiny that dots are necessary to capture the idea, as in figure 7–55A. Most of the other dried flowers in this figure are drawn with line and outline.

Look at figure 7–55H. This shows a fuzzy seed head even more tiny than the fuzzy dandelion seed head. Note how delicate lines and dots are used to indicate the texture and how a little bit of dark indicates the center of the seed head that can be seen through the delicate outer portion. I put the darks in last after I did the outer surface.

Figure 7–56
Silhouette of an ocotillo
plant.

Silhouettes of Flowers and Plants

Silhouettes make charming little drawings, and plant life offers an almost infinite variety of subject matter.

The pencil layout sketch is as necessary for silhouette drawings as it is for other drawings. When doing silhouettes, the problem of structure is greatly simplified since you do not have to suggest roundness. The importance of the pencil composition is not diminished, however, just because you are doing a silhouette. You still must ensure that you have the proper proportions, and the best way to this—while there is still time to make changes—is by making a careful pencil composition first.

Figure 7–56 shows a silhouette of a desert ocotillo plant in bloom. This drawing was done with my artist's fountain pen, a much coarser point than the 3×0 technical pen point.

Figure 7–57 shows five more plant silhouettes, including a pine branch in 57A and a pair of teasel pods in 57E. The teasel is also shown in nonsilhouette form in figure 7–47B.

Figure 7-57
Silhouettes of flowers.

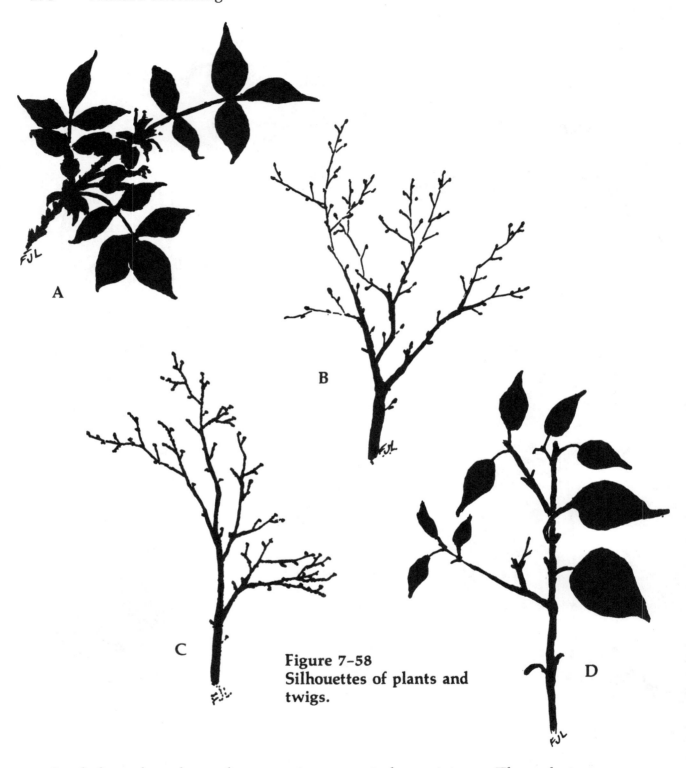

Figure 7-58
Silhouettes of plants and twigs.

Leafy branches also make attractive silhouettes, as you can see in figure 7-58. The beautiful ways that nature arranges branches and leaves provides countless compositions that would be difficult or impossible for the human mind to originate. These designs are there for our use, however, if we just look. The four drawings of figure 7-58 were done with an artist's fountain pen and a small watercolor brush dipped in ink.

When to Show Detail and When to Just Suggest It

Figure 7-59 shows catkins and new leaf growth fairly close up. At this scale it is imperative that you show detail such as the leaf edge serrations and the veins in the leaves, in addition to shading to establish bulk and roundness.

When you have several elements in a drawing, you must decide which is the dominant one and provide clues to the viewer about your choice. One way to provide a clue is by drawing more detail in your dominant element. Another way is by providing the greatest contrast where you want the viewer's eye to be attracted.

In figure 7-60, the foliage and flowers are completely subordinated to the split-rail fence. Here, all detail is devoted to the wooden fence, and the roses that climb on it are suggested by a silhouette approach to the leaves and the barest outline for the blossoms. In this case the subject is the *fence*, with the roses being secondary; they are only part of the setting in which we find the fence.

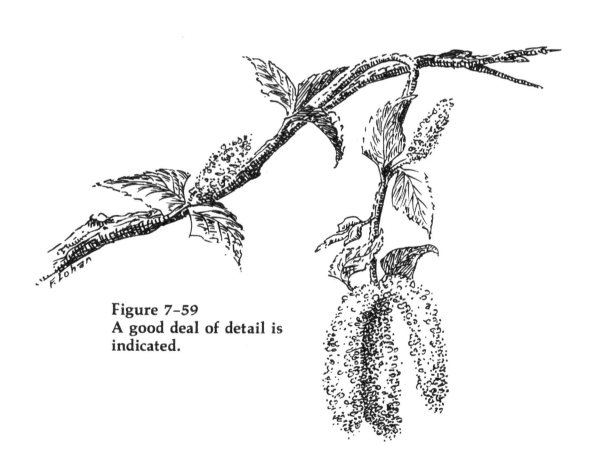

Figure 7-59
A good deal of detail is indicated.

Figure 7-60
No detail is shown in the flowers.

8
Mushrooms

The Many Shapes of Mushrooms
A Decorative Grouping of Mushrooms
Using Ink Wash with Ink Lines to Draw Mushrooms

The Many Shapes of Mushrooms

Mushrooms are often thought of as having a typical umbrella shape. While many of them do fit this pattern, many do not. There are club-like mushrooms like the shaggymane (fig. 8–2) and the morel (fig. 8–3), cup-shaped ones like the devil's urn, shelflike ones such as the beefsteak polypore, and mushrooms that look like coral, such as the crown-tipped coral. The last three are illustrated in figure 8–5.

There is little in the way of a standard structure diagram to guide you in drawing mushrooms. Your powers of observation and ability to discern geometric shapes will be your best guides. I have drawn a variety of mushrooms in figures 8–1 through 8–4 to indicate how I prepared my initial structure drawing for each and how I completed the drawing.

The inky cap in figure 8–1 has the typical umbrella shape associated with mushrooms. I used both line and stipple (dots) to complete the pattern and shading in figure 8–1B. This was done with my 3×0 technical pen point.

Figure 8–2 shows a club-shaped shaggymane mushroom. In 2B I completed the drawing in ink with my 3×0 pen point and in 2C I did the same subject using a 3B pencil. The little cap on top of this mushroom is brown and the bottom of the stem is blackish; the rest of the mushroom is white. I tried to indicate this tonal difference in both the ink sketch and the pencil sketch.

Another club-shaped mushroom is the morel. The surface is deeply folded and pitted. Figure 8–3 shows my construction drawing and the finished ink drawing. I chose to do this one completely in stipple (dots). I used a pencil to draw the outline of each of the dark indentations, as you see at the top of figure 8–3A, before I started the inking. I stippled these dark areas first, then stippled the outline ridges and the stem. Finally, I used stipple on the lower left part of the mushroom cap to give some roundness to the form by showing shading.

Figure 8–4 shows an umbrella-shaped mushroom drawn with a combination of outline and stipple. This is a method frequently used for technical illustrations.

Figure 8–5 simply shows some of the many other shapes of mushrooms and how these shapes can be rendered with the pen. When drawing curved or bottle-shaped objects, you must use lines to model the surface and help the viewer see at a glance just what the shape of the object is. You do this by using appropriately curved shading and toning lines as shown for the devil's urn, the scarlet cup, and the beefsteak polypore, as well as for the petallike common fiber vase. Parts of the devil's urn and the common fiber vase are left incomplete so you can see how I started these drawings.

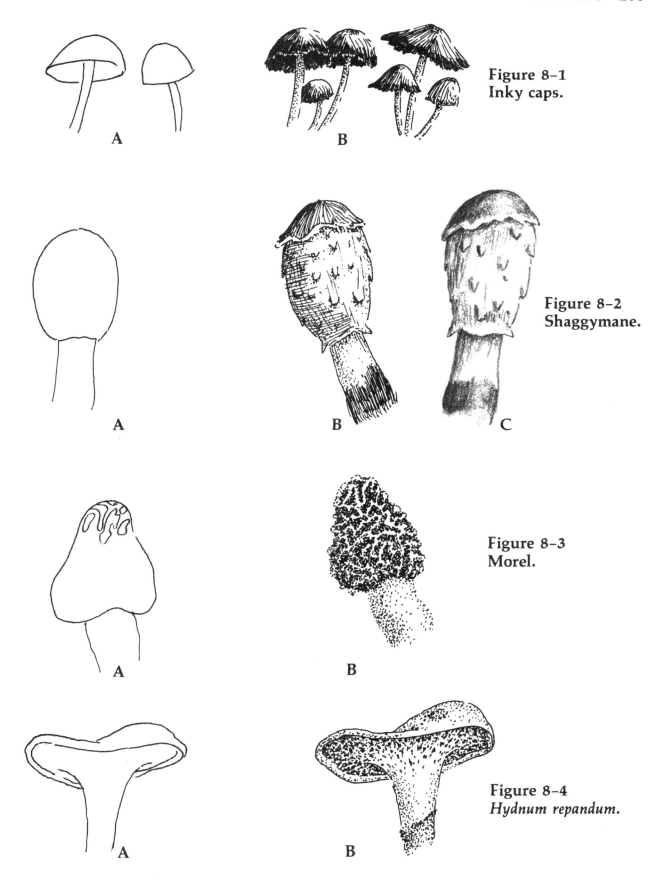

Figure 8–1
Inky caps.

Figure 8–2
Shaggymane.

Figure 8–3
Morel.

Figure 8–4
Hydnum repandum.

Crown-tipped Coral

Common Fiber Vase

Beefsteak Polypore

Devil's Urn

Scarlet Cup

**Figure 8–5
Some other mushroom
shapes.**

A Decorative Grouping of Mushrooms

Figure 8-6 shows a grouping of boletinus mushrooms with a little foreground rubble typical of the environment in which these mushrooms grow. If you are doing a little drawing, perhaps to have printed as notepaper, some indication of the setting makes the drawing more complete than just drawing the subject by itself.

Figure 8-6
Boletinus pictus.

Using Ink Wash Over Ink Lines

Ink wash is simply india ink diluted with water and applied with a small brush to create tone. It gives a very interesting effect, as you can see in figure 8-7. This is a collection of mushrooms, all of the family *Agaricaceae*, drawn with *waterproof* india ink in the usual manner. Then, when the ink was dry, the drawing was painted over with a dilute mixture of india ink and water. You must use waterproof ink for the drawing itself or the wet brush will dissolve the ink lines and make a mess. The wash is just a drop of ink, either waterproof or not, in about a tablespoon of water.

C. Steroiorarius

C. Quadrifidus

C. Bulbilosis

C. Atramentarius

Coprinus
Comatus

F. Lohan

C. Fimetarius

Figure 8-7
Agaricaceae.

C. Domesticus

9
Water Birds

Basic Approach—Structure of Ducks

Basic Approach: Structure

Water birds have a wide variety of shapes, although some—such as ducks—have a degree of commonality in the general proportions of their bodies. The same holds for sandpipers.

Figure 9–1A through 1E shows some basic views of a generalized duck shape. This shape is based on three balls, just as the songbird shape is in Chapter 4, but the balls are in different proportions and located differently here to account for the peculiar shape of a duck. Notice that the ball representing the head is the smallest and that representing the rump is the largest in these five sketches. The three balls are spaced about an equal distance apart.

Even if you draw a duck from a photograph, you will find it very useful to first make a light sketch of the three balls before you start to sketch the shape and feathers. The balls make the process of getting the proportions right and getting the features properly located much easier and faster.

Figure 9–2 shows some sketches of a mallard duck based on the structure drawings of figure 9–1. I had photographic references for each of these views which helped me get the proportions correct and locate the color features where they should be. Good reference material is one essential to realistic wildlife drawing; the other is the discerning eye that can see the differences in shape and proportion.

Different ducks have different features, such as the peculiar shape of the canvasback duck's bill or the slightly smaller head on the pintail duck. If you want your drawings to be realistic, you have to watch for such differences and build them into your drawings.

Getting action in your water bird drawing requires a lot of good reference photographs, as well as a lot of direct observation when this is possible. You cannot just "guess" at what a duck looks like when it is landing or taking off from the water; you have to know. Also you have to know that different species land and take off differently.

Action Sketches

Sketches showing action are always much more attractive than static poses. Compare the mallard taking off in figure 9–3 and the pintail landing in figure 9–4 with the mallards in figure 9–2A, 2B, or 2C. You can immediately see the difference in interest that the action sketches evoke. It would be almost impossible for anyone not *very* familiar with duck anatomy to correctly draw the bend in the body and the straining muscles and wings of the landing pintail duck of figure 9–4 by guesswork. Those details require very good reference photographs. In addition to photographs, paintings by dozens of excellent wildlife artists are also superb reference material; they often

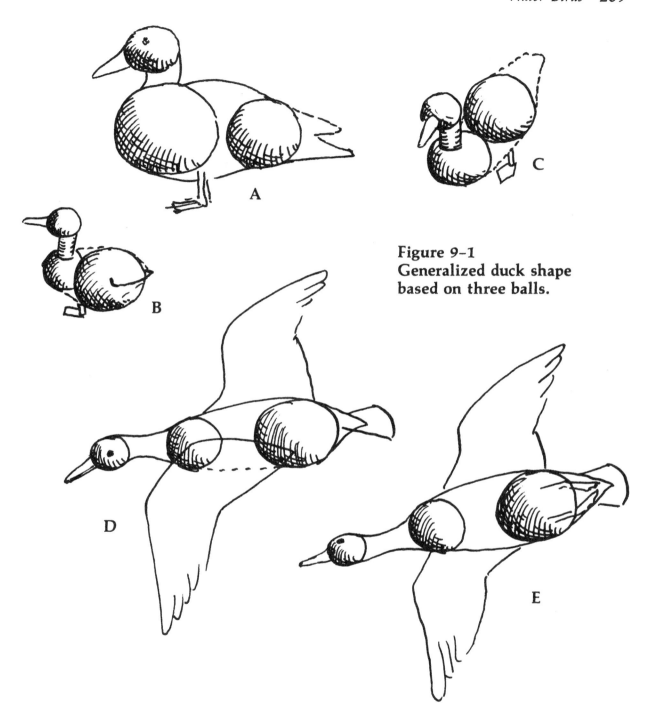

**Figure 9–1
Generalized duck shape
based on three balls.**

show details you cannot see in photographs.

Figure 9–5 shows the pintail duck coming in for a landing sketched in pencil. Both this pencil rendition and the ink study of figure 9–4 were drawn from the light pencil composition shown in figure 9–6B.

Notice that I showed, in pencil, the location of every major feather before I started to complete either drawing. I used a sharp HB pencil for figure 9–5 followed up by a sharp 3B pencil to put the darks in place. I used a 3×0 technical pen point (any fine point will do as well) for figures 9–3 and 9–4.

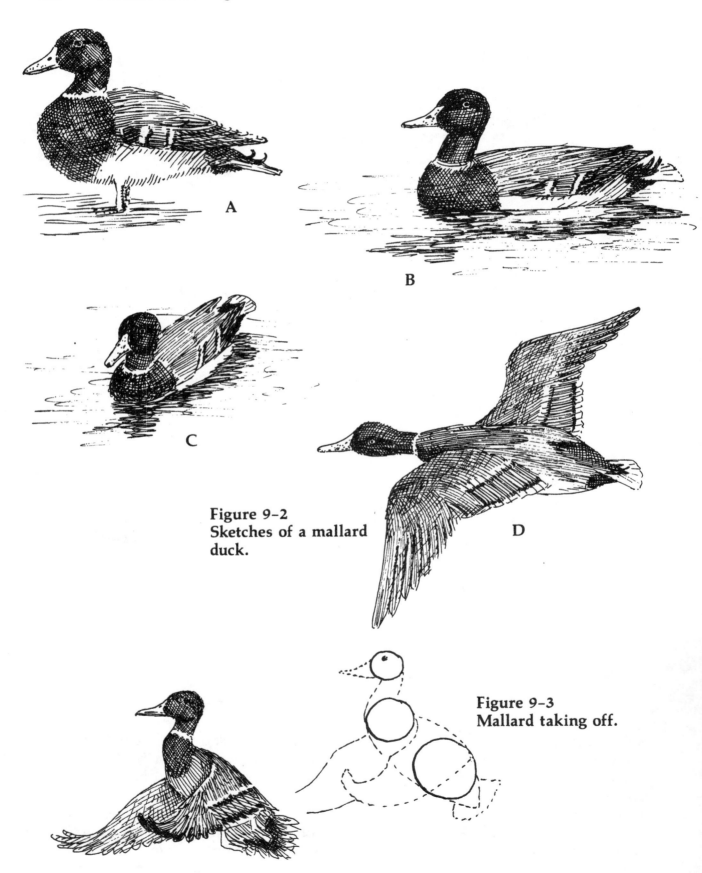

A

B

C

**Figure 9-2
Sketches of a mallard
duck.**

D

**Figure 9-3
Mallard taking off.**

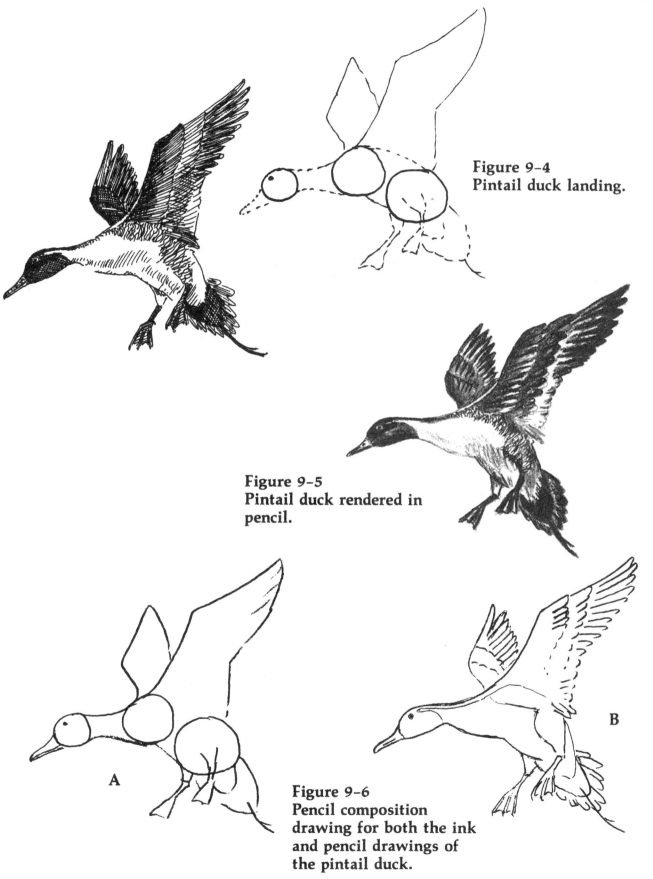

Figure 9-4
Pintail duck landing.

Figure 9-5
Pintail duck rendered in
pencil.

A

B

Figure 9-6
Pencil composition
drawing for both the ink
and pencil drawings of
the pintail duck.

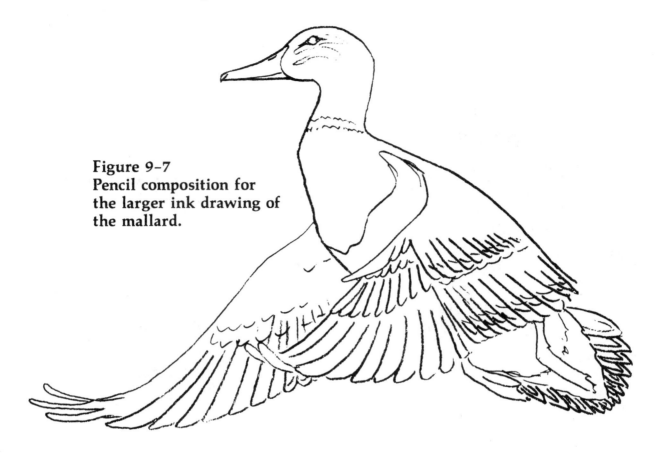

Figure 9–7
Pencil composition for
the larger ink drawing of
the mallard.

Details in Larger Sketches

It is almost impossible to properly enlarge the subject in a tiny, postage-stamp-size illustration and invent detail that you cannot see in the original. If you want to do larger, detailed drawings you had better have some reference photographs that show the kind of detail you want to draw, even if you take the action pose itself from a small illustration of a different pose.

Figure 9–7 shows a pencil composition for a larger sketch of the mallard taking off. This one, in the original, is about 6½″ × 5″. The smaller one in figure 9–3 is about 2½″ × 2″. The larger sketch requires that more detail be shown, so, as you can see in figure 9–7, I indicated more of the feathers on my composition before I started to ink the drawing.

Figure 9–8 shows how I indicated the wing feathers before I did the overtoning line work. Figure 9–9 shows the first layer of hatch lines on the head and breast of the mallard. A little of the second layer is shown on the bird's forehead. I used my finest pen point for this drawing—the 3×0 technical pen point.

There are two precautions you should observe when doing pen and ink drawing. First, do not use outline unless you need it for clarity in your sketch. In larger sketches the toned areas can be made to serve as the edges of your subject. In smaller sketches, where detail is very limited or missing entirely, you frequently must use outline to tell the story, but when you get to the size of figure 9–12, unnecessary outline often gives a coloring-book look to a sketch. In

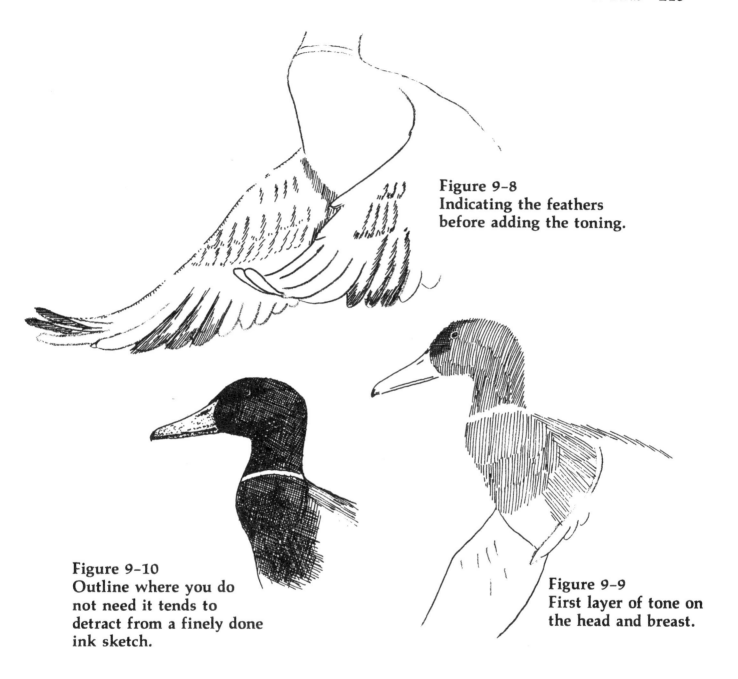

Figure 9–8
Indicating the feathers
before adding the toning.

Figure 9–10
Outline where you do
not need it tends to
detract from a finely done
ink sketch.

Figure 9–9
First layer of tone on
the head and breast.

figure 9–10 I redrew the mallard's head using the same toning as figure 9–12, but added a complete outline. Compare the two to see what I mean.

The second precaution concerns hatching and cross-hatching to create medium and dark tones. In order to get the effect of darkness, you have to cover the white paper with ink. When doing this by hatching and cross-

hatching, as opposed to painting the ink on with a brush, you must put the hatch lines close together. If you hatch with widely spaced lines you are not covering a large enough percent of the paper at one time with ink, and therefore to produce a very dark area you may have to cross-hatch eight or nine times. Such wide hatching is shown in figure 9–11A.

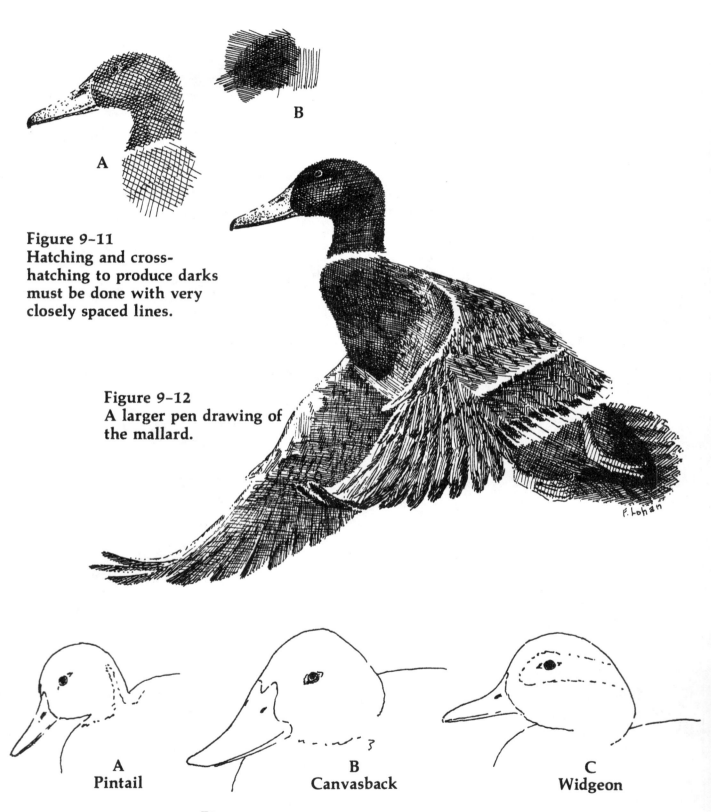

Figure 9–11
Hatching and cross-hatching to produce darks must be done with very closely spaced lines.

Figure 9–12
A larger pen drawing of the mallard.

A
Pintail

B
Canvasback

C
Widgeon

Figure 9–13
Differences in the shape and size of the head and bill.

You see in this figure the result of three layers—the first hatching layer and two more like it on top but with the lines in different directions. The widely spaced lines in 11A have produced a gray tone; but the closely spaced lines in 11B have, after the third layer, created as deep a dark as you would need.

Many times you will want to use a highlight to indicate an edge. I did this in figure 9–12 to show the leading edge of the near wing. The tone of the wing and that of the body surface it is in front of are just about the same. The two areas would blend together if I had not left the narrow white highlight to indicate that they were in reality two different surfaces. Sometimes you must take this kind of liberty when you are sketching. The same thing was done in figures 9–3, 9–4, and 9–5 in order to ensure that the wings were immediately perceived as separate from the body.

Variations in Head and Bill Shape

Not all ducks have the same shape head and bill. When drawing ducks you will have to look for such differences just as you look for differences in coloration and patterns on the plumage.

Figure 9–13A shows the round head and fairly long bill of the pintail duck. Compare this with the more triangular head and stouter bill of the canvasback duck in figure 9–13B and the more egg-shaped head and shorter bill of the widgeon in figure 9–13C. The wood duck shown in figure 9–16 has a very long head, as if he were wearing a helmet.

Sketching a Wood Duck

The wood duck is one of the most colorful ducks in North America. It is impossible to capture all of the iridescent blues, purples, greens, and reds of the wood duck's plumage in black-and-white drawings, but you can capture the patterns of the lights and darks.

Figure 9–14 shows my final structure drawing after a few trial and error changes. I was working from several guidebook illustrations and some photographs.

My working composition drawing, showing each of the major feathers and all major plumage patterns, is shown in figure 9–15.

I used three pencils to do the drawing of the wood duck—a sharp HB, a broad-point HB, and a broad-point 2H. In addition, when the drawing shown in figure 9–17 was completed, I touched up a few of the dark lines with a sharp 3B pencil.

In order to get a mottled appearance on the duck's back, I first used a sharp HB pencil as shown at A in figure 9–16, then rubbed over this lightly with a broad-point HB and then a broad-point 2H pencil to get the result shown at B. The inner wing feathers were started with the sharp HB pencil as shown at C, then rubbed over lightly as above with a broad HB, then more heavily with a broad 2H. The result is shown at D. The outer wing feathers were developed by first using a broad HB pencil as shown at E, then rubbing over this with a broad-point 2H as shown at F. Finally, I used a sharp-point HB pencil to sharpen the edges up a bit as shown at G. The dark markings on the head and breast were done with a sharp HB pencil as shown at H.

The final pencil drawing is shown in figure 9–17. The last thing I did to the drawing was to use the broad 2H pencil on all the white areas of the

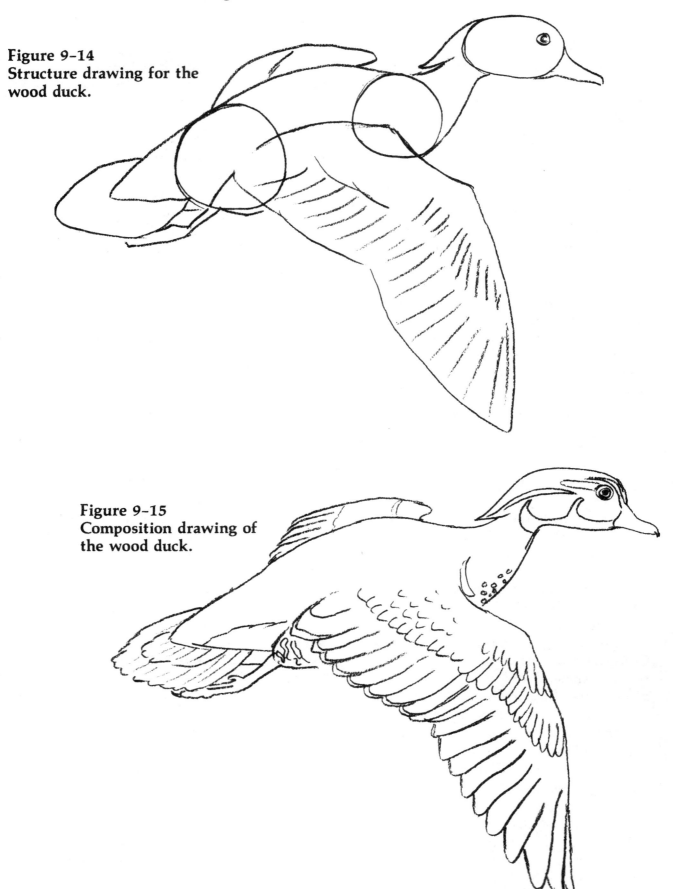

Figure 9–14
Structure drawing for the
wood duck.

Figure 9–15
Composition drawing of
the wood duck.

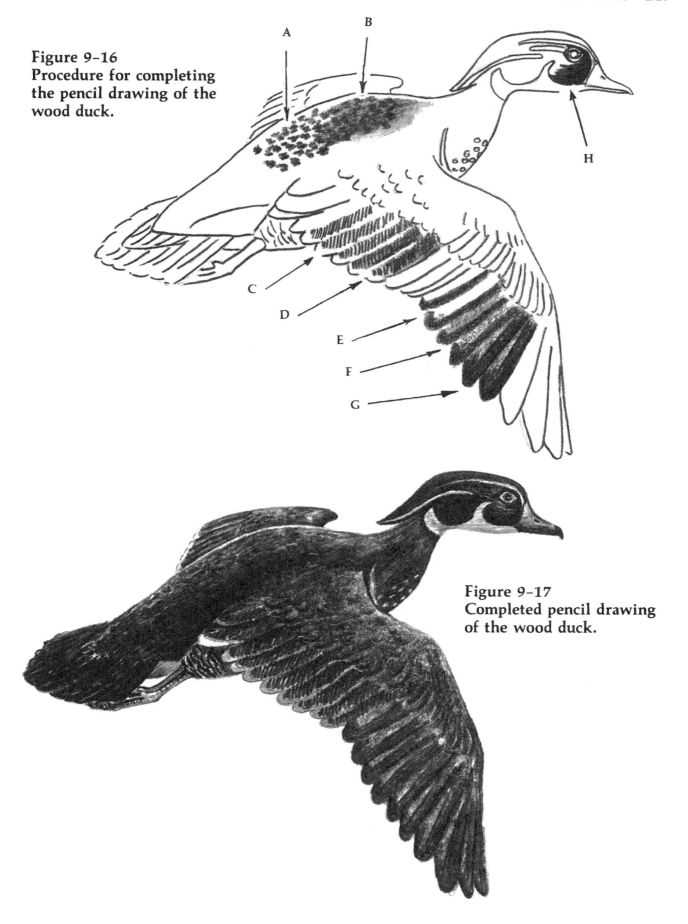

Figure 9-16
Procedure for completing
the pencil drawing of the
wood duck.

Figure 9-17
Completed pencil drawing
of the wood duck.

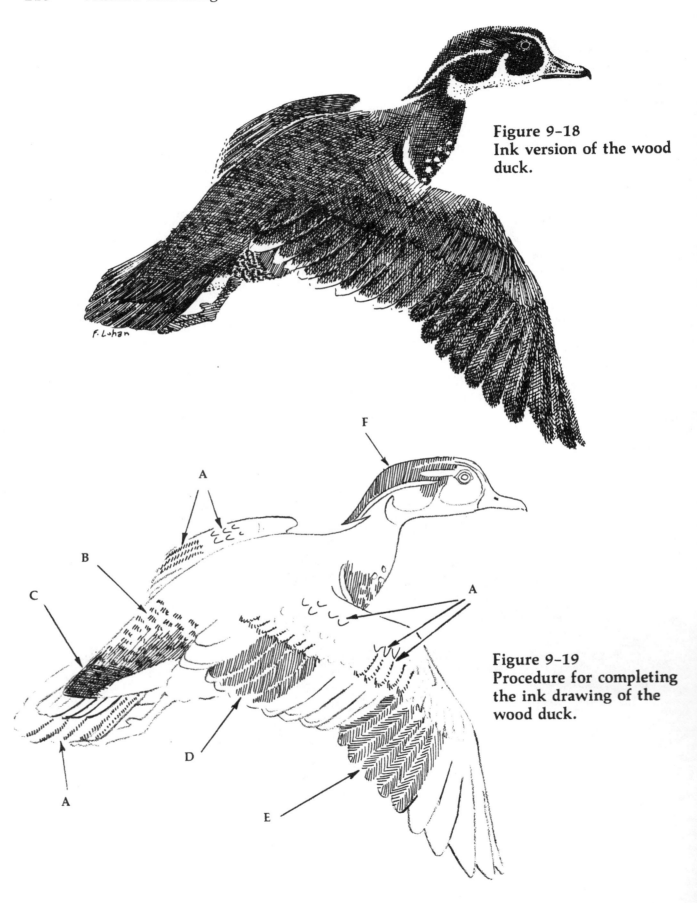

Figure 9–18
Ink version of the wood duck.

Figure 9–19
Procedure for completing the ink drawing of the wood duck.

duck's plumage and to put a few very dark strokes on the wings and tail with a sharp 3B pencil. Notice that I left a highlight along the duck's back to separate the back from the far wing. This was necessary since the wing and back have the same tone and would otherwise blend together.

My pen and ink version of the same composition is shown in figure 9–18. Note that I avoided ink outlines except where necessary on the bill and legs and the white edges of some feathers. I indicated features such as dark edges of feathers first, and then put the toning over. These feather indications are shown in figure 9–19 at A on both wings and the tail. The mottled appearance on the duck's back was obtained by first drawing little dark patches as shown at B, then cross-hatching over them as shown at C. D and E show how I textured the big wing feathers before hatching over them. F shows how I started the toning on the dark head areas.

The pencil outline in figure 9–19 is shown much darker than was actually used for figure 9–18. This was to ensure that the pencil lines would show up when printing this book. You should make your working composition drawing—the one you will ink over—as light as possible.

Sketching Sandpipers

Sandpipers are shore and marsh birds. They vary considerably in size, length of legs, and length of bill from species to species, but in general usually have mottled, barred, or spotted plumage.

Figure 9–20 shows the composition drawing for a member of the sandpiper family called yellowlegs. This is a fairly small drawing, so the opportunity to show much detail is very limited. About all I could hope to do was to indicate the mottled and spotted head and back, and show the barred tail and wings.

I used my finest point, the 3×0 technical pen point, for the ink drawing of the yellowlegs in figure 9–22. The wing patterns were developed as shown in figure 9–21; first a little hatching as shown at in 21A, leaving a little white space into which I put the bar marks as shown in 21B. The black outer wing feathers were completed as shown in 21C.

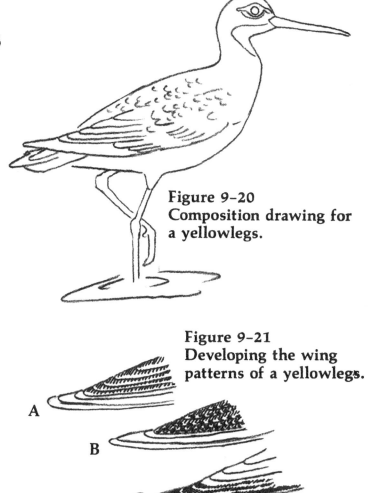

Figure 9–20 Composition drawing for a yellowlegs.

Figure 9–21 Developing the wing patterns of a yellowlegs.

A

B

C

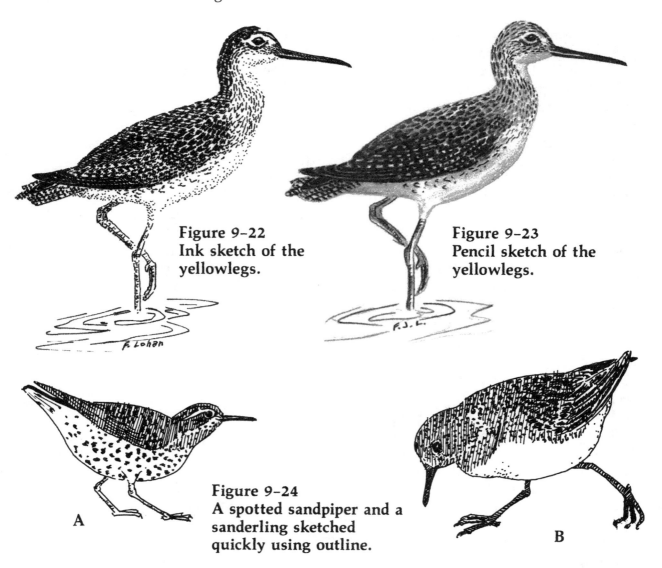

Figure 9-22
Ink sketch of the
yellowlegs.

Figure 9-23
Pencil sketch of the
yellowlegs.

Figure 9-24
A spotted sandpiper and a
sanderling sketched
quickly using outline.

A

B

Again I left narrow white lines to show the separation between the feathers. I loosely cross-hatched over these three outer feathers and the white spaces when I was finished with the ink work.

Rather than use outline for the white underparts of the bird, I used stipple (dots) to indicate a slight shading, which established the form of this part of the bird.

Figure 9-23 shows a pencil version of the same composition. The small size of the sketch required sharp 4H and sharp HB pencils to establish the mottles, spots, and wing bars. Then,

when the plumage was drawn, I went over the pencil portions with a flat-point 2H pencil. I also used this flat point to shade the undersides and throat establishing the outline of the body in these areas.

Two quick action ink sketches of other sandpipers are shown in figure 9-24. Compare these minimally toned drawings of the spotted sandpiper (24A) and the sanderling (24B) with the more detailed yellowlegs in figure 9-22. You can make quick sketches outdoors to capture action postures and then convert them at your leisure to fuller studies.

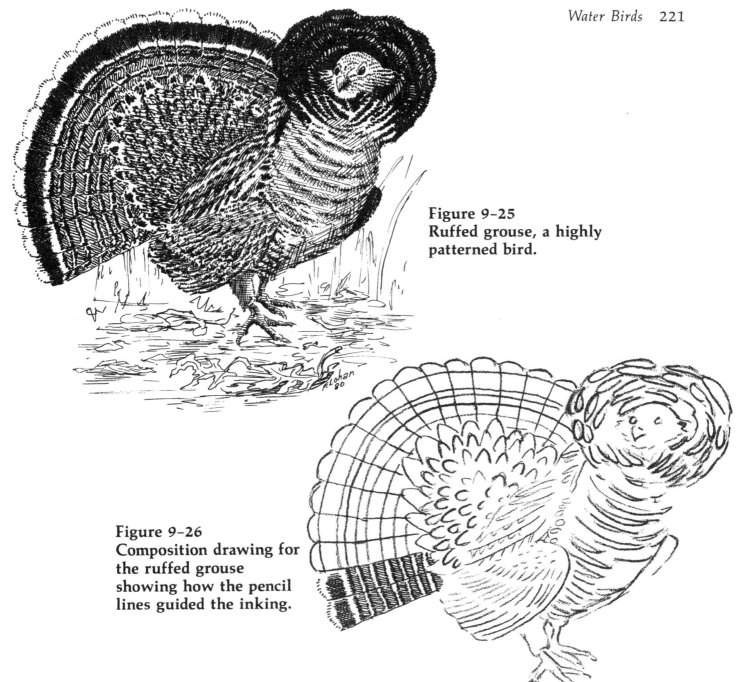

Figure 9-25
Ruffed grouse, a highly
patterned bird.

Figure 9-26
Composition drawing for
the ruffed grouse
showing how the pencil
lines guided the inking.

The Ruffed Grouse

Highly patterned birds make interesting pen and ink drawings. Although not a water bird, the ruffed grouse in figure 9-25 is included here to show one of the prettiest of our American birds in full display of its tapestrylike plumage. A drawing like this requires a carefully done, very detailed composition sketch to locate each of the major feathers and each of the different colored plumage features. It also requires some very clear illustrations on which to base the patterning. Figure 9-26 shows the pencil composition sketch over which I inked the ruffed grouse. It also shows, on the lower tail section, how I used the pencil guidelines to put the ink properly in place.

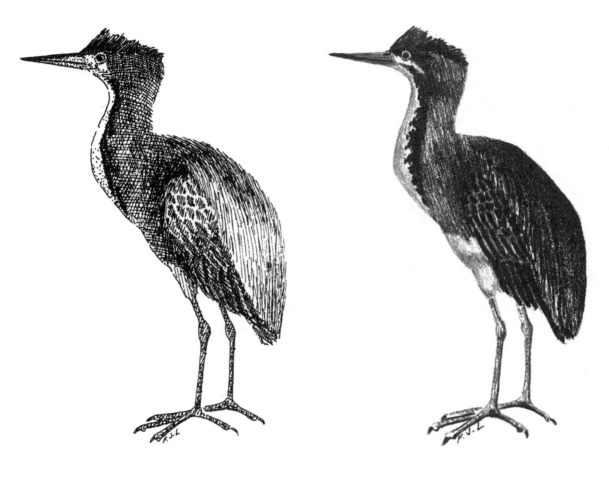

Figure 9–27
Green heron.

Figure 9–28
Pencil version of the
green heron.

Sketching Herons

Herons vary in size and proportions so there is no one structure diagram that applies to sketching them. Your observations and your ability to discern proportions from your reference material will have to be your guides in getting your composition drawings correct. The method of enlarging and reducing drawings by using a grid of squares, described in Chapter 2, will also be very helpful in preparing your composition drawing.

Figure 9–27 is an ink drawing of a green heron. All the techniques discussed earlier in this section—using outline sparingly, stippling, and cross-hatching—were used to complete this sketch with a 3×0 technical pen point. The feather features on the wing were defined first, then cross-hatched over to complete the tone.

A pencil version of the same bird is shown in figure 9–28. This drawing was done using sharp HB and 3B, and broad-point 2H and 3B pencils. I

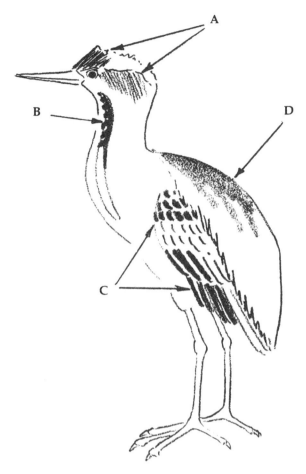

**Figure 9-29
Steps in completing the
pencil version of the
green heron.**

underparts and to rub over the wing patterns. Then I used a sharp 4H pencil to sharpen up the edges of the light chest and underparts and to tone the legs.

Figure 9–30 shows a pen sketch of a great blue heron. As with the pen sketch of the green heron above, there is nothing new here in terms of strokes or their method of application. You simply need to control the hatch mark spacing to obtain the tones you need. For instance, the bird's crest, tail feathers, and outer wing feathers are toned by three layers of cross-hatching with the lines placed very close together to get a dark tone. The part of the wing close to the heron's body is completed with two layers of cross-hatching but with the lines spaced further apart to obtain a lighter tone.

Figure 9–31 is a pen sketch of an American bittern. This is a rather simple sketch. The back of the bird and its underparts were started identically with groups of hatch-marks showing the mottled appearance of the feathers. One layer of cross-hatching on the back then darkened this area, while the breast was left white between the dark mottles.

started with a sharp HB pencil and completed the crest and red neck as shown at A in figure 9–29. I made individual strokes here, not attempting to make the tone too smooth. I used a sharp 3B pencil to put the very dark marks on the neck as shown at B and also to indicate the wing feathers at C. The back was completed with the broad-point 3B pencil as shown at D. The final step was to use the broad-point 2H pencil to tone the throat, chest, and light

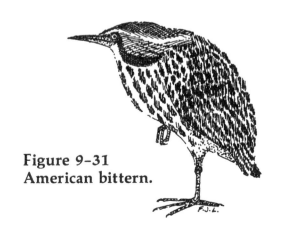

**Figure 9-31
American bittern.**

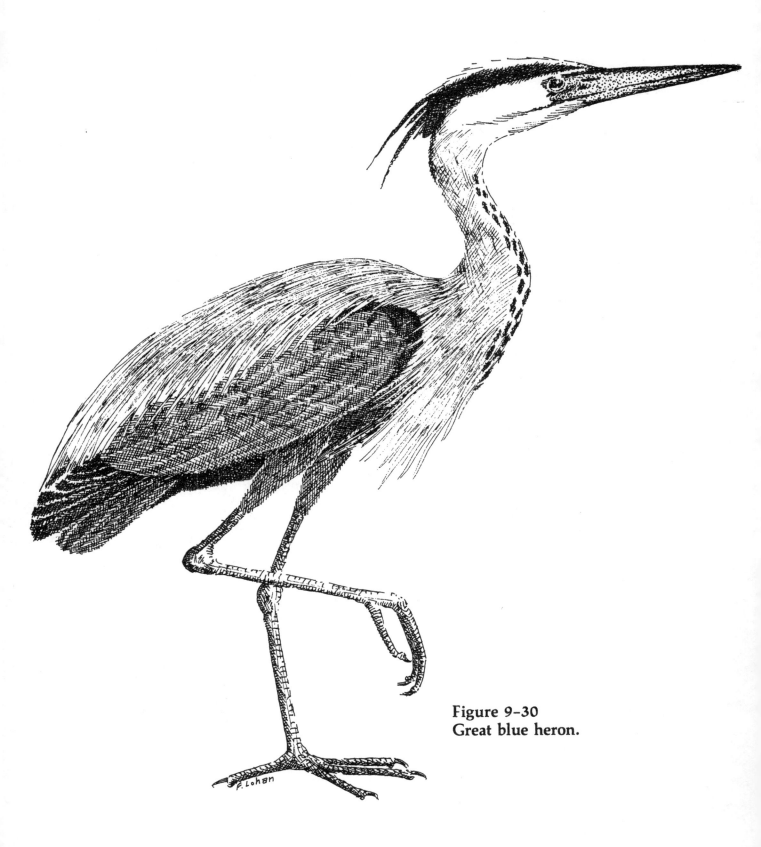

**Figure 9-30
Great blue heron.**

10
Reptiles and Amphibians

Sketching Snakes
Sketching Frogs
Sketching Turtles and Salamanders

Sketching Snakes

Except for the shape of the head and the color pattern of the scales, snakes all fit the same basic body shape. Accurate representation of the color pattern then becomes very important in realistically representing a particular snake species.

Figure 10-1 shows my composition drawing for the ink sketch of a garter snake. Working from several photographs, I first indicated the stripes that run the length of the garter snake's body on my composition drawing. Then I started inking as you see on the head in figure 10-1. The dark areas were all cross-hatched, starting as you see shown at A. Then, using dots, I showed some of the scales on the light parts of the snake as shown at B and C. Then I cross-hatched the dark stripes and sides of the snake. The final result is shown in figure 10-2.

The copperhead differs from the garter snake in the head—the copperhead's head is larger and triangular. It also differs in the stubbiness of its tail—the copperhead's body remains thick much closer to the tail while the garter snake tapers more gradually to a longer, thinner tail. Figure 10-3 shows these two changes incorporated into the garter snake composition drawing to produce one for the copperhead. At A in figure 10-3 the head was made to resemble a flat triangle, while at C the rear part of the snake was drawn thicker than that of the garter snake. Figure 10-3 also shows at B and D how I rendered the patterns on the snake's body. First, B, I outlined the dark patches with short hatch marks, then I hatched over these and over the darker areas (D). The result is shown in figure 10-4, an ink rendering of a copperhead.

The milk snake is a very pretty North American reptile. The pencil drawing in figure 10-5 shows the black edged, reddish patches that cover much of the snake's white or cream-colored body. The drawing was developed as you see in figure 10-6. The black marks were made first as shown at A with a sharp 3B pencil. Then, I used an HB pencil to indicate the reddish areas (B). Finally, a broad point 4H pencil was used to give the form roundness by toning (C).

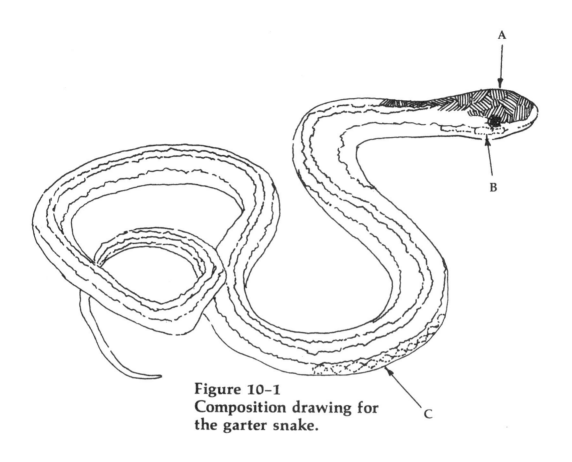

**Figure 10-1
Composition drawing for
the garter snake.**

**Figure 10-2
Completed ink drawing
of the garter snake.**

**Figure 10-3
Composition drawing for
the copperhead.**

**Figure 10-4
Ink drawing of the
copperhead.**

Figure 10-5
Pencil drawing of a milk
snake.

Figure 10-6
Composition drawing and
steps in completing the
milk snake drawing.

Sketching Frogs

Frogs and toads generally have the same shape, although there will be differences in the size of the hind legs and in the general fatness of the body. Both pen and pencil work well for drawing these animals.

Figure 10-7 is an ink drawing, primarily outline and stipple, of a wood frog. This frog is basically green with some light stripes running the length of its back and legs, and some black markings as well as fainter brownish patterns on its back and legs. Figure 10-8 shows how I started this drawing with a pencil composition showing all the major patterns on the frog's skin. After putting all the dark markings in place on its back and head, I used stipple (dots) to uniformly tone the green part of the skin, A in figure 10-8. When this was done (with the lighter stripes left white), I went back over

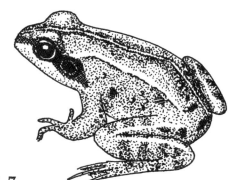

Figure 10-7
Ink drawing of a wood
frog.

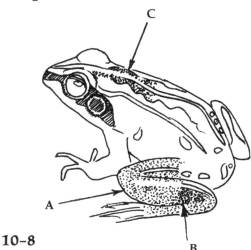

Figure 10-8
Composition drawing for
the wood frog with some
of the initial pen work
shown.

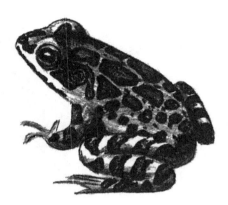

**Figure 10-9
Pencil drawing of a
pickerel frog.**

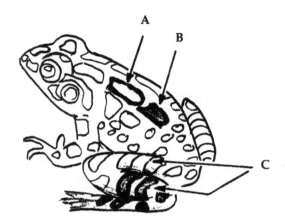

**Figure 10-10
Composition drawing of
the pickerel frog.**

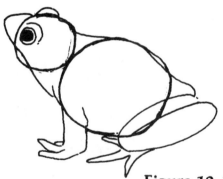

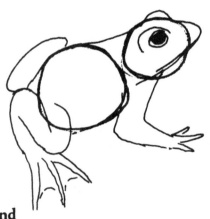

**Figure 10-11
Some general frog and
toad shapes.**

areas with additional stippling to create the slightly darker patterns shown at B and C. When the ink was all dry I lightly erased the pencil lines.

Figure 10-9 shows a pencil sketch of a pickerel frog. This highly patterned frog has basically light skin with dark-edged brownish blotches all over. Figure 10-10 shows the composition drawing I used for this subject. My pencil guidelines were much lighter than you see in figure 10-10—they are shown dark here just for clarity in printing. I first used a sharp 3B pencil to put the dark edges around each of the blotches. This is

shown at A. Then, with a sharp HB pencil I toned in each of the blotches (B). When this was done I used a broad-point 2H pencil to tone the light skin between the blotches. The near hind leg would have lost its distinctness and blended into the body of the frog if I had not left highlights as shown in C of figure 10-10.

Figure 10-11 shows a couple of generalized frog or toad shapes. Two circles form the basis for these drawings. You should have some good, clear reference illustrations to use as guides when sketching like this.

Drawing Turtles and Salamanders

Turtles

Figure 10–12A shows the structure of the box turtle. This animal was named for the boxlike shell it carries, which is diagramed in 12B and 12C. The painted turtle, on the other hand, has a shallower, dishlike shell which is shown in figure 10–13.

The box turtle has a great deal of light patterning on the dark shell, each segment of which is made prominent by being surrounded by a light outline. The ink sketch of a box turtle in figure 10–14 shows these patterns and segment separations drawn in ink using primarily stipple

(dots). The rear part of this sketch is unfinished so you can see how I indicated the patterns prior to inking the dark areas.

The painted turtle, shown in the pencil drawing in figure 10–15, has no patterning on its shell other than the light division lines between each dark shell segment. Its head and neck are striped, however, as are its legs. I used a sharp HB pencil for this drawing, and when completed, a broad-point 4H pencil to slightly tone the light areas. The rear portion is not complete so you can see the composition drawing I used.

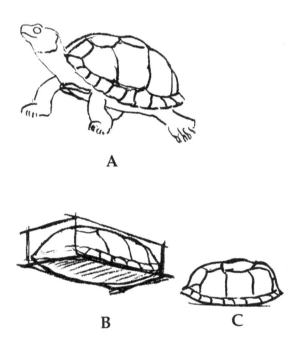

Figure 10–12
Structure of a box turtle.

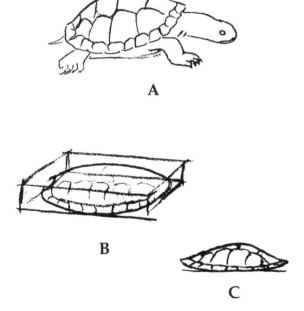

Figure 10–13
Structure of a painted turtle.

**Figure 10-14
Partially completed ink
drawing of a box turtle.**

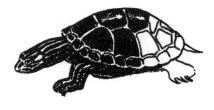

**Figure 10-15
Partially completed pencil
drawing of a painted
turtle.**

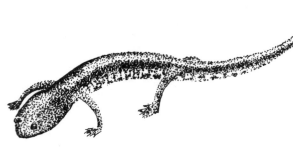

**Figure 10-16
Red-backed salamander.**

**Figure 10-17
Spotted salamander.**

Salamanders

Salamanders are generally like shiny lizards in shape except that salamanders have prominent grooves on their sides. The two salamanders illustrated in figures 10-16 and 10-17 were drawn in ink using stipple rather than line to produce the tone. The red-backed salamander in figure 10-16 has no distinct markings on its back, whereas the spotted salamander of figure 10-17 has large light spots on its dark skin. With most nature subjects, you should draw from the real thing or from good, clear, detailed reference material. Unless you are somewhat knowledgeable about the anatomy of the subject you are drawing, you will not be able to accurately create what you cannot see.

In Summary

Pen and Pencil Wildlife Sketching presents a simple, step-by-step approach to learning how to draw living things. These are the steps essential for nature sketching:

- visualizing what you want to draw
- putting a structure sketch of that visualization on paper
- toning the structure to bring out depth and shape

In other words, try to look at what you want to draw in terms of geometric shapes—boxes, spheres, cylinders, cones. Then take a few seconds to lightly sketch the structure of your subject in terms of these geometric shapes before you start to develop the form. It makes the process of arriving at a good working composition much easier.

This book has taken you through a wealth of subjects. Let it serve as a point of departure for you—as a collection of examples that serve to illustrate an approach, rather than a cookbook of how-to recipes. Take the suggestions I make here and extend them: try them with other subject matter and add to them from your own experience. This is the way your drawing skills will grow and develop.

Good luck!

Bibliography

Technique

Guptill, Arthur L. *Rendering in Pen and Ink*. Edited by Susan E. Meyer. New York: Watson-Guptill, 1976.

Hamm, Jack. *How to Draw Animals*. New York: Putnam Perigee Books, 1982.

Lohan, Frank. *Pen and Ink Techniques*. Chicago: Contemporary Books, 1978.

_____. *Pen and Ink Themes*. Chicago: Contemporary Books, 1981.

_____. *Pen and Ink Sketching Step by Step*. Chicago: Contemporary Books, 1983.

Pitz, Henry C. *How to Draw Trees*. New York: Watson-Guptill, 1972.

Sloan, Eric. *An Age of Barns*. New York: Funk and Wagnalls, 1967.
NOTE: Eric Sloan has written and illustrated a number of books on Americana. His pen sketches in any of them are worth studying.

Subject

Brockman, C. Frank and Merrilees, Rebecca. *Trees of North America*. New York: Golden Press, 1968.

Cole, Rex Vicat. *The Artistic Anatomy of Trees*. New York: Dover, 1965.

Lund Harry C. *Wild Flowers of Sleeping Bear*. Traverse City, Mich.: Harry C. Lund, 1978.

Mathews, F. Schuyler. *Field Book of American Wildflowers*. New York: Putnam, 1927.

Norling, Ernest. *Perspective Drawing*. Tustin, Calif.: Walter Foster Art Books.

Pearson, T. Gilbert, et al. *Birds of North America*. New York: Garden City Press, 1942.

Pond, Barbara and Norman, Edward and Marcia. *A Sampler of Wayside Herbs*. New York: Greenwich House, 1974.

Robbins, Chandler S., Bruun, Bertel, Zim, Herbert S., Singer, Arthur. *Birds of North America*. New York: Golden Press, 1983.

Sutton, Ann and Myron. *The Audubon Society Nature Guides—Eastern Forests*. New York: Knopf, 1985.

Index